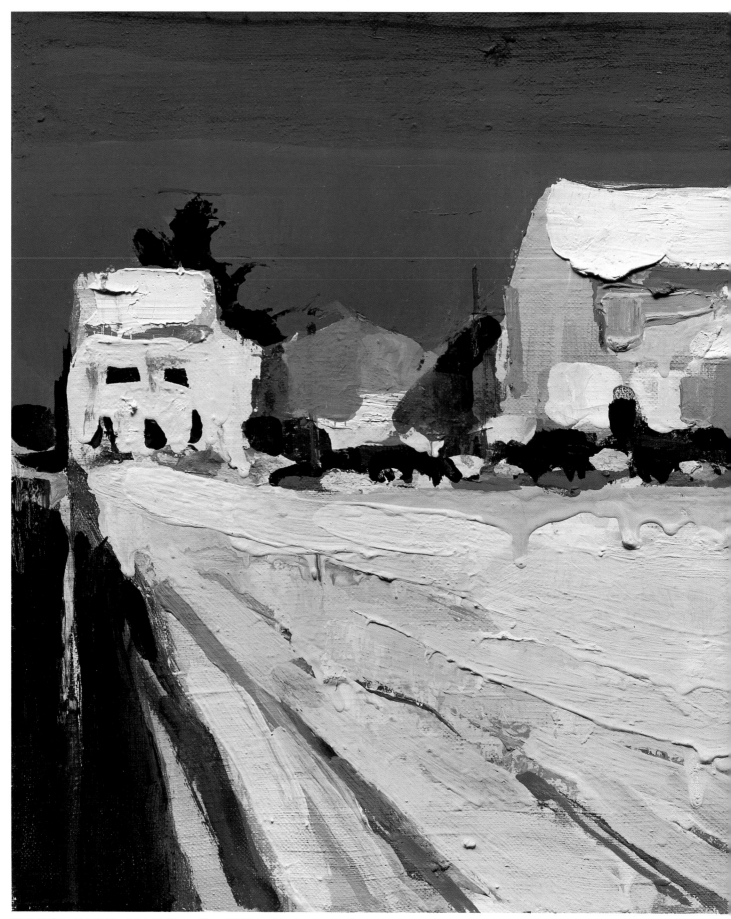

WINTER FARM, MAINE *12″ × 18″ (30 × 46 cm), collection of Dr. and Mrs. Daniel Miller*

Alfred C. Chadbourn

PAINTING WITH A FRESH EYE

WATSON-GUPTILL
PUBLICATIONS/
NEW YORK

This one is for Mary and Jessica

I want to pay a special tribute to Donald Sigovich
and the people at Gamma One Conversions for producing
the incredible transparencies that made this book possible.
I would also like to thank Bonnie Silverstein
for finally giving me the book I was looking for.

Copyright © 1987 Alfred C. Chadbourn

First published in 1987 in New York by Watson-Guptill Publications,
a division of Billboard Publications, Inc.,
1515 Broadway, New York, N.Y. 10036

Library of Congress Cataloging-in-Publication Data

Chadbourn, Alfred.
 Painting with a fresh eye.

 Bibliography: p.
 Includes index.
 1. Painting—Technique. I. Title.
ND1500.C46 1987 751.45 87-13302
ISBN 0-8230-3888-2

Distributed in the United Kingdom by Phaidon Press Ltd., Littlegate
House, Ebbe's St., Oxford

Manufactured in Japan

First printing, 1987

1 2 3 4 5 6 7 8 9 10/92 91 90 89 88 87

Chip Chadbourn helped me become a painter
(my background had been in illustration).
He introduced me to Bonnard, Vuillard, and
Matisse. This, and working with Chip,
opened up a new world for me. We still paint
together when possible so I'm familiar with
many of the pictures and ideas in this book.
I trust reading it will enrich your painting
life just as it has mine.

CHARLES REID

CONTENTS

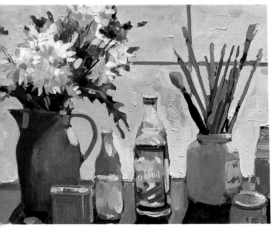

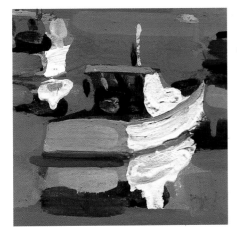

PATTERN AND COMPOSITION 70

FLATTENING THE PICTURE PLANE 88

PAINTING BEACH SCENES 100

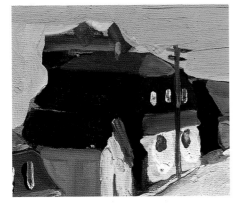

PAINTING A CITYSCAPE 112

EXPLORING A FISHING VILLAGE 126

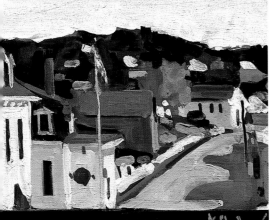

CONCLUSION 140

INTRODUCTION

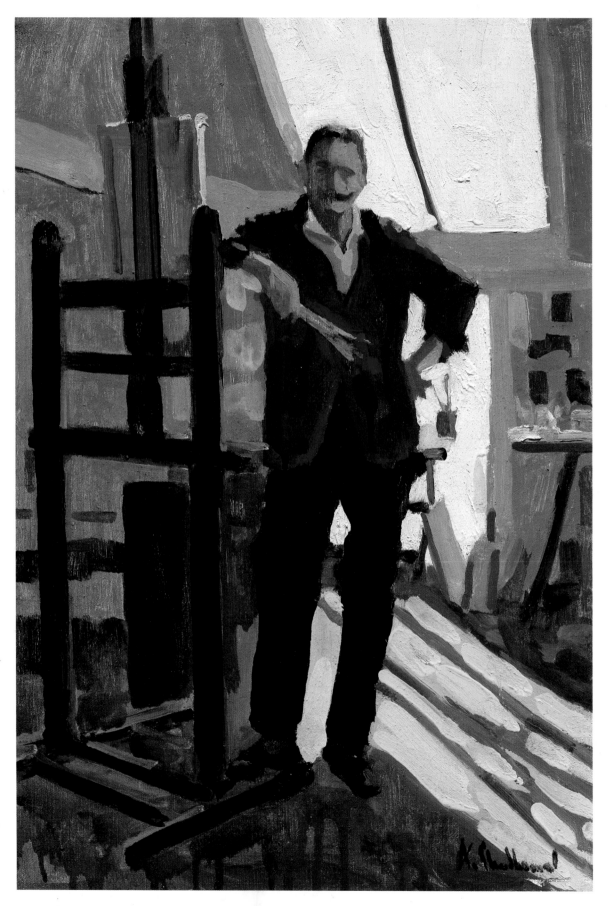

"I am simply conscious of the forces I am using and I am driven on by an idea that I really only grasp as it grows with the picture. Truth and reality in art begin at the point where the artist ceases to understand what he is doing and capable of doing—yet feels in himself a force that becomes steadily stronger and more concentrated."

—HENRI MATISSE

I have always felt that one of the most important objectives of a teacher is to show you new ways of seeing, rather than how to paint. Since this book is basically a visual extension of my teaching, my purpose is to show how I go about trying to solve my own painting problems, in the hope that this will encourage you to develop your own creative instincts. As a teacher, I have always been convinced that the problems I face with painting are really no different from those of my students. The only difference is that I've probably been at it longer, and I breathe, eat, and sleep with these problems as a normal part of my daily life.

This book is also about taking creative risks and liberties with your painting. As the word "risk" implies, there is always the chance that the final result may not be exactly what you had in mind. But what have you got to lose? As the painter Wayne Thiebaud has said, "I'm a firm believer in the notion that artists who do good work believe in the idea of extremes. They make it very tough on themselves." Expounding on the idea of spontaneity, he remarks, "If you know too much in advance how the painting is going to turn out, you tend to anticipate yourself. Then there's that lack of immediacy."

Since color plays such an important role in developing one's painting skills, a great deal of this book is devoted to this perplexing problem. Unfortunately, a confusion of color theories has been thrust upon us, with all conceivable forms of charts, wheels, and diagrams. I have purposely excluded them from this book. Instead, my approach—simply put—is how to look for color and how to mix and apply it.

Although there are eight chapters, I see this book as presenting two basic kinds of information. In the beginning, I deal with the physical properties of color through a discussion of my basic palette and a still life demonstration showing the actual mixtures of color as the painting progresses. The rest of the book then emphasizes developing a personal perception. After an exploration of different ways of using color, specific chapters focus on transforming light into color, taking liberties with nature, and flattening the picture plane. In discussing my paintings, I bring out different visual concepts, such as exploring the use of exaggerated color and looking for abstract shapes in nature. These concepts are intended to expand your skills.

Because I use a lot of reproductions in my classes, I am an unabashed name-dropper when it comes to studying art. I have been going to museums and galleries all of my adult life and, like some truffle-sniffing pig in the Perigord in France, I feed on the stuff with the hope that my enthusiasm will eventually rub off on the student. When it comes to taking chances and experimenting, we can do no better than to study some of the great examples of the past and keep a sharp, critical eye on the present.

SELF-PORTRAIT
16" × 10' (41 × 25 cm)
collection of Mrs. Alfred Chadbourn

COLOR AND
PAINT HANDLING

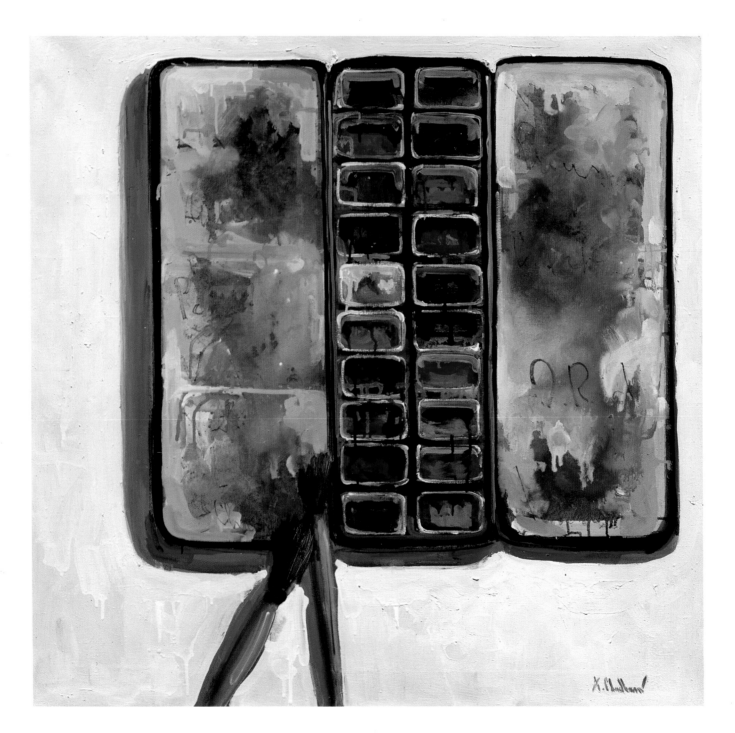

M y palette (shown on page 13) is based primarily on an Impressionist concept. The way the palette is laid out—with warm colors on one side and cool colors on the other—is basically no different from the palettes of Monet, Renoir, Pissarro, and Cézanne. From time to time I vary my palette, just as they did, but in essence these colors can produce almost any color you seek. Sometimes when I'm working on a violet "theme," I'll buy four different violets or four different blues to see if they will expand my violet mixtures. The same could be said of yellows, greens, or reds. But generally I come back to my basic set of colors, as they seem to produce everything I want. If I feel in a rut, that I'm always going to the same color mixtures, I may move colors from one position to another or turn my palette around.

When I first visited the old Museum of Modern Art in Paris, near the Trocadero, I noticed a display of the palettes used by the Post-Impressionists: Bonnard, Vuillard, Dufy, Matisse, Braque, Derain, Marquet, and others. The thing that impressed me was that all their palettes were basically the same. It confirmed my belief that the palette an artist chooses has little to do with his or her personal style of expression.

The way you use color, however, can be a major component of individual expression. Each of us may actually see color slightly differently, so that we wouldn't agree on the exact shade of red. But beyond that, there is the use of color to convey your own personal response to nature. As you look through the paintings in this book, you'll discover that I've taken a lot of liberties with color. Even if it's sometimes frustrating, making the colors in a painting work as a whole can be one of the most exciting challenges for a painter.

Mixing and Applying Color

If you are using a palette that has served you well, there is no need to change it—so long as it has some degree of order. Place your colors in whatever order you choose near the border of the palette to allow the maximum area for mixing.

I mix all my colors on the palette before applying them to the canvas, which is the age-old method of oil painting. Some artists mix their colors directly on the canvas, but this takes a very educated eye and is usually done to create a specific color vibration. Bonnard used this method occasionally, and some contemporary painters like Wolf Kahn use this technique exclusively. Essentially, this method involves laying in large, thin areas of paint, one layer over the next, allowing some of the undercoat to show through, thus producing vibrations.

Because I have always been a fairly direct painter, I find that mixing colors on the palette first is the easiest way for me to accomplish what I want. Generally, I start out with fairly thin mixtures diluted with small amounts of turpentine and build up the canvas surface slowly, as can be seen in my demonstration on pages 14–21. If you commit yourself to thick paint in the beginning stages, it is that much harder to scrape off if you make a mistake. The important thing to remember is that whatever stylistic path or method you choose, technique should be the servant of your vision, not the other way around.

Another suggestion for mixing clean colors is to keep the surface of your palette clean while painting. I clean my palette at least four or five times during a painting session. This prevents any old colors from getting into a new mixture. I'm a real fusspot about this, much to the annoyance of my students. Whenever I try to help students by painting on their canvases, I invariably have to clean their palettes first since I can't possibly perform any "magic" with a palette smeared with wet paint.

With our heritage from the Abstract Expressionists of the fifties, there seems to be a plethora of ways of applying paint to the canvas—with artists pouring paint from cans or using spray guns, sponges, spatulas, rollers, broken chinaware, and any other materials they can get their hands on. It may seem a bit old-fashioned and clinical to be so preoccupied with clean brushes and clean palettes, so I should qualify my statements by saying that most of these precepts are directed toward students who are interested in the general sphere of representational painting. On a final despairing note, I might add that I've seen a lot of beautiful paintings by artists who used incredibly messy palettes—Soutine, Rouault, Kokoschka, Leger, and Braque, to mention a few.

MEDIUMS

I use a simple technique in my painting, based on the truism that the less you do to a painting, the better. I use no medium—only good-quality rectified turpentine for thinning the color and cleaning my brushes. The turpentine allows the painting to dry somewhat faster, as in most cases the addition of linseed oil or other oils to your medium will slow the drying process.

If you do use a medium other than turpentine, be sure to keep it simple. The old-time favorite, recommended by most experts, is one-third damar varnish, one-third linseed oil, and one-third turpentine. I would avoid any of the commercial gels on the market such as Res-N-Gel, as they tend to crack the surface of thickly painted canvas. Taubes copal painting medium is a good choice if you don't want to bother mixing your own.

My use of turpentine is similar to Edward Hopper's technique. It seems durable: over the past thirty years I have not found any signs of cracking. Basically, I believe there is enough oil ground into the pigment when the paint is made, so it doesn't need any extenders.

In general I build up my painting from turpentine washes into fairly thick, impasto-like surfaces. During the final stages I'm mixing pure pigments together with very little turpentine. While painting, I use a thin spray of retouch varnish when I want to bring the painting back to its original luster. It's generally a good idea to wait a year or two for the thick paint to dry completely before applying a final coat of damar picture varnish. In most cases my paintings hold up well for several years with nothing but retouch varnish to protect them.

There is much confusion about manufactured colors due to the arbitrary names of colors, so it pays to open the tubes and test them on a piece of paper before purchasing them. Most "student grade" colors are diluted with a great deal of filler, which limits their tinting strength. The "professional" or "artists' grade" is therefore generally worth the extra cost. In my own case, because I use so much paint over a year, I buy the reasonably priced Utrecht colors in pound-size tubes. Occasionally I'll splurge and buy a small tube of Winsor & Newton for experimenting, but generally Utrecht colors have good durability, with no excessive fading.

Titanium or Permalba White. Titanium spreads more easily than flake or zinc white and dries faster. Permalba is more expensive than titanium but has a nice buttery quality, which adds maneuverability.

Yellow Ochre. This indispensable color is probably the most versatile color on the palette; it mixes well with any color, including black. Note that it varies a bit with manufacturers.

Cadmium Yellow Light. You can get by without this by using cadmium yellow medium. I use it in place of lemon yellow, which is not permanent and should be avoided—as should zinc yellow and chrome yellow.

Cadmium Yellow Medium. This good, basic opaque color stands up well.

Cadmium Orange. This color varies more than any other shade depending on the manufacturer. Open the tube and test it to be sure you get what you want.

Cadmium Red Light. This basic bright red is indispensable. Avoid Mars red and Venetian red, which are not permanent. Sometimes I use Winsor red, which has a very strong tinting power, but it's expensive and I use it sparingly.

Burnt Sienna. This is a good, basic, fast-drying earth color. I use it in place of raw umber or raw sienna. Avoid Vandyke brown, as it cracks.

Alizarin Crimson. This is a very transparent color, much stronger than rose madder. Avoid magenta and Harrison red, as they fade.

Thalo Green. Thalo green is much stronger than viridian and takes getting used to. Many artists prefer viridian, which is permanent. The choice is a personal one. Avoid Thalo yellow green, however, as it's a virulent color and fades.

Ultramarine Blue. This indispensable color mixes well with most colors. Years ago I used Thalo blue, which has a stronger tinting quality, but—like Prussian blue— it gets into everything. The early Cézannes and Renoirs cracked in dark areas, where Prussian blue was used. Cobalt blue is also a good permanent color.

Cerulean Blue. This bright blue provides a good contrast to ultramarine. Manganese is also a strong blue, with a slight greenish tint.

Ivory or Mars Black. Ivory black is slow-drying and tends to dry unevenly, but I use such small amounts it doesn't jeopardize my painting. You're probably safer using Mars black. Avoid lamp black, which is a carbon pigment and dries slowly.

Thalo Red Rose. I've been using this color only for the past four years. I like it because it has a strong tinting quality; mixed with white, it gives a juicy pink. I have experimented with various violets but have never found one that compares to alizarin crimson or Thalo red rose mixed with blue.

My Basic Technique

The intent of this demonstration is to show how I paint a still life, to answer questions about my technique. I want to stress, however, that this demonstration illustrates only one approach to the problem of painting a still life; in no way is it the only approach. I might also point out that I generally make a few mistakes along the way—for me, that is par for the course. I discuss these errors of judgment as I go along so you can share some of the trials and errors I normally encounter when painting.

For this demonstration, I worked in the studios of Gamma One Conversions, located in Lower Manhattan, where the paintings for this book were photographed. In setting up the still life, I chose some fruit and flowers in a nearby market. Combined with a few odd bottles that I brought from my studio, they offered a variety of shapes and colors.

SKETCH

First I do a simple black-and-white sketch of the subject using a fine-pointed Pentel pen. I decide to incorporate some of the old buildings outside as a background for the still life, which provides an unusual challenge. Notice that I keep the architectural details to a minimum, as I don't want them to dominate the scene. On the right side of the interior, I suggest a huge green plant in a bowl—actually, I use only the leaves, which add to the pattern of the whole.

The early morning light is beginning to perform all sorts of magic on the windowsill—creeping over the light blue cloth and casting deep, slanting shadows to the right. Although the drawing is just a suggestion of what I see in front of me, it catches the essence of my initial response.

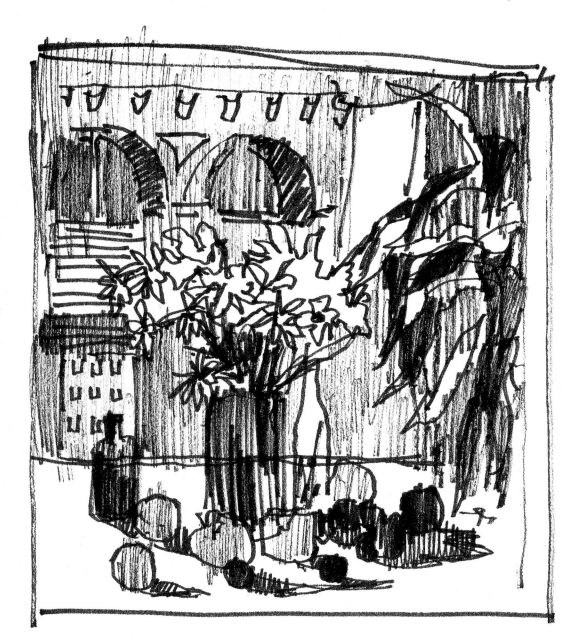

STEP ONE

Using straight ultramarine blue and turpentine, I start laying in the picture with two large flat bristle brushes (nos. 10 and 5). Because the canvas is fairly large (36 × 36 inches, 91 × 91 cm), I use the large brushes throughout the blocking-in period. When I make a mistake in the drawing, I wipe it out with a rag and turpentine, leaving a light blue tone on the canvas. (I should point out that I don't always start a picture the same way. Instead of ultramarine blue, I may use orange or yellow ochre, if I want an overall warm tone. And sometimes I rub a tone over the entire canvas first, rather than drawing directly on the white canvas.) Once the main features are in, I take a break and a long, hard look at how things are shaping up.

STEP TWO

My first reaction is that the large, leafy foliage on the right is too important and disturbs the balance of the picture. If I don't correct this now, it will haunt me later. After I wipe out the leaves with a rag and turps and redesign them, the foliage seems less distracting. Now I feel the need for another bottle on the right. Also, with some of those disturbing leaves eliminated, I can describe more of the building, and I add such architectural details as the three arched windows and the strong horizontal of the cornice above.

Note that I leave some of the bare canvas showing through around the flowers and in the foreground, as these are the lightest areas in the composition. Because I'm using a lot of turpentine as I draw, some of the dark areas—like the cast shadows of the fruit—drip a little, but they can always be cleaned up later. After about an hour, I realize that even though the drawing isn't perfect, there is enough of an image for me to start painting some color relationships.

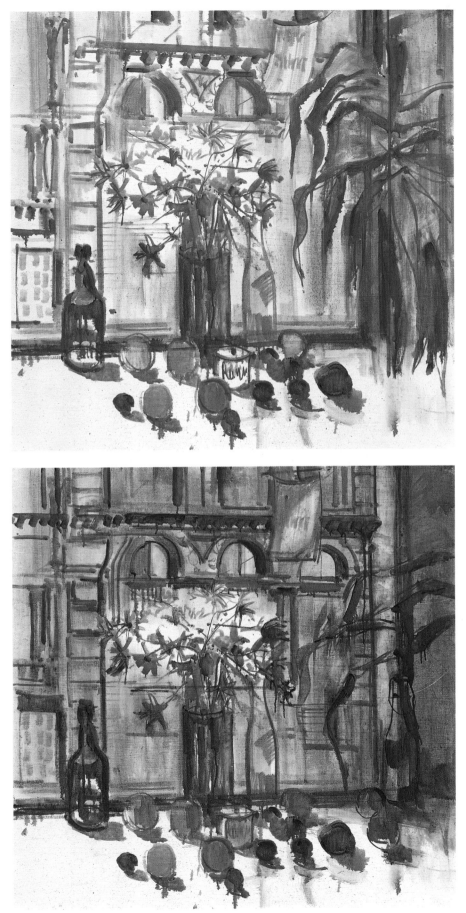

STEP THREE

Using a full palette of colors and a full array of flat bristle brushes (nos. 2, 3, 5, 7, 10, and 12), I begin applying color. Starting with the large background building, I mix a large amount of violet, using alizarin crimson, ultramarine blue, and white. The varied warm and cool violets suggested by the sooty buildings then act as a foil for the bright color in the rest of the setup.

Next I look for the darkest darks—in this case, the greens in the vase and the leaves on the right, which are mixed with yellow ochre, burnt sienna, and Thalo green. The dark plums are then painted with alizarin crimson and ultramarine blue. For some of the interior wall on the right, I use burnt sienna darkened with a little Thalo green. I also add this brown tone to the beer bottle on the left.

I try to cover as much of the canvas as possible, establishing large areas of color and value relationships. To define the bright pink flowers, I choose a mixture of Thalo red rose and white, with a few strokes of pure white for the daisies. Next I suggest the ultramarine blue banner and the red door on the left. With the door I experiment to see if I can get away with pure cadmium red light, even though it seems to jump a little at this stage. On the peaches I use some cadmium orange, darkened with a little yellow ochre. Next to the peaches I add some of the light blue cloth, mixed with cerulean blue and white. The painting may seem a bit sloppy at this stage, but I'm in a hurry to capture the effect of sunlight streaming through the window.

To keep my colors clean, I generally use one brush for the lights and one for

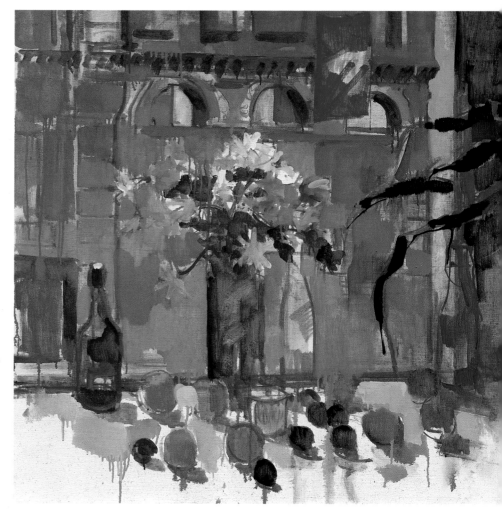

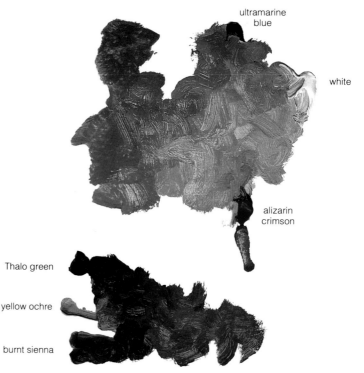

ultramarine blue

white

alizarin crimson

Thalo green

yellow ochre

burnt sienna

the darks. I wash my brushes constantly while painting by dipping them into turpentine after each stroke. As I continually stress to my students, you can't get clean color with dirty brushes.

Once the preliminary color relationships are set up, I take a break, stand back, and compare the painting to the setup. I know I have exaggerated some of the colors, but if I don't establish strong colors at the start they always seem to fade when I embellish their form. It's like holding the carrot in front of the horse—I try to stretch my colors as far as I think I can within the limits of the painting.

STEP FOUR

Now I can start adding light to the picture. First, however, I paint more violet tones on the building to cover up all those empty white spots showing through. Then I paint pure cadmium yellow on the apple and a mixture of Thalo red rose, orange, and white on the light side of the peaches. The chalky color on the light side of the herb jar is mixed with burnt sienna and white. I also add pure ultramarine blue on the bottle to the right. The light green vinegar bottle is a mixture of cerulean blue, yellow ochre, and white, while the daisies are painted with ultramarine blue, yellow ochre, and white—a reliable mixture for cool and warm off-whites. The strongest value contrasts are in the middle of the bouquet, with the white daisies against the dark greens of the vase.

Note that a lot of the original blue from the drawing shows through but doesn't jump out. I hope to leave some of this in the final painting, as it helps to energize large areas, particularly in the background building.

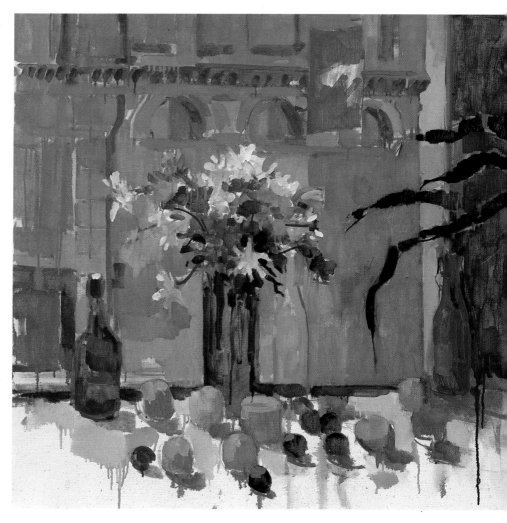

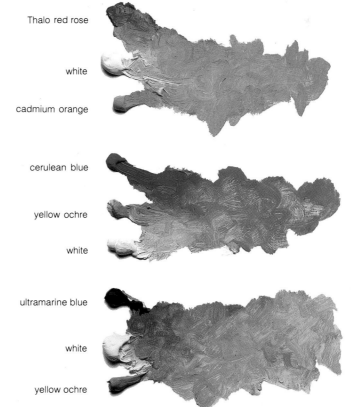

Thalo red rose

white

cadmium orange

cerulean blue

yellow ochre

white

ultramarine blue

white

yellow ochre

My Basic Technique

STEP FIVE

Just as I am ready to call it quits for the morning, I notice a diagonal shaft of light across the background buildings. Although the light continues to shift, I decide to introduce this diagonal by mixing a lighter tone of violet into this area. To carry this diagonal onto the vase, I lighten the greens by mixing a little yellow ochre and white into them. I also fill in the effect of light on the blue banner and add more light to the windowsill, as well as the pink corner of the building.

Since light now plays an important role, I establish strong cast shadows on the blue tablecloth, using a mixture of ultramarine blue, cerulean blue, and white, with a little cadmium red light at the edge to create a vibration, or halation. I also add some warmth to the cloth by mixing orange, cerulean blue, and white in the thicker, light-struck areas. Other small details that augment the effect of light include the light yellow on the apple and the light green on the dark leaves.

Although I define the brown and blue bottles some more, I keep the vinegar bottle relatively flat because it isn't affected by the sunlight. Later, when I scrutinize the picture, I observe that all three bottles and the vase line up on one plane—something I didn't notice during the heat of battle.

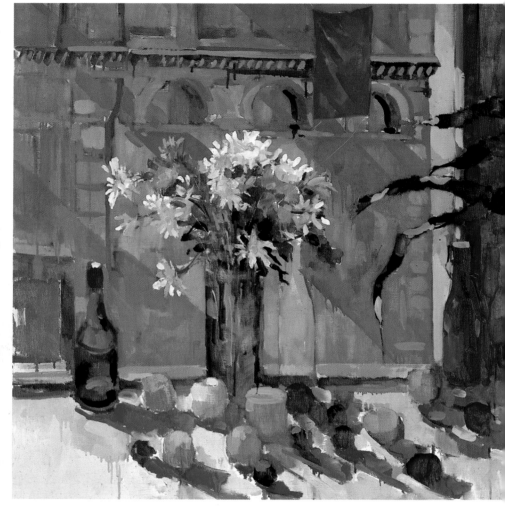

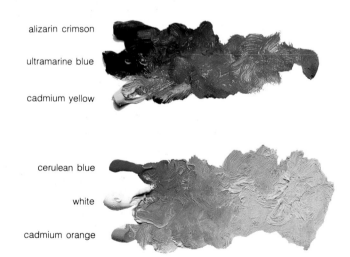

alizarin crimson

ultramarine blue

cadmium yellow

cerulean blue

white

cadmium orange

STEP SIX

The next day, taking a fresh look at the setup and the painting, I decide to move the brown bottle further down into the picture. To do this, I wipe out the original bottle with a rag and plenty of turpentine. Inevitably this disturbs some of the surrounding area, but that can be repaired later. By rubbing almost down to the raw canvas, I leave a thin surface, which will be easy to paint over.

The new position of the bottle helps to add depth by letting the eye go in and around the fruit in front of it. It also breaks up the static "line-up" of bottles that worried me earlier. This is the only change I make at this step, but I want to emphasize how important it is to change things if they don't feel right to you. The beauty of oils is that they allow you this freedom of choice.

STEP SEVEN

Even though I prefer the new position of the bottle, the left corner still looks somewhat empty. On an impulse I buy a fresh, ripe cantaloupe, cut it in half, scoop out the center, and place it in front of the bottle. Now this area has more weight. The cantaloupe also adds variety in shape and size to the fruit.

For the outer shell of the cantaloupe, I use a mixture of yellow ochre, ultramarine blue, and white. For the rim, I use straight cadmium orange and white. The deeper tones in the center are orange darkened with a little yellow ochre.

I then start cleaning up some of the edges on the light side of the cloth, using thicker pigment at each step. I also add more light to the windowsill and a slight diagonal of deep red on the door. To suggest the transparency of the brown bottle, I let some lighter tones, including the blue cloth, show through the bottle.

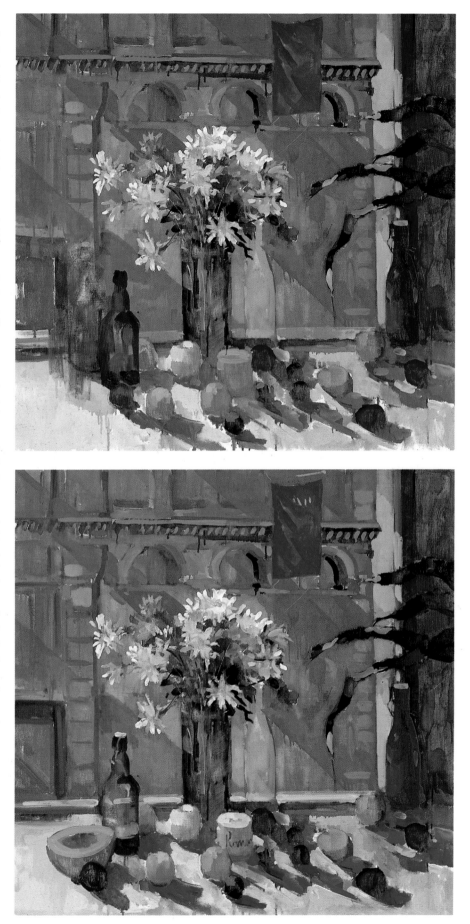

My Basic Technique

STEP EIGHT

Now for the final assault. The light is performing its magic again and I want to push the color and values as far as possible to bring this painting to its conclusion. Contrary to what many have said, I feel that the final stage of a painting should be just as bold and free as the initial steps.

With clean brushes, a clean jar of turps, and loads of freshly squeezed titanium white, I start to darken some of the cast shadows on the table with ultramarine blue, alizarin crimson, and white. I then build the light-struck areas of the cloth with a lot of thick pigment, continuing with my mixture of cerulean blue, orange, and white but adding more white as I go along to force the value contrasts.

One of the biggest problems I always have in painting flowers is getting the darks soft enough, particularly with white daisies. Here I rub some of the white petals with a rag on the halftone side. Generally, if you use too many hard edges, the daisies start looking like decals.

I also add some pure orange to the halftones of the peaches and darken some of the plums with pure ultramarine blue and alizarin crimson. To complete the cantaloupe, I load the brush with a lot of the white and orange mixture, letting some of the rich pigment drip slightly over the darks. Turning to the background, I suggest lettering on the blue banner and add the small squares on the paneling of the red door. Then I develop the greens in the vase further and add a few highlights to the flowers and some details to the background building. I also slightly soften the edge of the blue bottle as it meets the background by rubbing my fingers over the wet pigment. This keeps the bottle from popping out of the shadows.

It's always difficult for me to know exactly when a painting is finished. To some observers, the small blue areas showing through and the occasional drip here and there may be horrifying. For me, however, an attempt to "clean up" these areas would in some way take away from the freshness of the painting. The urge to "tighten up" during the final stages of a painting is something I try to avoid; it would be uncharacteristic of my way of painting and my way of seeing things. Maybe it's because I'm not a very good "noodler"; in any case I don't feel that slavish details would really help this painting.

Usually I hang onto a painting for two or three weeks before I send it to my gallery, just in case I notice something I haven't seen before and want to change it. Because this painting was photographed on the day of completion, I didn't have much time to scrutinize it carefully. Now, however, it's been in my studio for a while, and I still don't know what I would do to change it, if anything.

As I mentioned at the outset, the main purpose of this demonstration was to show you how I go about painting a still life in the hopes that it would give you a better understanding of my methods and technique. Once, after I had finished a similar demonstration, a student said, "Now I know how Chip thinks."

FLOWERS AND FRUIT,
LOWER MANHATTAN
36" × 36" (91 × 91 cm)
collection of Mr. and Mrs. Donald Sigovich

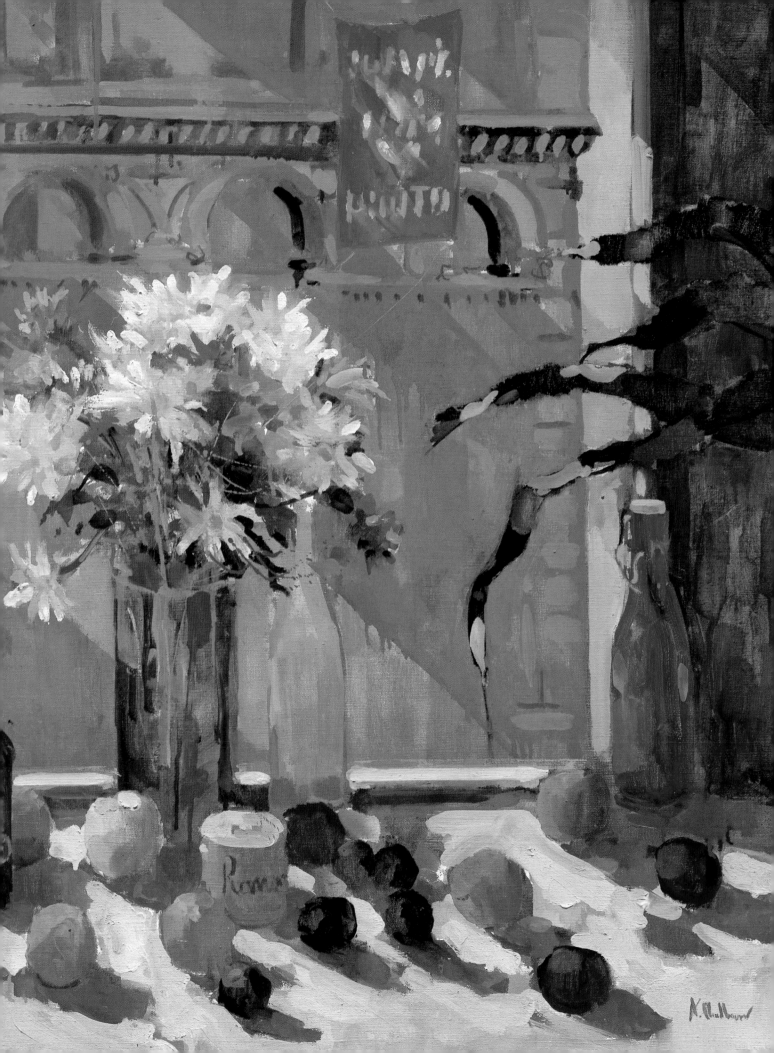

Building a Range of Greens

Every time I take the winding road to Stonington, I stop my car just past the crest of the hill and take in this expansive view. Wow! I must have painted this scene at least ten times under various conditions, yet each time there is a new enthusiasm, a new challenge, a new hope that I can do it justice.

This painting shows the scene in late summer, when the greens were becoming tinged with warmth, suggesting the approach of autumn, and the water appeared as deep blue strips. The small, white clapboard houses scattered amid all this blue and green made a sparkling contrast, and I let this contrast form the core of the painting.

As the painting progressed, I used thicker and thicker pigment in the green fields, constantly relating them to the dark water. The basic mixture for these fields is Thalo green, yellow ochre, cadmium yellow, and white. Note how the warm greens have been piled on, over the darker greens, with a bristle brush. The dark green accents running through the foreground are a simple mixture of Thalo green and burnt sienna. The light green building—a mixture of Thalo green, cadmium yellow light or lemon yellow, and white—has an almost acid quality in contrast to the warmer, earthier greens in the field. The deep blue water is a mixture of ultramarine blue and burnt sienna, while the lighter strips are ultramarine blue and white. The small, light-struck areas of land combine yellow ochre, alizarin crimson, and white, with thicker pigment painted right over the darks of the water. The white buildings are painted with yellow ochre, ultramarine blue,

and white, with an almost pure white on the light sides.

I want to stress that the greens in this painting were chosen to convey what I saw on a late afternoon toward the end of summer. Another season and another time of day might change my selection of greens. A recent trip to Ireland, for example, has plunged me into an entirely different range of greens in my attempts to capture that elusive Emerald Isle.

In fairness to those of you who don't like Thalo green, I should mention that

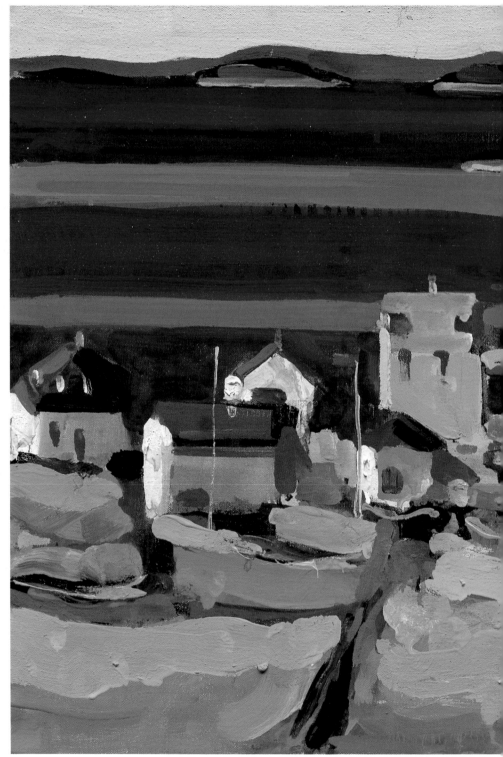

Use the greens you feel the most comfortable with, but keep experimenting to avoid getting into a rut.

many painters prefer viridian. Charles Reid, for instance, prefers the subtlety of viridian because he uses a lot of cerulean blue, lemon yellow, and permanent green in his mixtures and Thalo green would drown them out. Fairfield Porter used a lot of black mixed with yellow for another variety of green. It's really a personal choice. Use the greens you feel most comfortable with, but keep experimenting to avoid getting into the rut of using the same mixtures over and over.

Not long ago one of my students was having the kind of problems with greens that we all experience from time to time. I gave him a good reproduction of one of Cézanne's paintings of Mont Sainte-Victoire to copy at home. The next week I gave him a Corot landscape. He came back to class with some astounding results—all mixed with Thalo green. Even though I've been painting for over forty years, I still find it rewarding to study the masters or contemporary artists I admire for a keener perception of color.

VIEW OF STONINGTON, MAINE *20" × 36" (51 × 91 cm) collection of Mr. and Mrs. Goldberg*

Letting Blue Dominate

With a slight stretch of the imagination, some New England villages have an appearance not unlike some of the gleaming white Cycladic towns in the Aegean. Psychologically, some distant memory of those Greek islands must have influenced me when I started this painting of Provincetown, Massachusetts. I recall purposely setting out to do a predominantly blue and white painting from rough sketches I had made on a trip to Cape Cod. My intent was to use one blue—ultramarine blue in this case—and see how far I could extend it in creating an impression of a sparkling town seen from the water's edge.

After establishing the overall pattern of the geometric white buildings dominated by the church steeple, I painted in the dark green trees in the background to force a strong light-dark contrast. Then, using broad horizontal strokes, I anchored the foreground with the deepest blue I could obtain—made by mixing ultramarine blue and alizarin crimson. Next came the slanting violet rooftops and some hot pinks in the foreground, which I hoped would make this area vibrate against all those blues and whites. Later, I added some warmth to the buildings with small accents of reds and oranges, balancing the generally cool color scheme.

Note the various mixtures of blues used in this picture. I've always felt that

VIEW OF PROVINCETOWN,
MASSACHUSETTS
10″ × 14″ (25 × 36 cm)
collection of Mrs. June Martell

COLOR MIXTURES

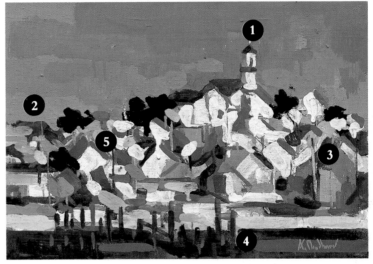

ultramarine blue is probably one of the most versatile colors on the palette, as it mixes well with practically every other color. I want to stress, however, that this painting was not done with any preconceived color theory. My point is that there are infinite possibilities, even when one color dominates.

COLOR MIXTURES

1. The steeple is pure ultramarine blue, with ultramarine blue and white in the sky. More white and a bit of alizarin crimson are added to the warmer, lighter areas of sky. Note that the basic mixture of blue and white is used for the darks in the white buildings in much of the painting.

2. Again, ultramarine blue is mixed with white and alizarin crimson for the lighter areas, where the sky meets the horizon. In nature, generally speaking, skies are darker and more intense at the top and tend to get warmer and lighter toward the horizon.

3. The dark violet rooftop is a mixture of ultramarine blue, alizarin crimson, and some white. The light side of the building is done with Thalo red rose, ultramarine blue, and white, giving a more intense violet. The lone yellow building—made of white, yellow ochre, and a small amount of cadmium yellow—provides contrast.

4. The deep blue in the foreground is done with ultramarine blue and alizarin crimson. Some pure ultramarine blue and white has been added on top of the dark water, which is slightly darker than the mixture in the sky.

5. The light green building consists of Thalo green, cadmium yellow, and white.

Painting Varied Grays

I don't know why painting grays presents a constant problem for students, but it's something that crops up all the time in my classes. One time, a few years ago, I began this painting as a demonstration for my class and finished it later in my studio. The purpose of the demonstration was to show how a whole painting could be developed with a few basic colors, using gray as the dominant color theme. In this case my palette consisted of white, yellow ochre, burnt sienna, ultramarine blue, and alizarin crimson.

A basic rule I use in mixing grays is to combine one cool color with one warm color plus white—I might, for example, mix yellow ochre (warm) with ultramarine blue (cool) and white, or burnt sienna (warm) with ultramarine blue (cool) and white. Or I might use Thalo green as the cool color instead of ultramarine blue (see my painting *Victorian Houses, Vinalhaven Island* on page 29). Once in a while a third color can be introduced, such as alizarin crimson. But often when you start using more than two colors, you end up with a muddy color. It's really that simple.

Although I tend to shy away from mixing grays with black in my own work, you shouldn't forget that some glorious grays can be made by combining ivory black and white with one other color. Look at Manet's paintings for exquisite examples of this.

white +
ultramarine blue +
yellow ochre

white +
ultramarine blue +
yellow ochre +
alizarin crimson

white +
ultramarine blue +
burnt sienna

white +
ultramarine blue +
burnt sienna

FISHING SHACKS,
MONHEGAN ISLAND, MAINE
30″ × 30″ (76 × 76 cm)
collection of Mr. and Mrs. Donald Sigovich

Limiting Color for Mood

During a sketching trip to Vinalhaven Island, off the coast of Maine, I ran across these old Victorian houses. It was a gray, overcast day, but the late afternoon sun added some drama, inspiring this painting. I made some sketches, took a few photographs, and later used this material to develop the painting.

Because I wanted to create a distinctly somber mood, I found myself using a relatively simple mixture of grays. Actually I probably could have done the entire painting with a limited palette, but I wanted to introduce some richer color in the foreground grass, as a foil for the prevailing grays. My primary gray mixture consisted of Thalo green, burnt sienna, yellow ochre, and white, while the buildings were painted with ultramarine blue, burnt sienna, yellow ochre, and white. As you can see, these simple mixtures give an extraordinary range of grays.

In developing the picture, I purposely played the soft, drippy edges of the sky against the dramatic, almost razor-sharp edges of the buildings. The lights on the buildings are almost pure white, with a small amount of yellow ochre added for greater luminosity. In the foreground—the only area with any real color—I started out with some very rich darks, painting the streaking shadows with burnt sienna and Thalo green. For the thicker, richer pigment in the light grass, I added yellow ochre and orange to this mixture. In some areas I had to mix white with orange and ochre to make the light-struck areas more prominent.

A lot of the paint in the foreground was applied with broad strokes of the painting knife. Later, I placed the canvas on the floor and took some broad swipes with a loaded brush for a spatter effect—much as in watercolor painting. If you get carried away with this technique, some of the spatter may fly over the images—so use this method judiciously. The same holds true with the dripping technique in the sky (done while the canvas was held vertically on the easel). Like any other special technique, it is valid only if it strengthens the painting. If it's overdone, it becomes a trick and has a false ring.

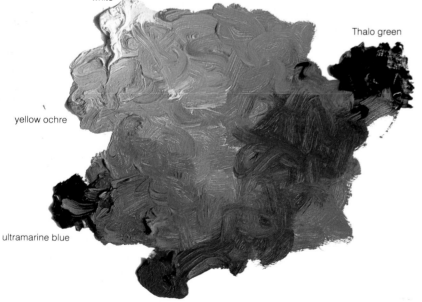

white

Thalo green

yellow ochre

ultramarine blue

burnt sienna

VICTORIAN HOUSES,
VINALHAVEN
ISLAND, MAINE
30″ × 30″ (76 × 76 cm)
collection of Mrs. Alfred Avison

Exaggerating Color for Impact

The creative process has always mystified me—how we look at a familiar scene, taking it for granted until, suddenly, a spark is ignited and we see the scene from an entirely different point of view. Although I had seen this view of Wiscasset from the bridge a hundred times and mulled it over in my mind as a worthwhile pictorial idea, only recently did I decide to put my impressions down on canvas. Parking the car on the bridge, I did a small rough sketch of this scene, emphasizing the bull's-eye effect of the road running right through the center. To counterbalance this, I used the strong horizontal plane of the water and a jumble of geometric shapes—the houses and steeple piling up against the hill.

When I started the painting, I realized that almost half the canvas would be taken up with the steep, ground-level perspective of the road. To make this large area more interesting, I decided to use warm, high-key violet tones—mixed with alizarin crimson, ultramarine blue, yellow ochre, and white—instead of the dull gray asphalt. By exaggerating the yellow and white dividing lines and guard rails on the bridge, I further emphasized the strong direction of the road. I wanted viewers to be pulled directly into the picture and then suddenly halt, applying the brakes, when their eyes reached the top of the hill, with its strong contrast of dark trees against white house shapes. Then their eyes would travel to the lively pattern of white, red, and yellow buildings, all sitting in a row on the far side of the river.

Although I don't think of this as being a particularly violet painting, I did use a variety of violet mixtures on the rooftops as a foil for the whites and bright colors elsewhere. By simply mixing alizarin crimson, ultramarine blue, and white in various degrees, you can get a wide range of violets. Since I seldom use black in my painting, I substituted alizarin crimson and ultramarine blue for my deepest darks—on the shadow side of the red building, for example.

Note that the light side of the yellow building is a mixture of cadmium orange, cadmium yellow, and white, while the dark side consists of yellow ochre, orange, and small amounts of ultramarine blue. The small strip of land contains Thalo red rose, cadmium yellow, and white. It's important that all these bright, high-key colors are surrounded with deep violet tones just mentioned. The deep tones of the foreground water are mixed with ultramarine blue and burnt sienna, with a light strip consisting of pure ultramarine blue and white.

Since this painting was done largely from memory, I kept asking myself: What was my initial reaction to the scene? What made me stop in the first place? Maybe it was the way the light struck the buildings, or perhaps it was the bull's-eye sweep of the road leading into the town. Whatever the reason, I had no idea how the painting would turn out, since I don't like to anticipate myself. I'm a firm believer that painting is a constant series of challenges, that a picture can't be created without involving a certain amount of risk. The artist Richard Diebenkorn addresses this quandary in another way: "I can never accomplish what I want, only what I would have wanted had I thought of it beforehand."

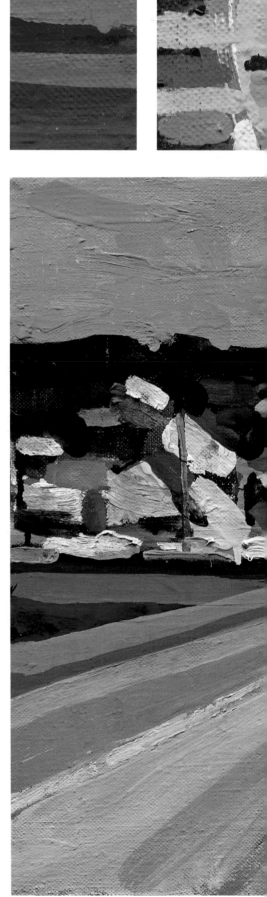

THE BRIDGE,
WISCASSET, MAINE
12″ × 18″ (30 × 46 cm)
private collection

These color swatches, taken from different areas of the painting, give you an idea of the range of violets possible using a basic mixture of alizarin crimson, ultramarine blue, and white.

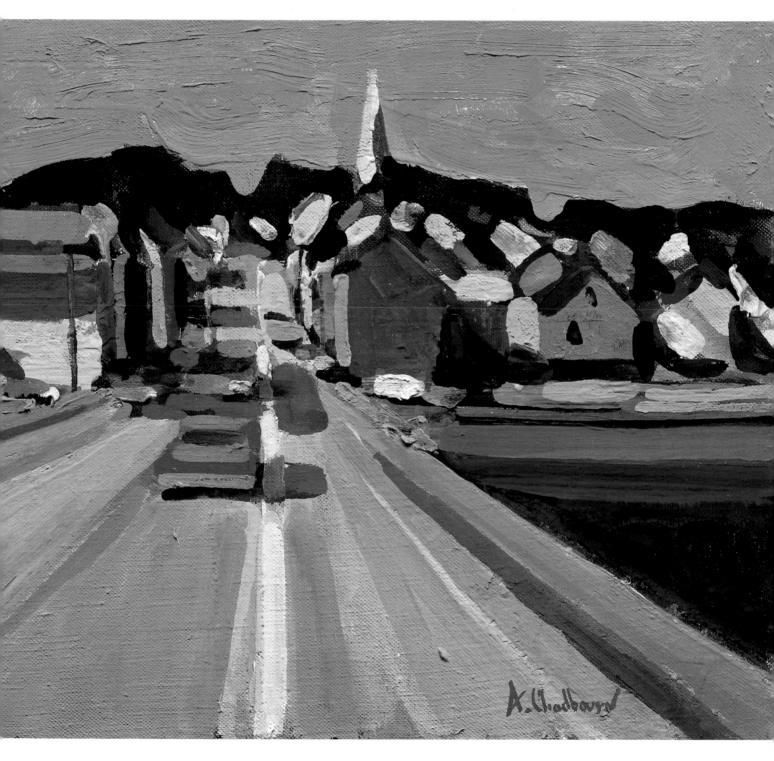

Painting Darks

As farfetched as it may seem, this painting resulted from viewing an exhibition celebrating the two-hundredth anniversary of Jean-Baptiste Siméon Chardin. Chardin has always been a favorite of mine, ever since my early Paris days. In his breathtaking still lifes, ordinary kitchen objects take on heroic scale and, under his peerless eye, everything falls naturally into place. Chardin is the kind of painter who lures you into looking at his paintings for a long time, much as Vermeer mesmerizes you with his discreet world of silence. From his notebooks, we learn that Chardin spent hours arranging his still lifes, and this is evident in his paintings. One has the impression that if one wine glass or bowl of fruit were moved a fraction of an inch, the whole composition would be disturbed.

Both Cézanne and Braque were influenced by Chardin. If we compare some of the still lifes by these three artists, at first glance they may seem to have little in common. On closer inspection, however, it becomes abundantly clear that all were superb colorists and all were flawless composers. Another pertinent similarity—one that touches a sympathetic chord with me—is that they cherished the objects in their still lifes and painted them over and over, whether we refer to Chardin's clay pipes or Cézanne's scalloped kitchen table or Braque's compote.

For my own painting, I deliberately chose some simple objects and placed them against a dark background to give myself a chance to explore the possibilities for a dramatic composition not unlike some of Chardin's monumental still lifes. I also decided to keep the colors somber but rich, with lots of siennas and ochres, as well as deep umber shadows reminiscent of the old masters. Although I had no intention of painting in the style of the old masters, while I was working out my color scheme, they seemed to hover in the wings.

Before I started the painting, I did a series of black-and-white drawings, concentrating on the abstract light-dark patterns on the cheese, which would be the core of my composition. I did some drawings in a local cheese store; otherwise those large wheels of Vermont cheddar would have cost me a fortune. But I also bought some cheese to use as props while painting.

The direct influence of Chardin can be seen in the horizontal emphasis of the table plane and the shallow perspective. Most of the objects in Chardin's paintings are placed within a confined area on the table, guiding your eye within a limited space. Arranging the cheese on a horizontal plane, right across the picture, allowed me to concentrate on the dramatic light-dark contrasts in the central part of the composition.

Notice the variety of color in the background and how the drapery folds break up into abstract shapes, keeping this large area from becoming too flat and two-dimensional. I wanted the background to be dark, but not so dark that you couldn't see into it. My use of ultramarine blue, ochre, violet, and alizarin crimson was all more or less tied together with sweeping strokes of the darkest dark—in this case, a mixture of Thalo green and alizarin crimson. I repeated this mixture on the front of the table and let a little pure alizarin violet show through the circular designs. As you can see, I worked quite wet in this area, with plenty of turpentine. Drips inevitably developed and I purposely left them in, as they seemed compatible with the general spirit of the painting. Note that, in contrast, most of the rich textures occur on the light-struck areas of the cheese.

This painting suggests one way of painting darks with a fresh eye. When students have difficulty seeing color in the darks of their still lifes, I invariably pull out some reproductions of works by Cézanne, Braque, and Chardin to show how each of these artists created luminous darks and how each, in his own way, orchestrated these darks into the overall design of the painting.

CHEESE AND GRAND MARNIER
30″ × 60″ (76 × 152 cm)
collection of Mr. William Ballard

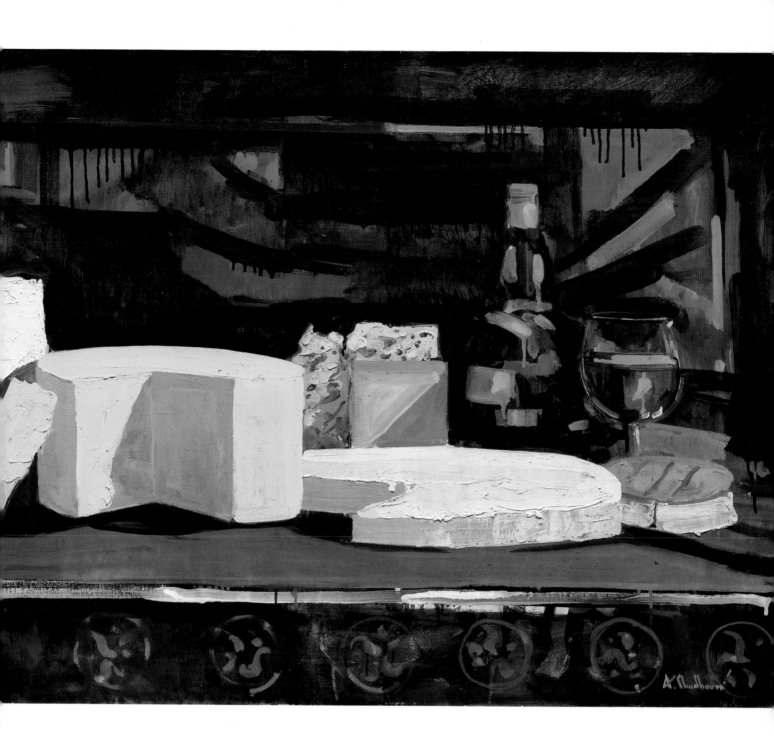

When students have difficulty seeing color
in the darks of their still lifes, I invariably pull out
some reproductions of works by Cézanne,
Braque, and Chardin.

In general I use a sketch only as a guide, for a clearer concept of my values. The sketch itself is just the germ of an idea or a "visual hunch," not an exact replica of the subject. Therefore, as I translate this idea onto canvas, I feel free to make changes if something doesn't feel right. Here I generally kept the value patterns from the sketch but made other changes as I developed the painting.

Playing Lights against Darks

I keep a stack of old sketchbooks in my studio, and during a dry spell, I pour over them, looking for inspiration. This painting was based on a sketch I made on an extended visit to Greece twenty-five years ago. My impression of the scene still haunts me as though it were yesterday.

The island of Santorini is one of the most dramatic in the entire Cycladic group. When you land by boat at the small jetty, you look straight up a 900-foot mass of tumbling volcanic rock to the gleaming white town of Thera perched on top. A skittery mule then takes you up an endless zigzag of steps, as if on a stairway to heaven. Once safely settled in the old Hotel Atlantis, I did a dozen sketches from the terrace while fortifying my shattered nerves

with a few belts of ouzo and an octopus salad.

Like most Greek islands, Santorini abounds in superstition and tales of vampires and ghosts. As evening sets in and the wind begins to whip up, small veils of smoke rise out of the molten rocks below—one might be sitting in the middle of a cauldron. It was with this mood in mind that I started this painting.

I began by laying in the darks, first drawing my images very loosely with ultramarine blue, alizarin crimson, and plenty of turpentine. I painted the middle-gray values next, holding off on the darkest darks until the final stages. For the most part I worked with cool grays, combining ultramarine blue, yellow ochre, and white. After I had

established the overall shadow patterns, I introduced some warmth in the pure whites by adding a small amount of cadmium red light.

Since I had established a fairly dark sky, I had no trouble making the lights stand out. When I added the lightest lights, I used much more pigment, giving an almost sculptural effect to the lights and shadows. Placing these lights was a question of working here and there until I achieved the overall effect I wanted. Also, if any shadow areas didn't look right or jumped out, I went back and redefined them until they took their proper place within the painting.

Notice that most of the hard edges occur on the diagonal cast shadows, which adds to the drama of the painting. Also notice how adding lighter or darker tones to the shadows of the buildings gives them greater luminosity than a single flat tone would.

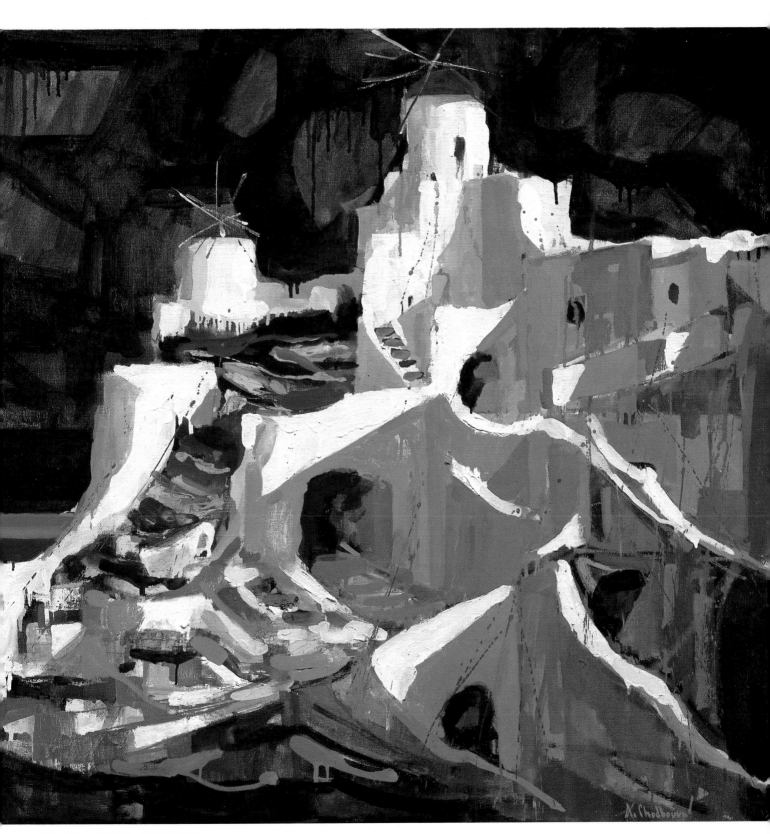

SANTORINI, GREECE
40″ × 40″ (103 × 103 cm)
courtesy of Barridoff Gallery,
Portland, Maine

Using Collage

Although sinks may not be the most appealing subject matter for the average viewer, they have been used by artists, dating from Chardin all the way to Diebenkorn in our own time. One reason that the sink shows up from time to time in paintings is that it's part of an artist's environment. It's like an easel or a tabouret or a work table—an icon of the workplace, readily visible but somehow overlooked in the relentless search for things to paint.

For me, this painting of a sink has a lot of associations with Walker Evans's haunting photographs in his book with James Agee, *Let Us Now Praise Famous Men*. I have never been to the Deep South, nor have I suffered in abject poverty like the tenant farmers Evans so honestly documented, but I am what the music critic John Crosby once called himself—a "Depression Baby"—and I can remember these images clearly. The sinks that Evans depicted all had the vestiges of those forlorn years: an old tin kitchen clock; faded family photographs; a torn calendar; a few empty, dusty bottles; a

wooden mirror; and the ever-present limp kitchen rag, hanging over the faucets. All of these remnants of the thirties suddenly presented themselves like an apparition when I stumbled across this old sink in a dilapidated barn not far from my house. After making my usual abbreviated sketch, I went back to my studio to do the painting.

I intended to use a lot of collage, so I had to do some preliminary thinking about the design, since it's hard to remove collage once it's pasted down. I decided on a blunt, straightforward view of the sink surrounded by personal memorabilia from my scrap files.

Once the sink was drawn in, I began applying the blue wallpaper designs using Hyplar acrylic medium, which acts as a binder. The photographs on the shelves above the sink have no particular psychological meaning; they were chosen at random from the collection in my studio. On the upper left is a double-image photo of Toulouse-Lautrec; on the far right, a crazy photo of the Red Baron; and below it, some English soldiers during the Crimean

War. Next to the old tin clock I stuck in a photo of myself, lurking in the shadows the way Alfred Hitchcock used to disguise himself in his films. Once all this collage was down, I covered these areas with another thin coat of the Hyplar medium, so I could go over these areas with oil paints. Because the "glue" for the collage is a water-based medium, it's important to remember to apply the collage first, *before* you work with oils.

As the painting progressed, I covered or rubbed over a lot of the wallpaper in my attempt to keep the wallpaper design from jumping out of the picture. Also, I think I spent the better part of a week painting and repainting the whites and off-whites of the sink, building up thicker textures as I went along and allowing some of the paint to drip, in character with the subject.

There are many artists who use collage more imaginatively than I do, since I seldom use it as an end in itself. Generally, I use it to expand the decorative possibilities within the structure of my painting. If you are interested in experimenting with this medium, there are many good books that discuss the use of collage.

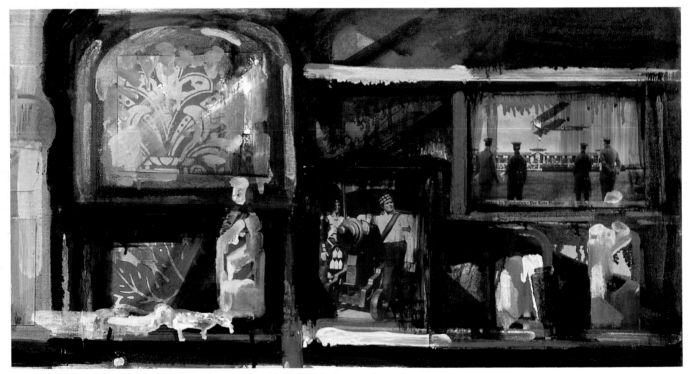

This detail shows the interplay between the paint and the collaged photographs and wallpaper.

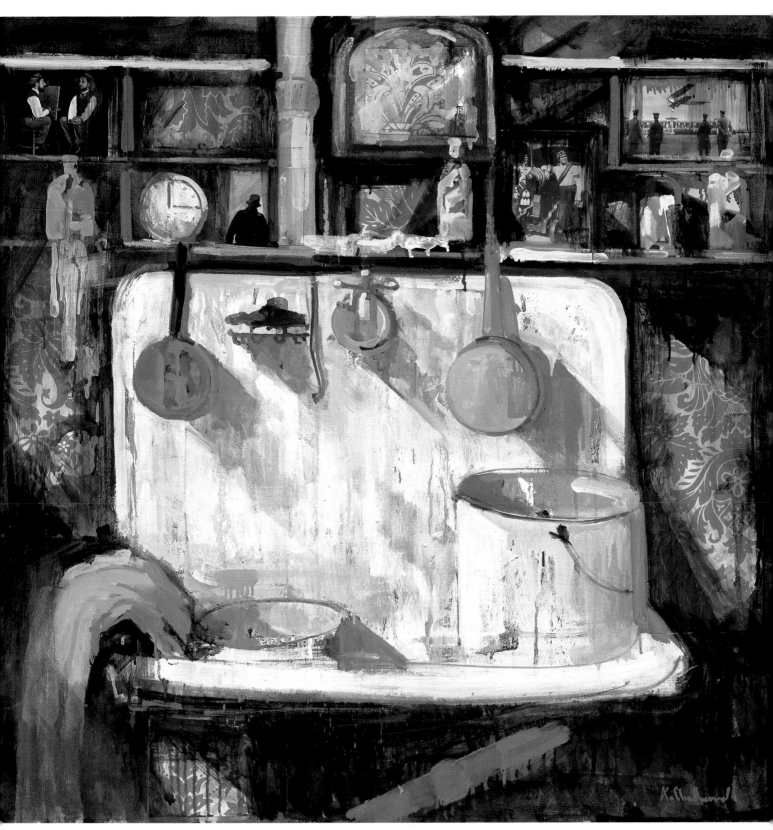

SINK
36" × 36" (91 × 91 cm)
collection of Mr. and Mrs.
Kenneth Williams

TAKING LIBERTIES WITH NATURE

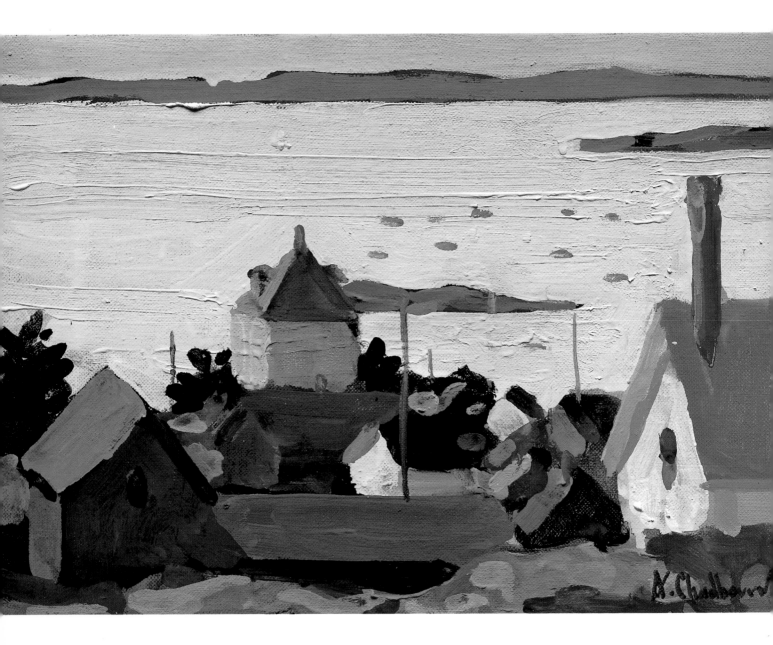

One of the hardest aspects of teaching students to paint is encouraging them to take liberties with nature, because this involves a certain amount of risk. Essentially, in my mind, taking a chance in painting nature has to do with a response to nature, more than any physical laws of vision. Because I'm such a big believer in personal expression, regardless of the individual's talent or aptitude, I try to focus on this aspect of learning—with the hope that it will encourage students to accept what I call the "capacity of risk."

To uncover the seeds of personal expression, I often ask my students to tell me something about the picture they are about to paint. Why did they pick that particular spot? What was it about the subject that attracted them in the first place? Was it a special quality of light? Or a pleasing arrangement of shapes and patterns? What colors seem to dominate? How might they enrich the scene in front of them? If you take a few minutes to ask yourself these questions before you start to paint, you're already a couple of steps ahead of the game. In the long run, this kind of questioning will help to give your painting a point of view, so it is not just an imitation of what you think you see in front of you.

A few years ago, when I was prowling around the hills of Cézanne's Aix-en-Provence, I was astounded by the similarity of the landscape to his paintings, even though the scenery had gone through some devastating changes. Forest fires, superhighways, and prefabricated housing had ravaged much of the nearby countryside, but there were still glimpses of his beloved Mont Sainte-Victoire. I could "see" Cézanne's paintings. At the same time, as I sat there in the late autumn light, piously observing the quilted patterns of fields and valleys leading to the majestic forms of the mountain, it became abundantly clear how many liberties Cézanne took with this heroic subject. Actually, all one has to do is look at the dozens of late paintings of Mont Sainte-Victoire to see the many different ways he discovered of transforming the scene into a personal reality of his own. Although they are all Cézannes, no two of these paintings are alike.

When I look at nature, I seldom see a complete picture. I look for a glimpse of what the painting might become. This is a similar attitude to that of the painter Wolf Kahn, who says, "The picture is the conclusion of an experiment in which the hint of an image becomes actuality."

STONINGTON,
MAINE—AUTUMN
10″ × 14″ (25 × 36 cm)
collection of Dr. John T. Libby

In this diagrammatic sketch, made from my photograph, I reduced the whole design of the picture to two values—black and white—to concentrate on the pattern of the scene. The sketch serves as a reminder while I paint that I'm dealing with basic abstract shapes seen in nature.

Finding Abstract Shapes in Nature

In developing a painting like *Rooftops—Stonington,* I generally proceed through three stages. First, I do a drawing directly from nature. Sometimes I may do several drawings from different viewpoints—walking around the subject and exploring various angles to find the most dramatic effects of light and shadow and the best composition. At this stage I am recording the facts as they are presented to me.

Next comes the analytic stage. Now I look over the drawing or drawings to decide which forms will build an interesting pattern of abstract shapes. At this stage I am not really concerned with details like windows, shutters, and chimneys. Instead, I keep searching for the basic abstract shapes—in this case, the geometric shapes of the

buildings and their relationship to the irregular, organic shapes of trees and shrubbery. Also, instead of paying strict attention to the light source, I look for light and dark tones that will strengthen the pattern of the composition. Sometimes this means using arbitrary darks, transforming shadows into abstract shapes.

In the third stage, I translate the black-and-white design into color relationships, which will eventually synthesize my pictorial statement. I find that painting in my studio encourages freedom in my interpretation of color, as I'm not tied to the physical realities of the scene. The red building in the distance, for instance, is probably much brighter in the painting than in reality, but I felt I could take this liberty

if it enhanced the overall color relationships. The same is true of the yellow buildings in the foreground and some of the violet tones on the rooftops.

There's another liberty I took. The buildings in this scene suggest a strong light source. Ordinarily, the trees would also have a light and a dark side. But, in this case, I kept all the foliage flat and two-dimensional. The irregular shapes of the trees provided a good contrast for the geometric buildings. Adding light to these dark masses would, I think, have destroyed some of this pattern.

This method of reorganizing a subject in abstract terms allows me plenty of leeway in trying to communicate my personal response to nature. I think it's important to point out, however, that I didn't set out to do an abstract painting of this scene. It was more the case that the subject actually lent itself to this sort of handling and interpretation.

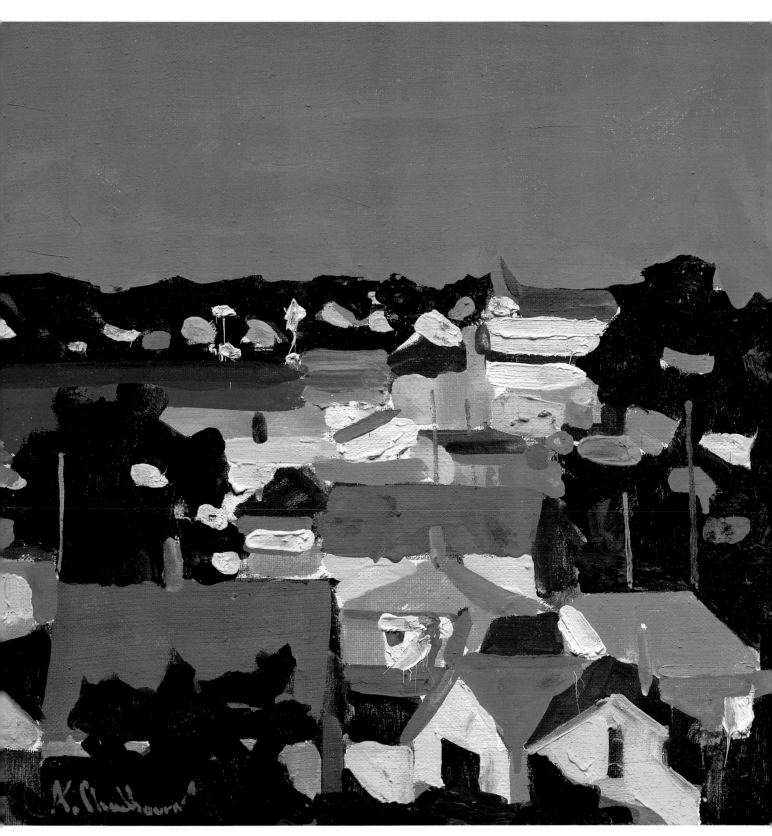

ROOFTOPS, STONINGTON, MAINE
18" × 18" (46 × 46 cm)
collection of Dr. and Mrs. Daniel Miller

Simplifying Nature for Impact

My small painting of Boothbay Harbor resulted from a watercolor sketch I did during one of my classes. Before we started painting, I showed the class a series of popular postcards extolling the cliché virtues of this coastal harbor. I asked the students to look at the subject in an entirely new light, as though they were seeing it for the first time, and to capture the essence of their emotions. I purposely asked them not to do a finished painting, but to experiment with new possibilities.

Later, back in my studio, I started thinking of what I had told my class about seeing nature from a personal, more evocative point of view and decided I had better practice what I preached. I chose a head-on view of the harbor, so the geometric buildings would stack up, one against the other, in angular patterns. As a foil for all the whites in the central part of the composition, I simplified the band of deep blue water in the foreground and the dark green hill in the background.

With the two dark areas established, I began to freely interpret light colors in the center. I picked out the red building at random and placed it slightly left of center. Then I began developing many subtle variations of white, mixing ultramarine blue, alizarin crimson, yellow ochre, and white in varying degrees. A few darks were spotted about, both to structure the buildings and to create a strong value contrast with the whites. I kept going back and forth, readjusting and redefining areas until I felt I had captured the overall pattern.

Later, I added some warm notes of color near the wharf, against the darks of the water, and suggested the shapes of the boats in simple terms, using the same rich textures as in the buildings. To energize the overall white patterns, I introduced a few light, horizontal strokes of ultramarine blue to the water and a few bright spots of blue to shadows around the buildings. A few details of masts and windows then helped to clarify the scene, without disturbing the painting's semi-abstract quality.

A DIFFERENT VIEWPOINT

My other painting shows an exaggerated, almost elevated view of the harbor in South Bristol, Maine—commonly called "The Gut" because of its narrow boat passage through a drawbridge in the center of town. I tried to reduce the clutter of small houses, piers, and boats to a sweeping pattern cutting across the canvas and surrounded by the expanse of bright blue water. To flatten the picture even more, I omitted the sky and used thin, horizontal bands of dark and light blue running across the top to close the composition. By repeating the curve of the road in the curves in the foreground water and upper portion, I enhanced the circular motion of the design. The slight angle of the piers and buildings on the right then acted as a wedge, pushing against the strong direction of the road and helping to hold the viewer within the picture plane.

The light blue you see in this painting isn't very typical of Maine waters. It was chosen more as a color idea than as a faithful reproduction of the scene. I was thinking in terms of a light blue field of color juxtaposed against all the busy activity of the village and wharf. Notice how some of the buildings and piers have been reduced to thick slabs of hot pinks and cool violets, forming an array of lively shapes. The offbeat light green strokes in the center represent the drawbridge and the small, deep blue verticals translate as reflections of the pilings. The dramatic impact of.the village is further intensified on the right, where squares of bright yellow-green play against the angular shapes of the houses and small accents of pink light flicker against the cooler cast shadows. Finally, notice the small white boats sitting on top of the water. Even though I treated the water as a flat plane, adding these boats contributed to an illusion of depth.

Some of the liberties I took depended on my familiarity with this scene. This is very important in taking liberties with nature. Obviously, the more you know about a subject, the more you will feel at liberty to take a few chances in characterizing it.

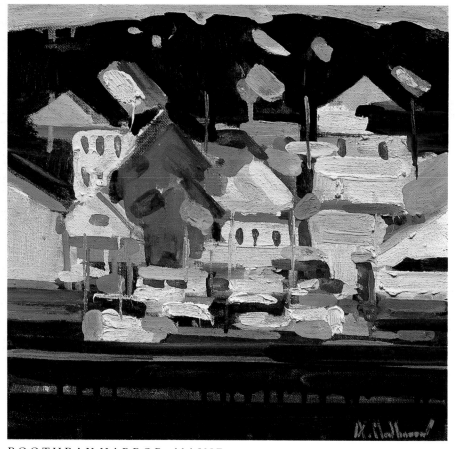

BOOTHBAY HARBOR, MAINE
12" × 12" (30 × 30 cm), collection of Mr. Larom B. Munson

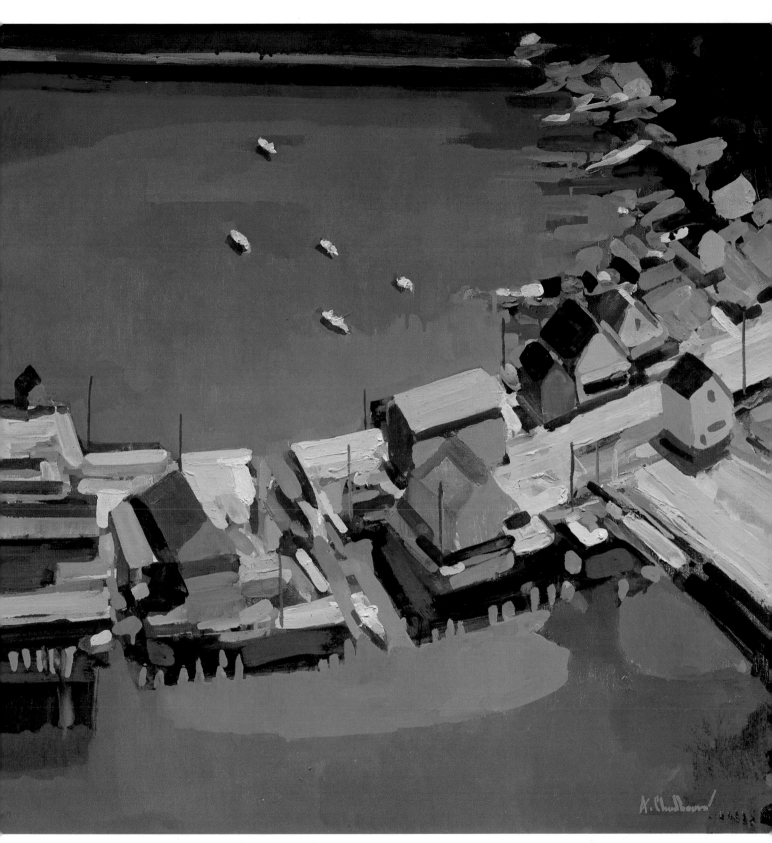

THE GUT, SOUTH BRISTOL, MAINE
30″ × 30″ (76 × 76 cm)
collection of Carol and J. L. Wishcamper

Transforming Everyday Objects

This painting of sardines is about as close as I've ever come to the realm of Pop Art. The tins of sardines were like so many commonplace objects around the kitchen that we take for granted, and it was a challenge to see if these objects couldn't be transformed into paintable subject matter. In this respect I was deeply influenced by the work of Wayne Thiebaud, the West Coast painter who turns gumball machines, racks of ties, sandwiches, lipsticks, soda bottles, and lollipops into elements of sheer beauty. In my own work, however, I wasn't attempting to make any deep psychological statement about the American food habit, but merely to use some conventional objects, which gave me pleasure to paint.

I placed the tins of opened sardines on a large sheet of paper on the floor and made several compositional studies until I arrived at this rather simple design. Then I started the painting in my usual manner, laying in swatches of thin paint to establish the local colors of the sardine cans and their contents before getting involved in any details. Because I wanted a luminous white area offsetting the cool, light blue shadows, I gave the white background a slightly pink tinge.

Once I could see the general color and value pattern taking shape, I concentrated on painting the sardines from one can to the next, building up the textures as I went along. In some cases, I scratched out lines with the end of the brush handle to emphasize the bony structure of the sardines. I also used fairly deep shadows inside the cans to suggest as much depth as possible, as though the viewer were looking down into the tins. In a way each can presents a little still life in itself, glistening in the sunlight.

Basically, the idea behind this painting involves separating an object—here, the tin of sardines—from its everyday environment. This kind of distancing can help you to see and paint ordinary things with a fresh eye.

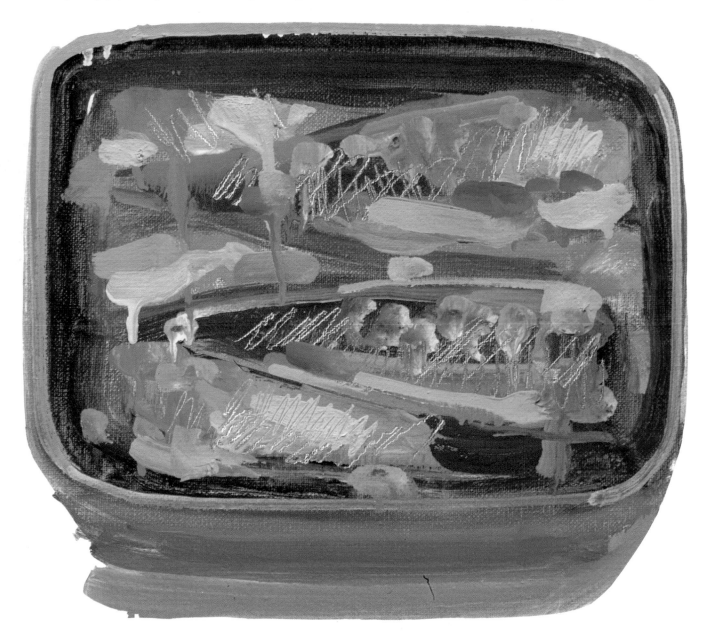

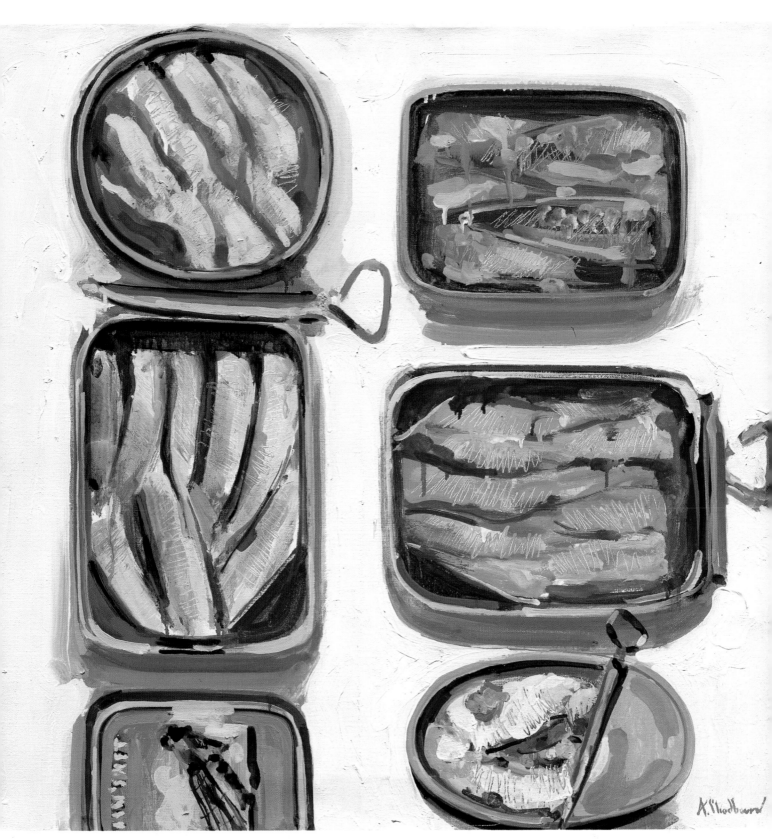

SARDINES
36" × 36" (91 × 91 cm)
courtesy of Barridoff Gallery,
Portland, Maine

*Each sardine can might be
a still life in itself, as you can
see in the example opposite.*

When you compare these sketches to the final painting, you can see just how many liberties I took with my subject.

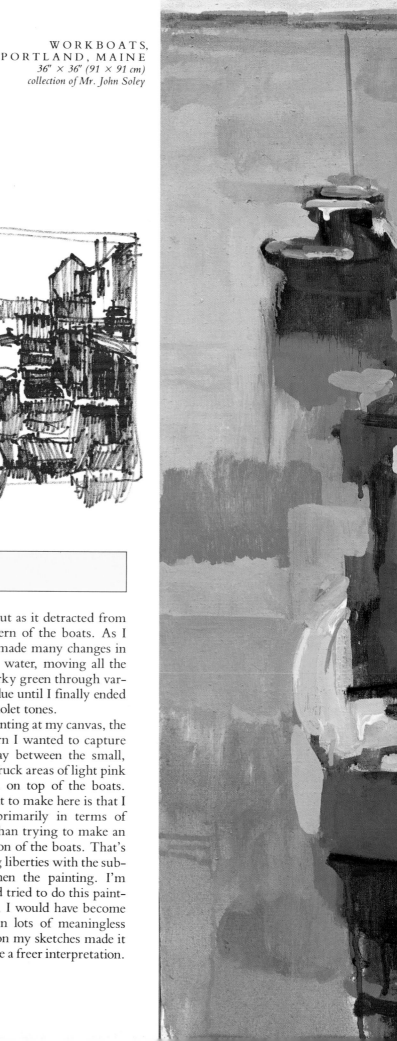

Reinterpreting Sketches

When all else fails, I can always lure my students to paint in this active harbor. I suspect something about a harbor appeals to some hidden, romantic notion. The challenge, as with most overpainted subjects, is to bring a fresh sensibility to the material and to open up our creative instincts.

Usually I tell my students to prowl around the wharfs and make several sketches before they start to paint, in the hope that they will warm up to the subject by looking at it from various points of view. While they do this, I furtively make a few rough notes of my own and, when possible, take a few photographs as well. This painting of workboats, completed in my studio, was the result of one such expedition.

When you compare the sketches to the painting, you can see how many changes took place. At one time part of the wharf showed on the right, but finally I took it out as it detracted from the overall pattern of the boats. As I worked, I also made many changes in the color of the water, moving all the way from a murky green through various shades of blue until I finally ended up with gray-violet tones.

As I kept squinting at my canvas, the dominant pattern I wanted to capture involved the play between the small, intense, light-struck areas of light pink and light green on top of the boats. The point I want to make here is that I was thinking primarily in terms of shapes, rather than trying to make an accurate rendition of the boats. That's all part of taking liberties with the subject to strengthen the painting. I'm sure that if I had tried to do this painting on the spot, I would have become bogged down in lots of meaningless detail. Relying on my sketches made it possible to create a freer interpretation.

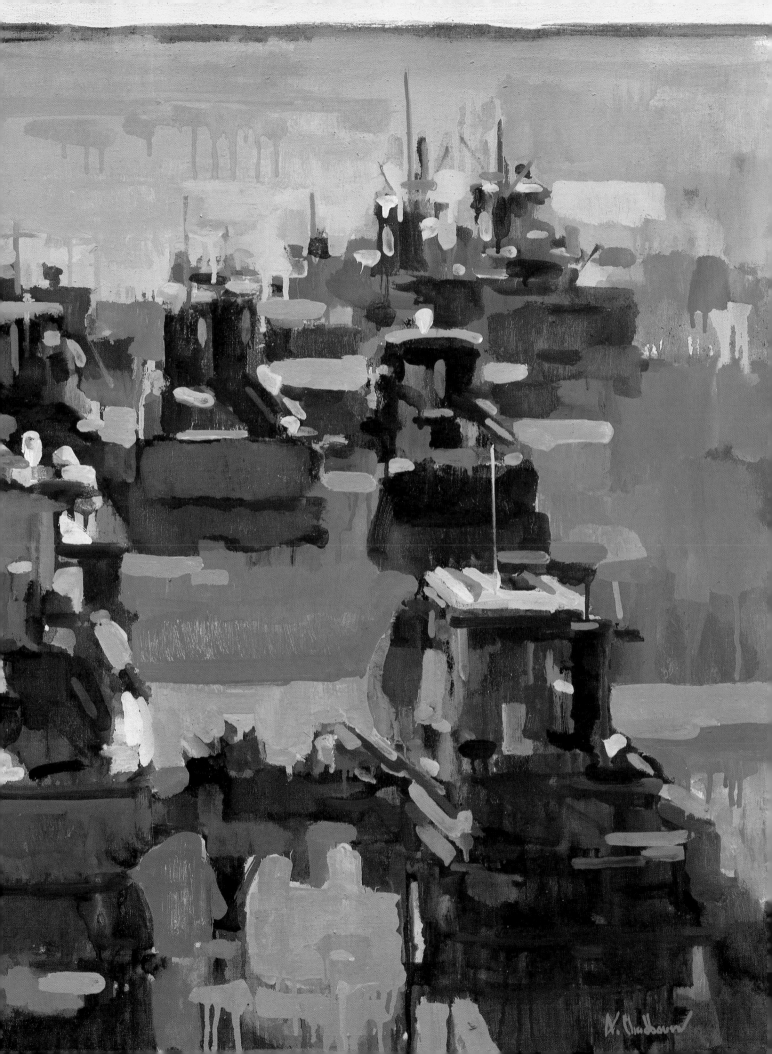

Taking Liberties with Color

Taking liberties with color doesn't necessarily mean squeezing a lot of bright colors out of the tube and spreading them haphazardly over your canvas. This view of Stonington, for example, is relatively mellow in its general demeanor, but I did take liberties with the colors to evoke the feeling of autumn.

Although I have painted Stonington many times (see pages 126–139), when I saw the harbor on this late October day, a complete metamorphosis had taken place. The green grass had turned a lovely burnt-out orange and the water had taken on a pink tinge in the late afternoon light. I made some color notes on my sketch, took a few photographs, and then painted the scene in the comfort of my studio. Had I done this painting directly from nature, I wouldn't have taken as many liberties as I did. I was able to push the color much farther by remembering the scene and just concentrating on the canvas in front of me.

In analyzing the color balance of this painting, notice that the warm red-orange and deep red-violets in the foreground are almost evenly matched by the cool pinks and purples in the distant water and islands. The juxtaposition of these colors is also important to the contrast of the light and dark houses across the lower middle distance. There deep darks (mixed with Thalo green and burnt sienna) anchor the long shadows next to the houses, and form a series of horizontal patterns against the bright red-orange grass (mixed with cadmium yellow, orange, Thalo red rose, and varying amounts of white). The textures in the grass, by the way, are done with a bristle brush, piling on the thick paint almost as though it were icing fashioned by a pastry chef.

As I developed the painting, the lone, black-green tree played an important part, providing a strong value contrast against the white house and thus forming a focal point for the entire picture. The rest of the buildings more or less fell into place as I had sketched them. Although I relied on my color notes, many of the exact color choices evolved somewhat spontaneously as the painting progressed. Notice, for example, the small patch of green grass I added on the left for a good contrast with the orange-red area.

The hardest part, strangely enough, was getting the right pink for the water. It had to be subtle enough to convey the effect of autumn without becoming too pink and dominant. In the end, I used a favorite mixture of mine: Thalo red rose and lots of white.

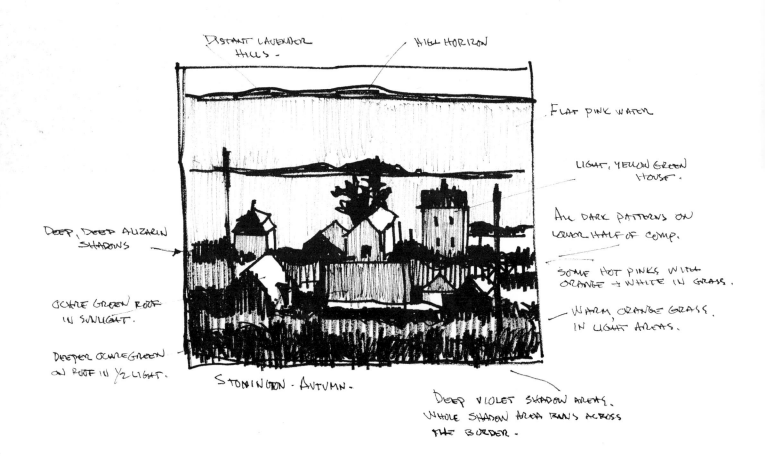

Very often these "word pictures" are just as useful and informative for me as the basis of a painting as a photograph would be.

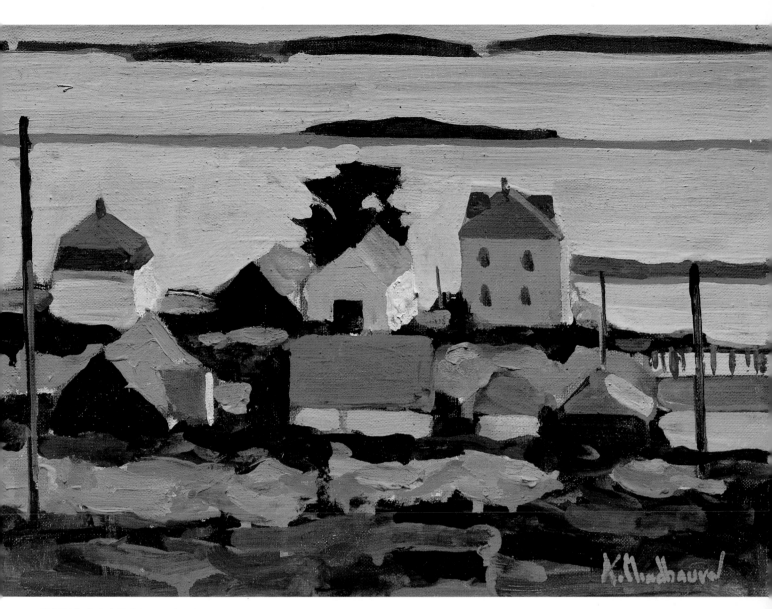

VIEW OF STONINGTON,
MAINE—AUTUMN
10" × 14" (25 × 36 cm)
collection of Mr. and Mrs. Hazzard

INTERPRETING LIGHT

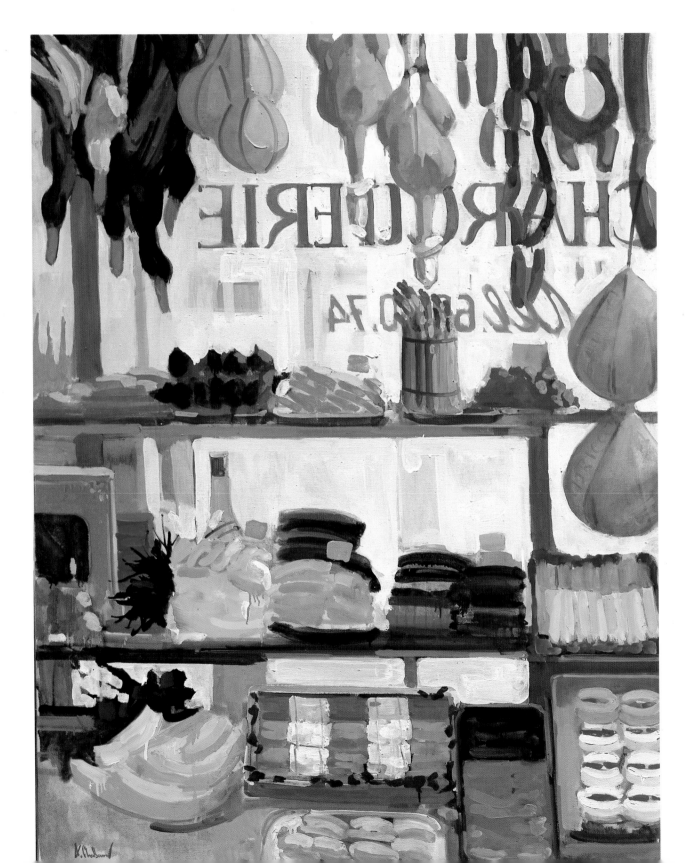

*T*his section deals with the challenge of interpreting light and how to strengthen your perception of it. It's the quality of light and which colors best capture its various effects that we'll be examining. Early morning light, evening light, seasonal light, backlighting—all these conditions affect a painting. Those of you who have done a lot of outdoor landscape painting would agree, I'm sure, that a painting started at nine in the morning won't look the same by five in the evening. What this all boils down to is the need for a constant awareness of nature and of how you are responding to what you see.

A less obvious consideration with light is the painter's geographical location. When I was living in Connecticut, every painter I knew complained about the suffocating monotony of greens in the summer and the almost subtropical humidity. Now, in Maine, I find the light clear, razor-sharp, and full of intensity, even during August (although I must admit to some heavy fogs along the coast). I'm told it has something to do with the angle of the sun, or because we're nearer the sun. In any case, my point is that the aware-ness of different light conditions can be an important part of your visual response—and this awareness may even creep up on you, without your being conscious of it. To be honest, I hadn't given it much thought until a few months ago. During a show of paintings I realized that all my Maine scenes had, by and large, a brittle, sharp quality, which was obviously a result of the kind of light I was painting. In contrast, a recent show of Charles Reid's paintings of Nova Scotia, only a few hours from Maine, revealed an effusion of soft edges. There were hazy yellow-green and brown fir trees swathed in a misty orange light—all indicative of that area's atmosphere.

I have often said that if I were able to buy light, I'd buy a bucket full of the stuff and throw it on all of my paintings. Neil Welliver, another Maine artist, bemoans the fact that he can't buy air in a tube, as all he wants to do is paint air. Wayne Thiebaud's obsession is with energized light. No matter what you call it, these interests lead to one conclusion—that real light, the light we're all struggling toward, is the light that comes from the painting itself. That, in a nutshell, is what painting is all about.

CHARCUTERIE
50″ × 40″ (127 × 102 cm)
collection of Mrs. Paulette Parker

Cold Winter Light

Seasonal light strongly affects the mood of a painting, as can be seen by comparing this painting with the summer scene on page 55. *Hillside, Yarmouth—Winter* was done in January, based on a small sketch I did from a hill overlooking Yarmouth, the town I live in. I'm particularly fond of New England villages in winter because you can see their underlying structure, with the gleaming white clapboards forming geometric patterns against the snow.

As in most of my paintings, I took liberties with my subject to create a more compelling drama. By making the road almost vertical, I exaggerated the curve and elevated the perspective, which helps to flatten the picture plane. I used a strong, simple diagonal in the foreground to help compress the eye within the patterns of the trees and buildings, where most of the attention

It would have been easiest to paint the hillside, with all the buildings, and then take a lot of dark paint to paint the trees on top. But I didn't paint this that way. Instead, I started with the overall pattern of the buildings, adjusting their colors against the softer snow tones and gradually building up areas, adding trees more or less at will.

is focused. There were a few barren trees, but I added many more to capture the feeling of looking through a maze of branches.

The key to the color in this painting is probably violet, although when I started I didn't have a purple painting in mind. I did, however, tone the canvas first with a thin coat of ultramarine blue and turpentine, which helps to control the value and color relationships, particularly in a snow scene. Then, in developing the painting, I used my normal range of colors, which allowed me to obtain a variety of colors while letting violet predominate.

Note that the lights on the houses—made by adding varying amounts of yellow ochre and lemon yellow to white— are relatively warm, in contrast to the deep blue-white tones of the snow. The violets on the road, rooftops, and trees are different mixtures of alizarin crimson and ultramarine blue, with white added for the violets in the distant hills and sky. The brick red on the chimneys and deep violet-reds on some of the buildings help complement the cool violet harmonies in the rest of the painting. I kept these reds muted, however, as a bright red might have jumped out of the picture.

Overall, the effect of snow was accomplished by letting cool colors predominate. It would, however, be too easy to make a rule suggesting that cool shadows are the only way to make a snow scene look convincing. I am thinking specifically about an unforgettable snow scene I saw in Vienna—*Hunters in the Snow* by Pieter Bruegel. There isn't a cool shadow in the painting, yet one almost shivers in front of it due to the dramatic use of rich, dark patterns dancing against austere whites. Closer to home, the same can be said of Andrew Wyeth's snow scenes, where the effect of snow is achieved through a judicious use of dark and light patterns, limited colors, and an incredible ability to leave everything unimportant out of the painting. One advantage of painting snow scenes is that the patterns and shapes of objects are easier to see because the snow has covered all the unnecessary details.

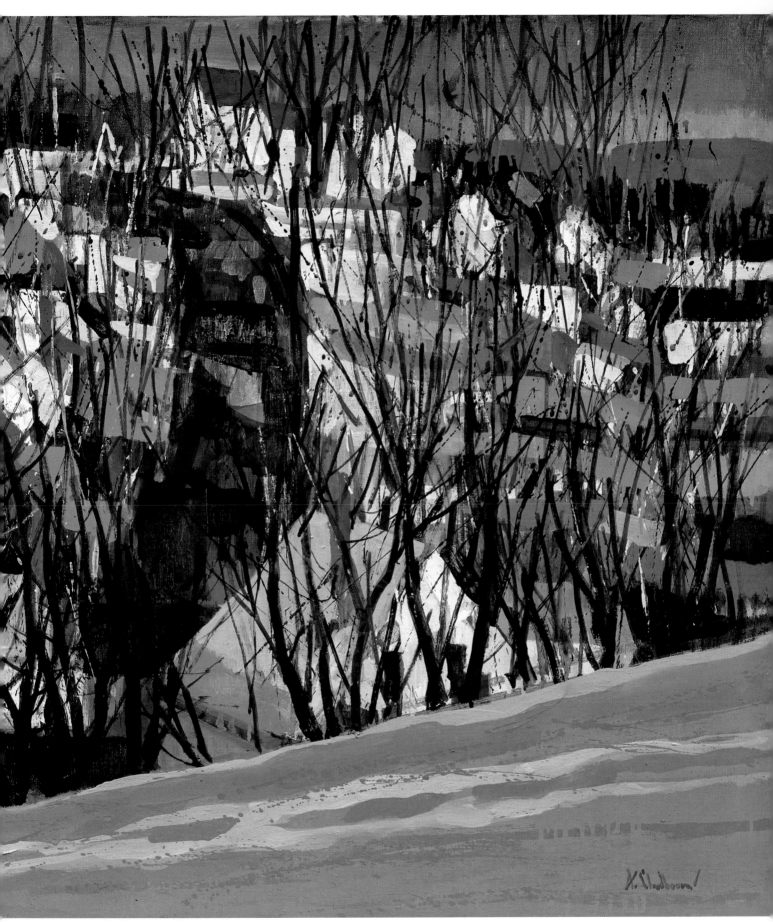

HILLSIDE, YARMOUTH, MAINE—WINTER *30″ × 40″ (76 × 102 cm), collection of Mr. and Mrs. William H. Adkins*

Hot Summer Light

In this beach scene, the colors are the complete opposite of the snow scene. To portray the warmth of the beach and the crowded atmosphere, I played hot, feverish colors against deep, rich darks. It's worth noting, however, that I used my normal palette (see page 13) for both summer and winter scenes. What's involved is not so much a change in palettes as a change in one's thinking in interpreting the different seasonal impressions of nature.

Although the water isn't shown in the beach scene, the idea of high tide is expressed by the way the figures jam themselves like sardines against the snow fence at the top, escaping the incoming tide. Many of the figures are taken from quick sketches done on the spot, but others are pure figments of my imagination. As you can see, I wasn't concerned with literal accuracy in the bodies; I was striving more for an impression of a mass of bathers sprawled on colorful beach towels against the hot, pink sand.

As I began adding clusters of figures in small patches, I felt a certain rhythm evolving, moving from the lower left in an S-curve, weaving through the painting, and finally culminating in the dark band of evergreens against the horizontal snow fence. As with most paintings without a predetermined composition, a lot of decisions were made instinctively during the painting process, with scraping out and re-painting of areas until the whole pattern began to gel.

Note that I used a lot of high-key blues and deep violets as complements to the warm pinks on the bathers and the sand. This color contrast is important—if I had just used warm colors throughout, the painting wouldn't have had the same vitality or dramatic impact.

It's also worth pointing out that the paint handling is somewhat brittle. There are no soft edges, nor was any attempt made to reproduce a realistic light source. To quote Degas, "The fun is not always in showing the source of light, but rather the effect of light."

T**he color contrast is important—
if I had just used warm colors throughout,
the painting wouldn't have had the same
vitality or dramatic impact.**

HIGH TIDE,
SCARBOROUGH
BEACH, MAINE
*18″ × 18″ (46 × 46 cm)
collection of Mr. John Holt*

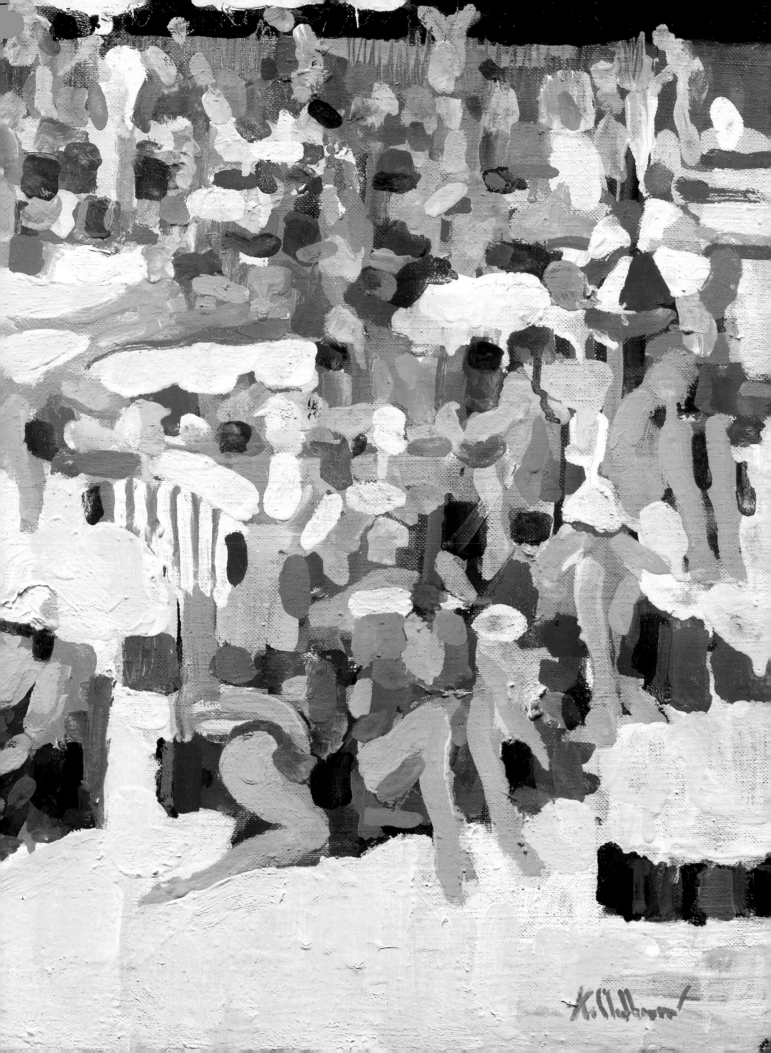

Morning versus Afternoon Light

In the bright light of morning, the lively colors of this market attracted my attention—in particular, the vibrant complementary colors of the bright blue wall and the orange awning. Painting this subject was a case of starting with the local colors, but then taking liberties to see how far I could push the dramatic color relationship.

In the finished painting, there are other, secondary complements at work—for example, the deep purple eggplants against the light yellow-green vegetables and the bright red to-matoes against the dark green avocados. Basically, however, they are subdued compared to the violent complements of the orange awning and the blue wall. Note, too, how the white square on the wall helps to bring out the intensity of the blue next to it and how the white is repeated in the scale's dial on the upper right, near the orange area.

Another important aspect of this painting is edges. Outside of a few soft edges on the darks of the blue wall, the drain pipe, and some lost edges in the interior, most of the edges are fairly hard, with an almost brittle quality. I'm not sure that this is always desirable, but here I felt it enhanced the bristling feeling of early morning light. You might compare this picture to the still life demonstration (page 21), where there are many more soft edges. In general, interior light has a much softer feeling than the harsh reality of bright outdoor light.

Also notice the way the light breaks up some of the objects, like the cans of condiments on the background shelves, so they become semi-abstract shapes. These relatively hard-edged shafts of light seem in tune with the rest of the composition.

NORTH END MARKET, BOSTON *36" × 36" (91 × 91 cm), courtesy of Barridoff Gallery, Portland, Maine*

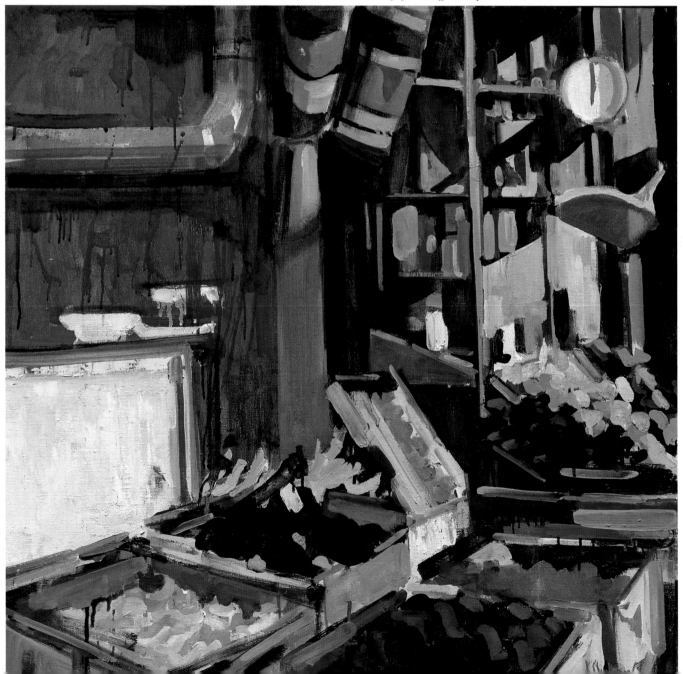

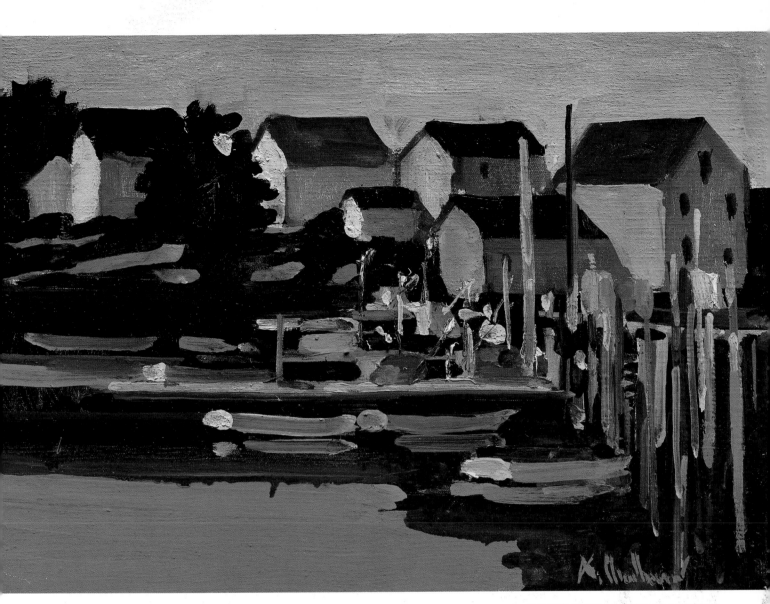

SOUTH BRISTOL HARBOR
10" × 14" (25 × 36 cm)
private collection

A CHANGE IN TIME

Completely different in feeling is a fairly simple painting that I sketched while my students painted in South Bristol, a small harbor near my home. I wasn't as inventive, nor did I take as many liberties as in other paintings of this village. What captivated me here was the late afternoon light.

The strong light and dark pattern of the simple, toylike houses against the dark evergreens, contrasting with the busy clutter on the wharf, became the basis for the whole composition. As you can see, I simplified the houses by leaving out most of the detail, just treating them as blocks of color with a strong afternoon light coming from the left.

When I got to the small boats and details of the wharf, I again simplified everything and emphasized contrasting values. What I actually saw was probably old oil barrels, masts, rigging, a gas pump, buoys, ropes, and all the other paraphernalia that pervades a wharf. But all that clutter was handled with a few strokes of rich, thick pigment. Detail should be used only if it enhances an object and not slavishly copied just because it's there. The detail that a painter like Andrew Wyeth puts in usually feels right because there are a lot of large, empty surrounding areas, which let you pause and rest for a while.

Notice the overall pattern of the shadows in this painting. The richness of the shadows found in late afternoon light is a key to the strong value contrasts throughout the painting.

Dappled Sunlight

This is one of the first paintings I did when I moved to Yarmouth about twelve years ago. I always have an impetuous feeling of excitement, like a new kid on the block, when I move to a new environment. After scouting the neighborhood for material, I settled on this view of Main Street, just around the corner from my house. Although I'm somewhat suspicious of the role of nostalgia in judging a painting, I do feel a bit wistful about this painting because the scene has changed so dramatically. The old-fashioned, Rockwellian barbershop has been replaced by a gussied-up boutique in the latest shades of decorator's pink and puce, and the two-hundred-year-old elm trees have vanished, due to the blight of the Dutch elm disease, transforming Main Street into the bleak monotony of suburbia.

My biggest challenge with this painting was interpreting the sun-splashed pattern of light and shade on the old houses, trying to capture the essence of a summer day on a typical New England street. I did, however, take one liberty with the design. In my original sketches, the sidewalk literally zoomed out of the right corner, so I slowed this strong directional pull by flattening the perspective, tipping the sidewalk vertically. Admittedly, in a fairly conventional picture like this, this remedy may appear cockeyed with the rest of the perspective. But, for the sake of composition, I felt forced to overlook this inaccuracy.

To depict the dappled light, I used warm lights and cool shadows throughout the painting, which is basically an Impressionist approach. Unlike the Impressionists, however, I used very few soft edges in the shadows. Had I softened the edges on the dark green grass or on the shadows of the buildings, it would have taken away from the brittle, sharp quality of light

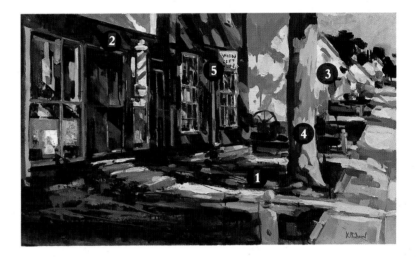

MAIN STREET,
YARMOUTH, MAINE
24" × 40' (61 × 102 cm)
courtesy of Barridoff Gallery,
Portland, Maine

I was trying to convey. I think that each subject demands its own set of choices, which must be determined before you start your painting.

While I was painting, the scene changed constantly. Had I come back an hour later, all the shadow patterns would have changed drastically, forming an entirely different composition. That's why I had to draw the buildings in first and then add the shadow patterns on top. This process was more complicated than it sounds because the cast shadows were so strong that they tended to destroy the three-dimensional form of the buildings. Look, for example, at the upper right corner of the picture. There the whites of the sidewalk and the buildings are basically all on one flat plane. The only things that determine the form of the buildings are their diminishing size and the small diagonal shadows of the sloping roofs.

COLOR MIXTURES

1. The long, horizontal strokes of grass are a mixture of Thalo green and burnt sienna in the darks and Thalo green, cadmium yellow, yellow ochre, and white in the lights. To accentuate the long cast shadows, I used splattering techniques here and there, flicking the paint on with a loaded brush.

2. The deep bottle-green of the barbershop is again Thalo green and burnt sienna, with a little ultramarine blue to cool it down.

3. The light areas of the white clapboard houses are a mixture of alizarin crimson, yellow ochre, and white, with ultramarine added in the shadows. Basically, then, the shadows are a cool violet, contrasted with pinker lights in the thicker, white areas.

4. The tree trunk is painted with burnt sienna, ultramarine blue, yellow ochre, and white in patches that suggest both its texture and the play of light on its surface.

5. The red trim, windows, barber pole, and other details were not just added at the end. Instead, I worked on them during various stages of the painting, until they became an integral part of the overall design.

Early Evening Light

I know of no painter who describes specific times of day, emphasizing a mood through the varying effects of light, as well as Edward Hopper. Evening or dusk seemed to fascinate him particularly. Some of the impetus toward the suggestive content of this hour may have come from his interest in the French Symbolists—Baudelaire, Rimbaud, and Verlaine, for example—whom he read throughout his life.

At first glance at almost any of Hopper's evening landscapes, the thing that hits you is his tremendous reliance on shadows to form the basis of his compositions. It's the pattern of these shadows that sets the mood of the entire scene. With this in mind, I used strong, dark shadows on the grass and the buildings in the painting shown here to create an evening mood.

In this case, I was looking into the light, so all the buildings were seen as a cool halftone contrasting with a warm, pink sky. Probably the hardest part of this painting was getting the white houses dark enough to appear as dark buildings against a lighter sky, but still remain within the context of white buildings. If you place a sheet of white paper against these buildings, or compare them to the white page, you can see how far the mixture is from pure white. Ultramarine blue, alizarin crimson, yellow ochre, and white were used in varying degrees, with the emphasis on the cool blue-violet tones. The rooftops, too, fall within this range, and even the dark alizarin crimson barns are cool in tone.

After I had established the relationships of the dark buildings against the pink sky, I spent a lot of time splashing around in the foreground grass, hoping I could make this area rich and exciting without detracting from the feeling of the village in the early evening light. For the areas of dark green, I used burnt sienna and Thalo green,

adding a little yellow ochre to keep the shadows luminous. The light, warm greens were painted on top, using white, cadmium yellow, and Thalo green. Because I didn't want these bands of light green to detract from the subtleties of the houses, I kept the contrasts within the green to a minimum. I added some light pink-violets in the foreground on an impulse, perhaps to

repeat some of the pinks in the sky—although I'm never sure about these offhand, unpremeditated accents.

In analyzing evening light, it's worth keeping in mind that, under most conditions, the light source will be warm. Just how warm depends on the lateness of the evening. Ask yourself: How does this affect the colors of the shadows? Since shadows will probably play an important role in determining the mood of your scene, it's a good idea to spend some time investigating your color options.

EVENING, ROUND POND, MAINE
10″ × 14″ (25 × 36 cm)
collection of Dr. Daniel Bryant

In analyzing evening light,
it's worth keeping in mind that,
under most conditions, the light
source will be warm.

Drama before a Storm

Needless to say, this isn't the prettiest part of Portland, Maine, but somehow I find these old brick buildings captivating under different lighting conditions. It remains a constant challenge to transform them into pictorial concepts.

When I first sketched my impressions, there was a storm brewing. A sky full of ominous clouds hung over the scene, with a bright, luminous piece of blue showing through at the horizon. It reminded me of those seventeenth-century Dutch landscapes by Hobbema and Ruisdael with their horizontal compositions dramatically lighting up the golden middle distance, very much like a stage set. It's probably difficult to compare the bright colors I used to a somber, brown Dutch landscape, but in terms of black and white values that's the basic concept for this picture.

Actually the painting shown here was done from a much larger version of the same scene. Comparing it to my original sketches, I tried to decipher where I had missed the boat. Somehow the large painting lacked the drama I wanted, so I decided to see what I could do by simplifying the shapes and pushing the warm and cool color contrasts to the hilt.

To build the strong shaft of light running over the warm-colored buildings, I began piling on the paint with a painting knife, using rich mixtures of cadmium red light, cadmium orange, Thalo red rose, cadmium yellow, and white. In contrast to this thick wall of warm color, I used a simple band of deep, cool violets in the foreground and a black-blue band in the sky. Note in the foreground where I added a small strip of pure ultramarine blue next to the hot, pink shaft of light.

For the light area of the sky, I chose a mixture of cerulean blue and white. I used an unnaturally sharp edge where it meets the dark portion of the sky, to tie it in with the other hard edges, playing throughout the composition. Oddly enough, when I tried softening this edge, it jumped out—probably because it was the only soft edge in the picture.

By exaggerating the yellow dividing strips on the road, I created a feeling of depth, leading the eye into the jumble of hot buildings in the distance. Note the spots of ultramarine blue in the dark shadows on the road in the distance. This is the same blue I used in the foreground strip, but you can see it more clearly against the warm reds and yellows.

Although I'm not conscious of color balance while I paint, the basic division of warm and cool color in this painting is two-thirds blue-violet and one-third warm red—sort of like a dry martini.

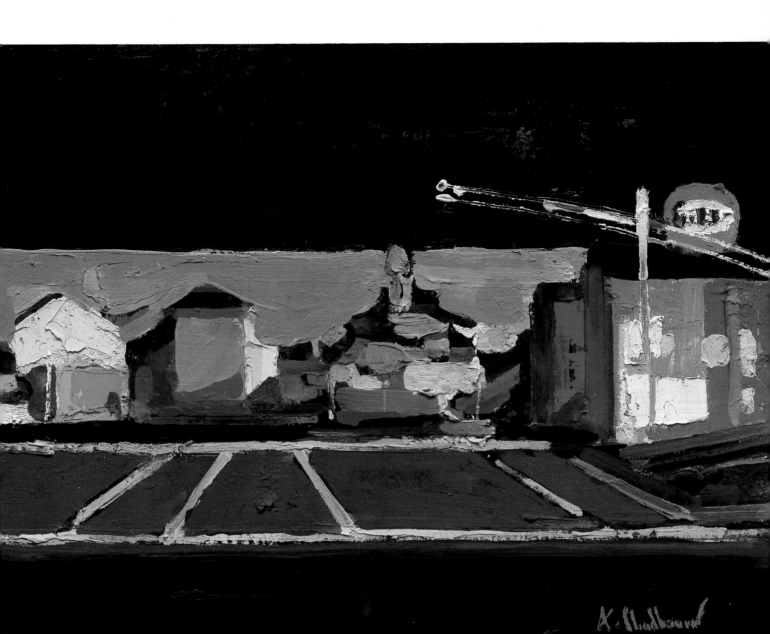

PARK AVENUE, PORTLAND, MAINE
12" × 18" (30 × 46 cm)
collection of Mr. William Ballard

Throughout the painting, the buildings are reduced to basic, simple shapes. The odd-looking dome-shaped building here is Portland's City Hall. It isn't actually green, but it does take on a coppery tonality in late evening light. In any case I felt it made an interesting contrast against the yellows and reds of the surrounding buildings.

Painting against Light Indoors

There is really something magical about the way objects are transformed when seen against the light. A mundane setup suddenly takes on totally different characteristics—no longer appearing as apples, bottles, and flowers, but as shapes existing in ephemeral light. If you don't have a window in your painting space, look around the house for other suitable windows to paint from. Some of Bonnard's and Vuillard's best works were done from kitchen and dining room windows.

The objects in this still life were chosen and placed at random. Primarily I was captivated by the strong patterns of the cast shadows, and these formed the basis of my composition. Constantly squinting at the setup, I noticed that the flowers, tall oil bottle, and mustard jar with brushes were silhouetted against the backlight, forming

harder edges than the rest of the still life. Observe, for instance, the softer edges in the halftones, where the objects meet the shadows on the table.

Basically, to capture the effect of light streaming through the window, I looked for color separations within the objects and kept the cast shadows flat. In the yellow and green apples on the left, for example, color variations were first painted within the dark halftones; then highlights were painted on top with lighter, thicker pigment. The surrounding, dark blue shadow area remains fairly flat in comparison.

When I set up similar still lifes against the light in my classes, the biggest problem for the students is getting the halftones dark enough. This difficulty is best overcome by constantly squinting at the whole subject to see just how dark those halftones are in

contrast to the direct light on the objects. It's also important to establish the pattern of the constantly changing cast shadows first. Try not to get too involved with minor details in the beginning. Work on the broad, overall pattern; then go back to develop the forms and intricacies of the objects.

Painting the light in the window itself can be particularly difficult. I went over this area three or four times until I settled for the cool, off-white tones that make this a quiet, restful area. Unfortunately, there is no general rule for this, as the light will differ with the type of day and the location.

Those of you familiar with Charles Reid's work may notice some similarities between this painting and some of his still lifes. Actually Charlie and I shared the same studio in Connecticut for a few years. We both like to paint against the light and share a fondness for the same kind of everyday objects, although we differ in our use of hard and soft edges. In any case, I hope that you, too, will share our enthusiasm for painting against the light, if you haven't already tried it.

HANDLING VALUES AND EDGES

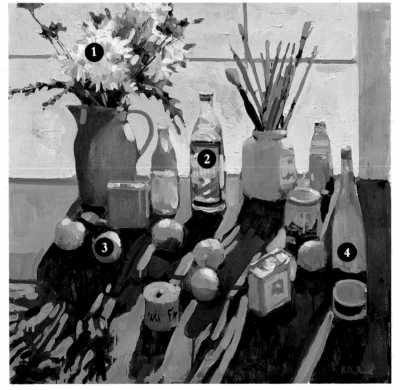

HANDLING VALUES AND EDGES

1. The closest value relationships are in the white daisies, where the petals are almost pure white in direct sunlight and only slightly darker than the window in the darks. Note that the leaves only look dark because they are placed against the light—they're not really that dark.

2. The darkest yellows on the bottle were painted in first with variations of yellow ochre, ultramarine blue, and white. Mixtures of pure cadmium yellow and white were painted on top with thicker pigment, making the edges appear brittle. Contrast these edges with the softer edges of the solid, gray mustard jar holding the brushes.

3. Generally, the soft edges appear in the darker halftone areas, where the light and color are subdued. The highlights are painted with thicker, richer pigment on top of these halftones.

4. Because the tall vinegar bottle is completely in shadow, it has softer edges. Some of the light blue and lighter green showing through the bottle were softened by rubbing the colors together with my fingers.

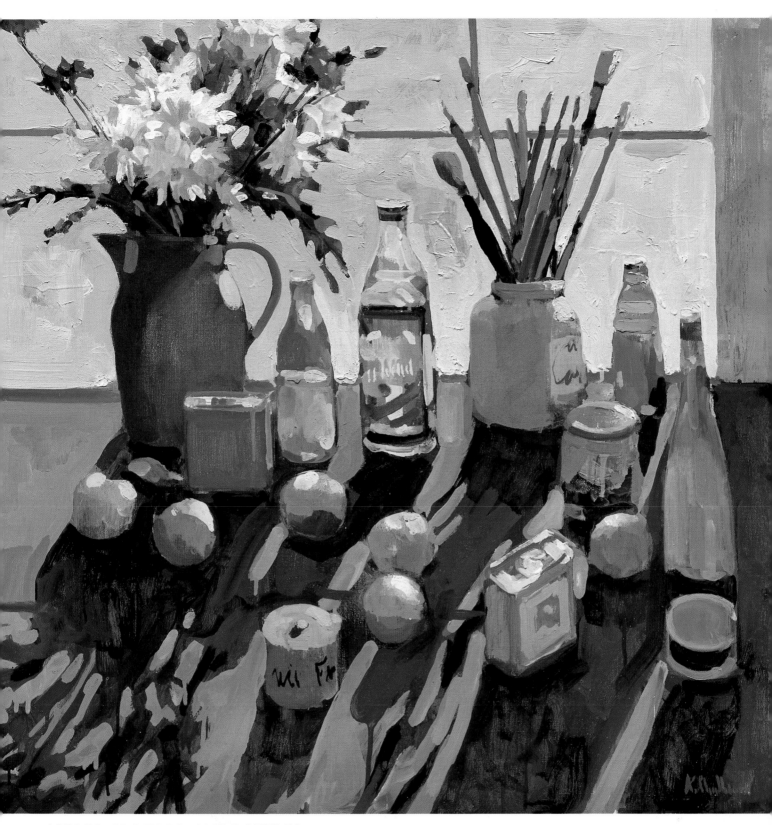

APPLES, FLOWERS, AND BOTTLES
30″ × 30″ (76 × 76 cm)
private collection

Painting against Light Outdoors

Five Islands is a small fishing village, somewhat off the beaten track. There is nothing particularly unusual about the place, but I've always been attracted to the simple group of buildings and the laid-back, unhurried atmosphere.

One of the reasons I enjoy painting against the light is that it tends to simplify a scene, so it is possible to concentrate on the vivid color contrasts of basically dark images against a strong backlight. In this case I started by establishing the dark reds of the buildings, using a mixture of alizarin crimson and ultramarine blue. Later, I went back into these areas, adding small amounts of orange to increase the luminosity of these shadows, so you could see into them.

Next came the bright, high-key colors of the sky, water, and foreground land masses. Loading my brush with a lot of pigment, I hoped to convey the bright, warm light that permeated the scene. For the sky, I mixed cadmium orange with lots of white, piling it on against the buildings and distant islands. I made the foreground slightly darker than the sky, but still very warm in tone. Here I used a variety of hot pinks, combining cadmium orange, cadmium yellow, and Winsor red with lots of white and keeping the area texturally on par with

the sky. For the light blue water, I mixed ultramarine blue and white, repeating this in small areas around the trucks.

Working back into the painting, I established the shapes of the pick-up trucks and other small, nondescript elements, which formed a cluster of bright accents against the deeper, bluish shadows. I probably overstated the blue in the dark areas and some of the cast shadows aren't correct, but this didn't bother me. I was more interested in producing a rich color pattern with strong color contrasts.

I think it's worth repeating that I don't use any color theories in a painting like this—I work spontaneously while the pigment is still wet, forcing me into the use of thicker pigment. Originally, I had no intention of using this much pigment, and I'm not sure the painting wouldn't have worked just as well with thinner paint. However, once I committed myself to one area of thick paint, it seemed only natural to continue in this somewhat exuberant manner.

It's also worth mentioning that I didn't work with a palette knife at all in this picture. The whole painting was done with three or four bristle brushes, which is my normal practice when working on a small canvas.

The sketch shown above was made during the early morning hours, while I was looking straight into the sun, so all the buildings are in deep shadow. Later, in my studio, I used this sketch and a few color notes to guide me through the painting.

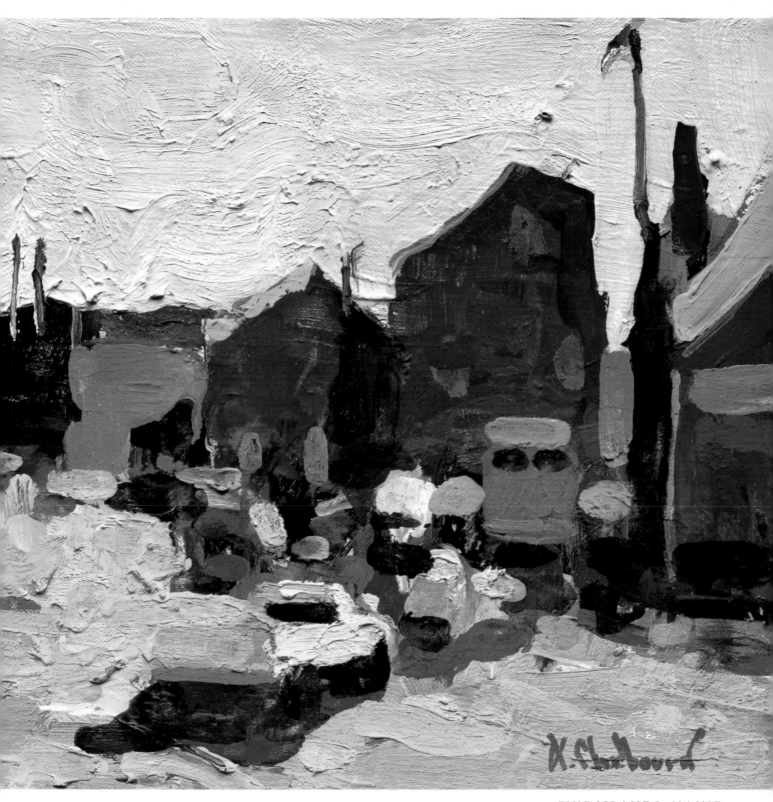

FIVE ISLANDS, MAINE
10″ × 14″ (25 × 36 cm)
courtesy of Barridoff Gallery,
Portland, Maine

Transforming Pigment into Light

Sometimes in my painting classes I tend to go overboard in arranging complicated still lifes, due to my fondness for jumbled masses of color and pattern. In this case I wanted to clear the air, or "defog" myself, so I opted for a simple assortment of bottles seen against the brilliant light shining through my studio window.

It's all too easy to forget that a perfectly valid pictorial statement can be made with the simplest of objects. We have only to look at Manet's mouth-watering little canvases, in which a simple asparagus stalk set against a white tablecloth fills us with unexpected pleasure through the sheer beauty of his manipulation of the paint. Or, on another level, think of the arresting dramas of dusty jars and bottles by Giorgio Morandi. These, too, become eloquent statements of poetry in paint.

For my own setup I chose an intense color—red—to cover the tabletop. This area would become one of my major concerns, for it covers half the composition and contains the play of the shadow patterns against the reflected light of the bottles.

My main objective was to paint the fractured light coming through the bottles. Because I didn't want a lot of overlapping forms to confuse the issue, I more or less lined them up in a row against the window. I did, however, choose a variety of sizes and shapes for interest.

After everything was arranged, I started painting directly on the canvas, without any preliminary sketches. The excitement of seeing all that lovely light and the strong, splashy patterns of the cast shadows on the tabletop was enough to get me going. I knew that the cast shadows would change drastically as the sun kept moving across my field of vision, so I purposely set a time limit to each painting session. If the shadows started moving, I went back and did more work on the bottles and window, squinting constantly to capture the elusive quality of light bouncing through the window. All in all, I probably spent the better part of four two-hour sessions painting this picture, using fairly large bristle brushes throughout the procedure.

As you can see, I used much more pigment in the light-struck areas than in the cast shadows, which were done with relatively thin washes of dripping paint. I have always had a great fondness for white pigment, which was probably influenced by my travels to the incredible Greek islands more than thirty years ago. Then, too, white pigment in a literal sense resembles light, and that, I'm sure, has something to do with my emotional reaction to areas of thick, light pigment.

Use my painting as a springboard for your own ideas. The next time you run into a dry spell and are looking for something challenging to paint, go to your kitchen cupboards and pull out a variety of bottles: wine bottles, beer bottles, herb bottles, oil and vinegar bottles, even a simple glass with a few sprigs of parsley. Then place them in your kitchen window or any other window with a lot of direct light shining through. Discover for yourself the infinite possibilities of transforming pigment into light.

I t's all too easy to forget that a perfectly valid pictorial statement can be made with the simplest of objects.

STUDIO BOTTLES ON RED TABLE
24" × 24" (61 × 61 cm)
collection of Mr. William Ballard

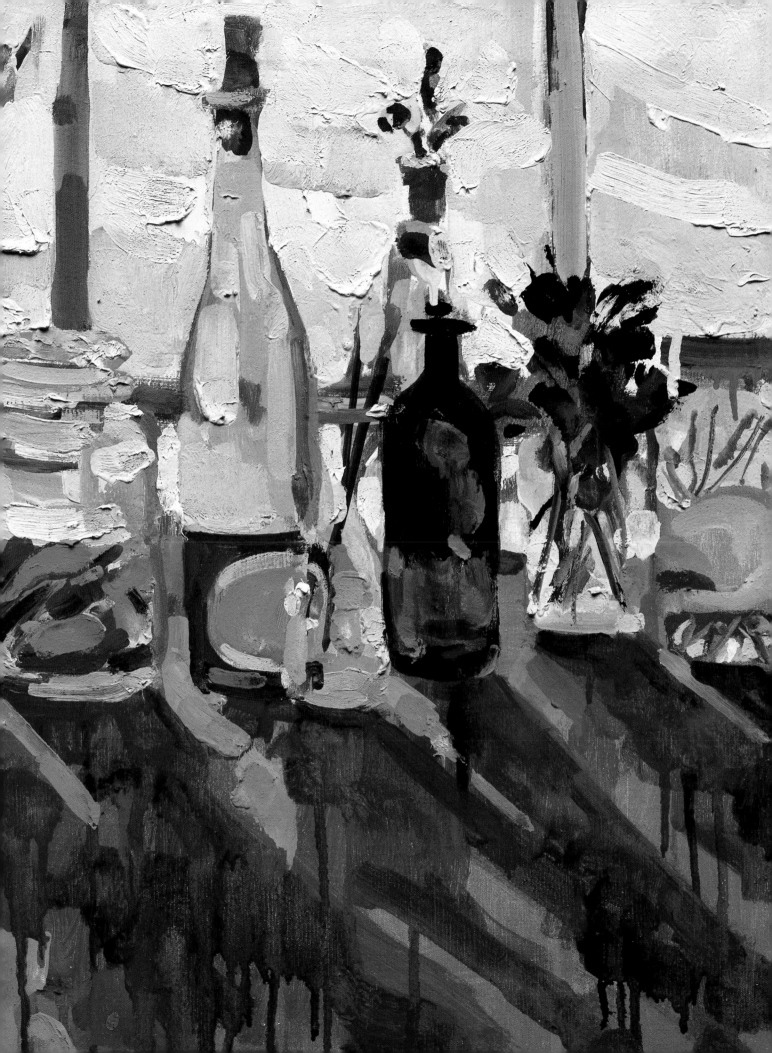

PATTERN AND COMPOSITION

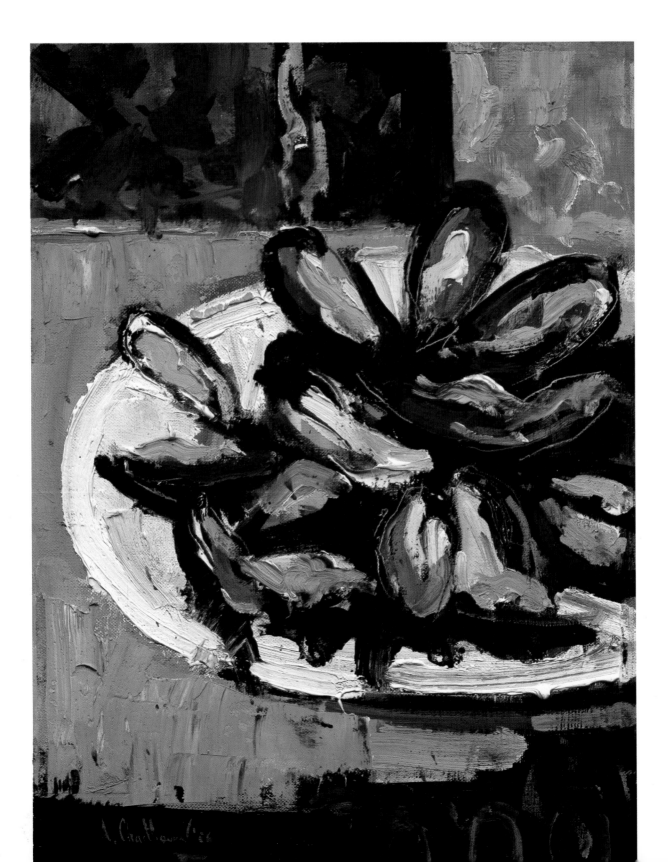

These diagrammatic sketches of tugboats illustrate what I mean about Dong Kingman's ability to look for pattern in common objects. The first sketch is a symbol of a tugboat—the proportions and shape are fairly accurate, but the boat remains static. In the second sketch, with the addition of just a few values, the boat becomes more interesting. This is the kind of pattern that Dong sees in everyday objects.

I wish I knew why composition is so difficult to teach. Hard as I try, it seems a painful experience for students to take a little extra time before they start a painting and make a few, simple compositional drawings. I'm sure that part of the problem stems from their belief that they don't draw well enough to make a competent-looking sketch. My feeling is that if you can place a line on your paper and fill in a shape with tone, you're capable of composing.

There are two diametrically opposed approaches to beginning a painting. One is to make a careful black-and-white value drawing, arranging the elements in a given order, which will be transferred to the canvas. This time-honored tradition was used by the old masters and still has many adherents today. The other approach is to attack the white canvas directly and solve all the artistic problems during the painting process. This risk-taking method was favored by the Abstract Expressionists in the belief that part of the thought process should coincide with the direct action of painting—hence, the term "action painters."

My own personal choice lies somewhere in between these two approaches. Since most of my sketches are somewhat fragmentary, I seldom blow up or transfer an image onto the canvas. Instead, my sketches are mostly what Wayne Thiebaud calls "visual hunches." Sometimes I may work from half a dozen sketches, considering different viewpoints. Nothing is "nailed down" before I start a painting. Although the sketches provide some preliminary thinking, I still feel free to move things around and adjust my composition while I'm painting.

About thirty years ago I had the pleasure of painting several times a week with the watercolorist Dong Kingman. One of my lasting impressions from those sessions (beyond the fabulous meals we cooked together) was of his marvelous sense of pattern. Dong has an eye for pattern in everything he sees, whether it's a telephone pole, a leaf, or a reed of grass. But more important, perhaps, is his way of going after the pattern of the picture. He told me this is due in part to his Oriental training, in which the central part of the composition is developed first, then secondary areas such as skies and foregrounds are adjusted accordingly. This method of digging out the pattern first allows you more freedom in interpreting your ideas because the central theme has been reduced to abstract shapes and patterns.

Whichever method you choose, it goes without saying that constant practice in sketching your ideas before painting will further your ability to transform your ideas into a strong composition, regardless of how inept your sketches may look at first. I hope the examples throughout this book will encourage this effort.

MUSSELS MARINIERE
18″ × 12″ (46 × 30 cm)
collection of Mr. John Muench

Relating Objects with Pattern

While visiting my friend the artist John Muench in Maine several years ago, I did a series of sketches of the marvelous cast-iron stove that dominated his kitchen. These sketches eventually became the basis for several paintings, with the stove as the paramount attraction. In the painting shown here I also referred to some sketches of a baked red snapper served on a Victorian platter and incorporated this image into the painting. In addition, I found a wallpaper design that I thought would enhance the distinctive Victorian aura of the picture.

The related shapes of the stove, fish, platter, and wallpaper pattern formed the basis of the composition. I started by laying in the dark forms of the stove with thin washes of turpentine, keeping details to a minimum. Next I pasted on several cut-out pieces of wallpaper with Hyplar medium. I then painted a thin film of Hyplar over the paper, making it possible to go back over this area with oils.

As the painting developed, I started building up thicker pigment in the platter, fish, and background, trying to keep a free interpretation of the objects through an emphasis on pattern and color. No attempt was made to use perspective; instead, I wanted an overall flat design, which I augmented with the vertical shafts of light and dark over the stove and platter. Some of the actual pattern of the wallpaper was painted to fool the eye—*trompe l'oeil*—so the identity of some objects is diffused.

It was important to tie the background pattern in with some of the other elements. That's why the stove, platter, and fish have various design patterns running through them. Notice how in some places I incorporated the wallpaper design into the structure of the fish. Had I painted a realistic fish on top of the platter, it would have destroyed the decorative feeling.

Introducing some of the swirling patterns on the platter into the stove helped to relate these two elements. Another way I tied the stove into the rest of the picture was by adding some deep grays into the darks so it would gain a certain feeling of depth, yet still read as an overall dark shape. If I had painted the stove a flat black, it would have looked too much like a cut-out.

Because of all the visual activity with the patterns in this painting, I felt the need for a restful, flat area. This is what prompted me to add the large white area on the left of the composition. The white is then repeated in the wallpaper design and the platter.

In these two details you can see the interplay between the painted pattern and the wallpaper design.

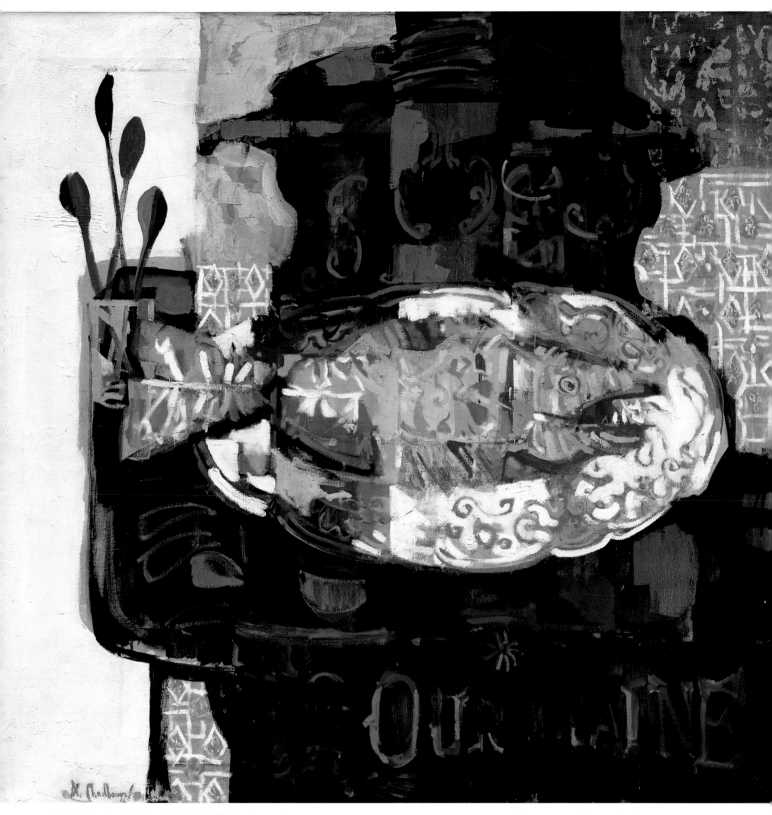

RED SNAPPER ON STOVE
40″ × 40″ (102 × 102 cm)
collection of Mr. John Muench

Composing with Color

My fondness for market scenes probably stems from my Paris days, when the daily routine of marketing was one of the more pleasant pastimes of everyday life. When I visit the Italian markets in Boston's North End, it's as if I were hurled into a Proustian time warp, revisiting the past and recapturing all those sights and smells that made marketing such a gratifying event instead of a chore. The small market depicted here is a favorite of mine, both for sketching and for buying the well-displayed produce. It's nice to know that there are still a few places left in our brave, new, plastic world where you can squeeze an eggplant, fondle a pear, or stick your nose in a cantaloupe without the fear of being arrested.

After collecting my sketches and photographs, I made my usual compositional roughs before starting to paint. What captivated me most were the worn-out gold letters on the prismatic storefront windows and their relationship to the surrounding warm and cool browns of both the building and the crates full of fruit and vegetables. I used the white-smocked figure as the focal point of the composition, since he made such a good foil for the darks of the doorway.

The color relationships and play of light help to structure the painting as well as provide visual excitement. If you look closely at the window on the left, you will discover that a warm lavender tone shows through. This mixture of alizarin crimson and ultramarine blue was rubbed over the entire canvas before I started painting, as a base for the contrasting golds and browns I would be using for the lettering and patterns of reflected light on the windows.

The only real browns I had on my palette were yellow ochre and burnt sienna. To achieve the range of browns you see in this picture, I added alizarin crimson and ultramarine blue to the ochre and burnt sienna, along with white. The wood frame of the building, for example, is a very warm mixture of alizarin crimson, yellow ochre, and white, while the boxes and crates—considerably cooler in tone—are yellow ochre, ultramarine blue, and white.

For the gold lettering, I mixed yellow ochre, cadmium yellow, and white; but I went back and rubbed out part of the lettering as I started to develop the shafts of deep shadows playing over the glass. Indeed, I went back and forth for several days working on the windows, constantly wiping out areas and repainting them, until I felt I had created the impression of broken light bouncing around in a diagonal direction. This diagonal play of light is also evident in the boxes in front and helps to connect different elements of the composition.

I kept the green vegetables in warm, earthy tones with Thalo green, burnt sienna, yellow ochre, and white. I didn't want to make this area too bright, lest it interfere with the busy pattern in the other areas. For the whites on the smock, I used ultramarine blue, yellow ochre, and white, keeping the shadow side reasonably cool against the warmer, white lights.

Although I don't think time is an important criterion for good painting, it might be of interest that a busy subject like this took me the better part of three weeks to paint. During this time there were a lot of changes. Even the scale and other small incidentals in the windows went through many stages of transformation during the painting process.

NORTH END
MARKET, BOSTON
30″ × 40″ (76 × 102 cm)
collection of Dr. and Mrs. Daniel Miller

My photograph provided important information about the reversed lettering and the fractured light coming through the window. At the same time I had to keep the detail subordinate to the overall pattern of the girl at the counter. That's one reason my sketch, with all of its ineptness, still captures more of my immediate attraction to the scene. Although there are inaccuracies in the drawing, such as the overlong arms, I felt I could work these out in the painting. Had I done a super-realistic drawing of the scene, I'm not sure I would have felt as free to take the liberties I took in creating this picture.

Finding the Pattern of Light

The Porthole Restaurant, on Portland's old waterfront, hasn't changed much since the twenties. Every time I enter the large, sun-splashed room, I feel as if I were in an Edward Hopper interior. Sitting over a mug of coffee at one of its empty tables in the late afternoon light, I made a small black-and-white sketch of a girl at the counter. Immediately I was drawn to the abstract patterns of light and shade playing little tricks against the window behind her. Because I wasn't sure I could remember all the fussy details of the reversed lettering and patterns of fractured light against the window, I also took a few snapshots.

Although a strong nostalgic feeling probably lured me into doing this painting, it was the overall pattern of the single figure against the light-struck window that became the central idea. If I had concentrated on the Rockwellian details of the napkin holders,

ketchup bottles, sugar containers, and salt and pepper shakers, it would have been another kind of painting. In my rough sketch I had already simplified these objects into an overall mass of shapes seen against the light and, as I painted, I didn't want a lot of fussy detail to detract from the strong shape of the girl at the counter. I did, however, add a potted green plant on the upper left, as a singular accent of color against all the surrounding blues, pinks, and violets.

Actually, in terms of color, I went out on a limb and chose a mixture of cerulean blue and white for the whole interior—a far cry from what actually existed. In reality, the restaurant has a lovely cool, off-white cast, but I felt like experimenting with an offbeat approach that would force me into color relationships I normally wouldn't use. Although I'm not sure I succeeded, in that the painting may look a bit garish,

I hope you'll be encouraged or provoked into using unexpected mixtures of colors in organizing your paintings. Instead of going to your normal tried-and-true color combinations, try to change your thinking by arbitrarily choosing a different color scheme. This kind of experimenting has less to do with color theory than with using your own intuition and letting your emotions go to work for you.

After I had established the various tones of cerulean blue, I found that the most difficult part of the painting was orchestrating all the high-key pinks bouncing through the window. It was the abstract shapes of fractured light surrounding the girl that took most of my time and energy.

On a final note, observe that even in the darkest darks, no pure black was used. This is true of most of my paintings that deal with the problem of painting against the light. In most cases, a mixture of ultramarine blue or Thalo green and alizarin crimson gives your darks more luminosity than pure black would.

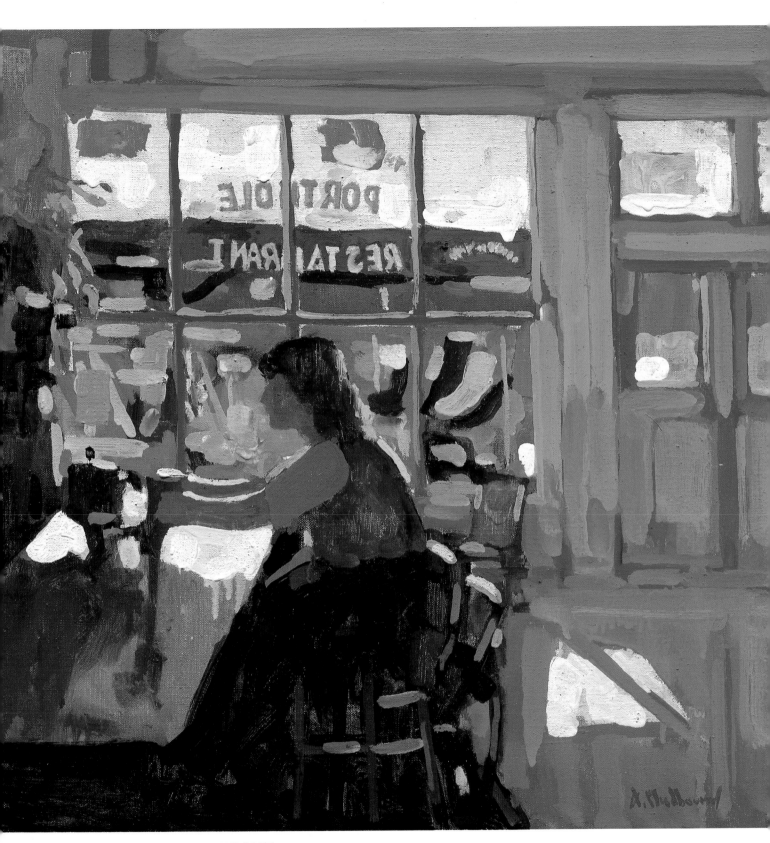

THE PORTHOLE RESTAURANT
18" × 18" (46 × 46 cm)
collection of Dr. and Mrs. Daniel Miller

Creating a Rhythm

Because mussels are so cheap and plentiful in Maine, I cook them often in my kitchen. Invariably I end up sketching them, either in the pot before cooking or later, when they have been steamed open and are served in a dish. I find the contrast of the deep, shiny purple outer shells and the translucent inner shells against the bright yellow-orange meat a particularly intriguing color and design problem.

In this case I set up a fairly simple arrangement on the floor of the opened mussels on a plate along with the other condiments generally used in the cooking—a bottle of white wine, some parsley and shallots, butter—and a kitchen knife. After several small thumbnail sketches, I realized that the plate of mussels was really the most compelling object there. I chose a small, square canvas and put the plate directly in the center of the composition, to see if I could make it work. I purposely placed some of the shells on the edge of the plate, overlapping the circle, which helped to break up the strong bull's-eye effect. This also created a circular movement, much like the spokes of a wheel going from left to right.

The colors in this painting are almost limited. I used alizarin crimson and ultramarine blue for the dark shells and the same mixture plus white for the inner shells. Then I combined yellow ochre, cadmium orange, and cadmium yellow with white for the meat of the mussels. The plate was painted with lots of white and a small amount of yellow ochre, as well as some ultramarine blue in the shadows. After some trial and error in the background, I finally decided on a flat mauve mixture of Thalo red rose, ultramarine blue, and white.

Notice how, on some of the shells, I scraped out the dark color with the point of a painting knife while the paint was still wet. These scratchy lines accentuate the movement in the design. They also provide an interesting contrast in texture.

The scraped-out lines add to the rhythm of the whole.

MUSSELS
18" × 18" (46 × 46 cm)
collection of Mr. Richard Wright

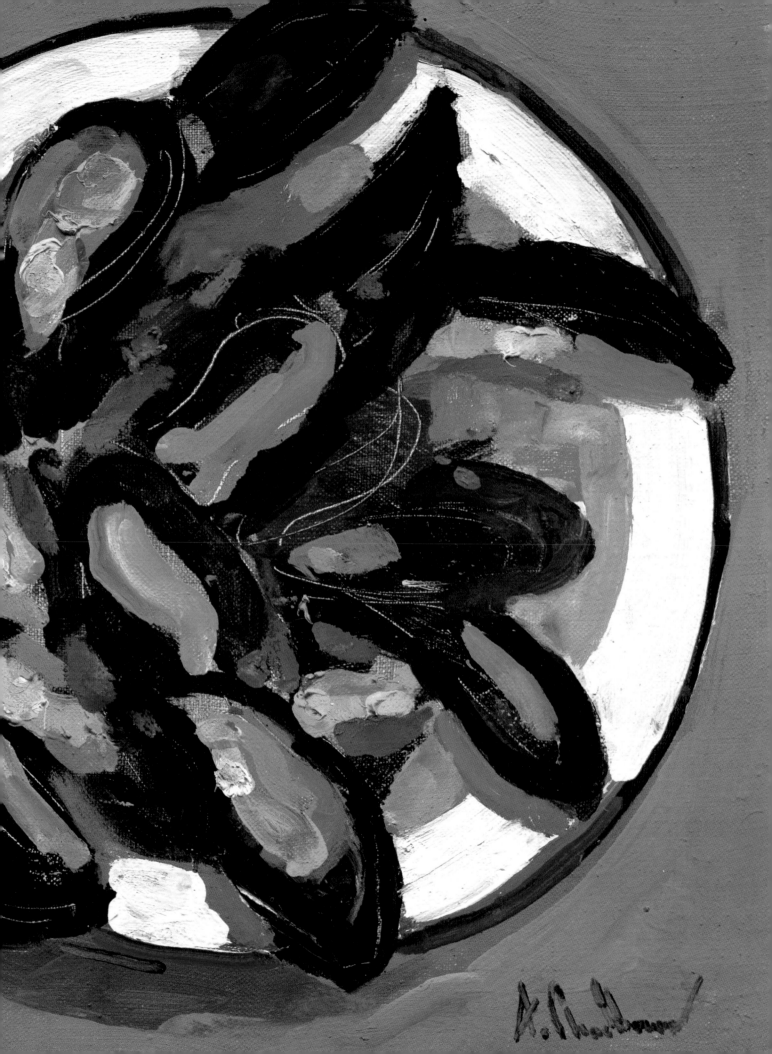

Bringing Life to a Cliché

Recently my good friend Charles Reid and I conducted a joint painting workshop on a beautiful spit of land near Bath, surrounded by an inlet with an array of fishing boats, trawlers, and sleek pleasure boats. Worrying, as I usually do before facing a room full of all those eager faces, I confessed, "You know, Charlie, I'm not very good at painting rocks and surf and boats in harbors." His astonished answer was, "But Chip! What are you doing in Maine?"

My reluctance to tackle a subject like boats in a harbor stems, I'm sure, from a deep-seated notion that any scene that's been painted so many thousands of times must be "corny." By the same token, I think we are sometimes blinded by the images we carry around with us of subjects like harbors, covered bridges, and barns. All those mediocre paintings looming up in front of us before we even put a brush to the canvas. It's like going on location and finding twenty artists already painting your subject.

Casting my fears aside, I did this painting from some sketches I had done many summers ago, during a session with my classes at Five Islands, Maine. My impulse was to do a very simple, blue painting, seeing how far I could carry this idea using only one blue—in this case, ultra-

The detail of the boats decreases, and they become more and more suggestive as they recede into the distance.

marine. Color then became an almost secondary consideration; I had to rely on pattern and textures to carry the painting.

After establishing the overall plane of the water, I placed the white boats in a scattered arrangement, forming the basic light-dark pattern of my composition. Adding the dark blue horizontal strokes intensified this pattern and helped anchor the boats to the foreground plane of the water. I also introduced one red boat for color contrast, along with a couple of light yellow dories to break up the monotony of white and blue. Note that I gave more attention to detail in the foreground boats; then, as they recede, they become more suggestive, finally ending as small dots of light paint in the distance.

The sky in this painting presented unexpected difficulties. At first I tried a plain, light blue sky. But it looked too empty, so I decided to add some light cloud formations I had noted in one of my sketches. After loading a large, flat bristle brush with a thick mixture of white and a little cadmium red light, I used sweeping strokes to generate some excitement in this area. By offering a contrast to the smoother, horizontal strokes of the water, the varying textures of the clouds helped to finalize my impressions of the scene. These kinds of liberties, although not radical, helped to create a more exciting statement with a subject that, at first glance, seemed overworked and beyond the realm of my sensibilities.

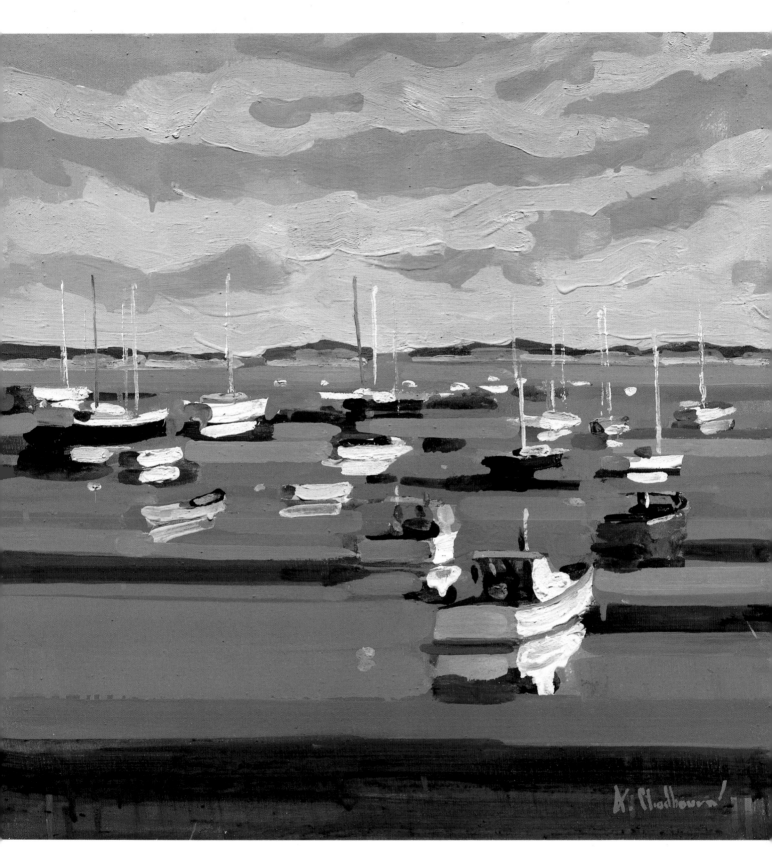

BOATS, FIVE ISLANDS, MAINE
14" × 14" (36 × 36 cm)
collection of Mr. William Ballard

This painting originated with a photograph I saw in *Vermont Life,* a magazine devoted to extolling the bucolic virtues and pictorial beauties of the Green Mountain State. The subject was a challenge, since I didn't know the first thing about painting cows. What appealed to me were the strong, irregular shapes and patterns of the cows in late summer light.

When working from a photograph, it's important to assess your response and to learn how to take liberties with the photograph, as I did in this painting. It's much more fun and challenging to create a statement of your own, interpreting what you see, than to copy a photograph in a slavish manner.

I started in my usual way by making a few compositional sketches, trying to eliminate extraneous material from the photograph and reduce the whole subject to a simplified pattern. The hardest part was analyzing the jigsaw shapes of the cows and transforming them into a simple mass, which would still be recognizable as cows. Later, in the painting, I carried this reductive line of thinking even further by simplifying the distant hills and foreground road into bare, unadorned shapes.

To start out, I laid in a simple band of black and white swatches for the cows. Then I painted the dark hills with the deepest black-green I could muster—mixing Thalo green with burnt sienna and covering the whole background with large, flat strokes. To indicate the effect of sunlight, I added small patches of bright green with a

thick mixture of Thalo green, cadmium yellow, and white. For the foreground, I used a violet tone of alizarin crimson, ultramarine blue, and white, which helped to define the shadow areas in and around the cows' legs. Later, I added the warm strips of light on the road with a mixture of alizarin crimson, yellow ochre, and white. Then I went back and did more work on the cows, adding some cool tones to the whites in shadow and piling on the thicker paint in the light-struck areas—hoping the characteristics of the cows would eventually emerge despite this impressionistic treatment.

Describing the painting procedure, however, always makes it sound so much easier than what actually takes place. Although the painting may appear simple, many hours of readjusting values and changing colors passed before I finished the painting.

The key to this picture lies in the strong value contrasts. The color theme, broken down to its simplest terms, is dark green, black, white, and violet. If you look at the picture upside down, stepping away from the subject matter, it's easier to see the role of proportion in the value and color relationships. The strip of black-and-white patterns stands out because of the large amount of dark green surrounding it. The small strip of warm violet also gains prominence from the value contrast. Had the lights and darks been evenly distributed throughout the picture, I don't think the painting would have been as effective.

When working from a photograph, it's important to assess your response and to learn how to take liberties with the photograph.

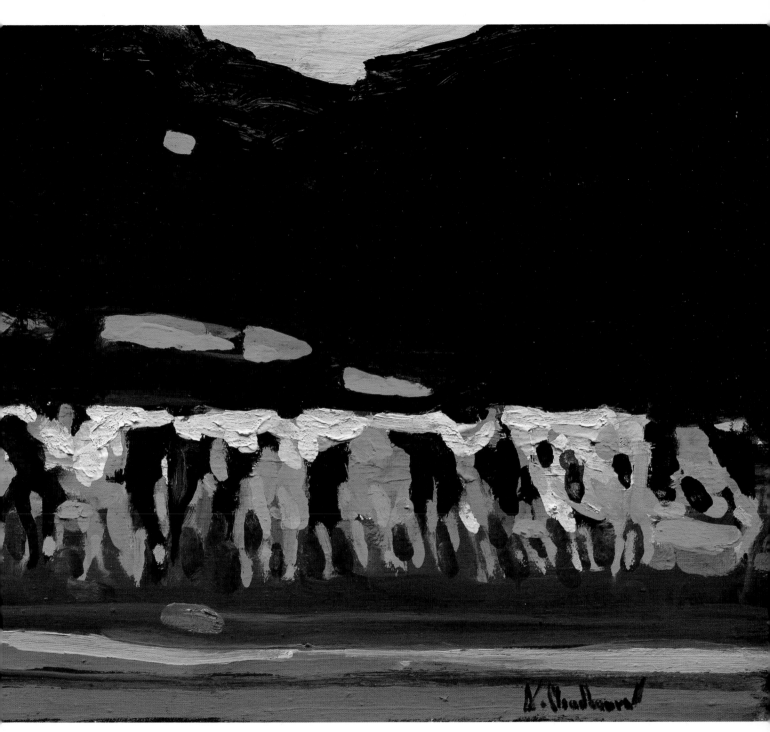

COWS, VERMONT
12" × 18" (30 × 46 cm)
collection of Mr. and
Mrs. Robert Ellowitch

Developing a Painting Idea

The two oil paintings shown on pages 86–87 began with this sketch of Kennebunkport, Maine, done more than twenty years ago. My studio is filled with hundreds of sketches like this, which I keep not because they are great drawings but because they represent the germ of an idea that might be worth developing into a painting. Drawings have an uncanny way of rejuvenating my memory. A photograph may give me the facts I need, but with a drawing I remember the smell of the place or what I had for lunch. That's

why I implore you to hang onto your sketches regardless of how inept or fragmentary they may appear.

As you can see, no attempt was made to record an exact likeness of the scene in front of me. In a quick drawing like this, I try to grasp the essential pattern of the buildings with a somewhat arbitrary use of light and shade. A loose interpretation in the drawing promotes freedom when I begin to rework these images on the canvas; a more detailed description might intimidate my vision or expression.

This drawing, by the way, was done with a BB Wolfe carbon pencil, which gave me a rich variety of darks and a fine incisive line. The only drawback in using a soft carbon or charcoal pencil, particularly for the beginner, is that it becomes messy if you have to erase a lot. Also, the drawings tend to rub off in a sketchpad unless properly sprayed with a fixative. In my own case, if I make a mistake in the drawing, I draw right over the mishap instead of trying to erase the error. This is purely a personal choice.

COLOR SKETCH
A few days later, in the comfort of my studio, I did this opaque watercolor

KENNEBUNKPORT
MAINE 12 AUG 62

INITIAL SKETCH

sketch, adding the element of color in a preliminary study for the large oil painting I had in mind. I used pen and ink for the underlying drawing and added opaque white to my normal watercolor palette so I could move back and forth with the medium, much as with oils. I didn't change much in terms of the original composition, although I did make the church steeple more important, and I added a vertical pole in the foreground to offset the horizontal shapes of the buildings.

Since I wanted a subdued color theme, I used a fairly limited palette, consisting of ultramarine blue, alizarin crimson, burnt sienna, and raw sienna. By superimposing flat washes of color over the drawing, I gradually built up the geometric pattern of the buildings, surrounded by the dark shapes of the foliage and deep tones of the piers and pilings. While I used the white paper for the lightest buildings, I added a few white accents with opaque white to the pilings in the foreground.

Because the original drawing was relatively free of precise detail, it allowed me to move around the paper more or less at will, changing shapes and patterns as the sketch progressed. With this kind of sketch, I like to work with my drawing board flat on my work table, surrounded by all the materials and tools I need. "Messing around" in this way somehow keeps the work more spontaneous and frees it from conventional easel painting.

I want to emphasize that this color sketch wasn't intended to be a finished picture, but rather a probing and sifting exploration in my quest for an evocative statement. You might find it fun and rewarding to dig out some old sketches and try your hand at similar color sketches. Pick a medium that you feel comfortable with, to be free of any technical problems. If you're unfamiliar with watercolor or acrylics, try working with oils on heavy vellum paper tacked onto your drawing board, or use small gesso panels. The main thing is to keep your mind open and receptive to "picture hunches."

VIEW OF KENNEBUNKPORT, MAINE
watercolor, 16" × 20' (41 × 51 cm)
collection of Mr. Charles Reid

Developing a Painting Idea

INITIAL OIL PAINTING

This painting was done shortly after I finished my color sketch, while the subject was still fresh in my mind. Because I chose a more horizontal format than with my sketches, there were inevitable changes in translating the information. Also, I decided on a much more somber color scheme—probably based more on a psychological feeling for the place than on what was in front of me at the time. I'm afraid the good people of Kennebunkport would have a hard time recognizing their charming village, but since I was more interested in an emotional reaction to the scene, I felt these liberties were justified.

When I started laying in the general composition, I used a couple of large bristle brushes and a fairly limited palette, consisting of Thalo blue, burnt sienna, yellow ochre, and white. (In those days I used Thalo blue instead of ultramarine blue, which makes the overall image darker.) One of the big changes that occurred early on was in making the pilings and rock formations more prominent. I felt the foreground was the weakest area in the watercolor sketch, and I tried to strengthen it by using the staccato rhythm of the light and dark patterns of the pilings. Then, as the painting progressed, I added many more buildings than either sketch suggested in my attempt to build up a loosely structured image of the village.

One might describe this process as the "push and pull" stage of the painting, to borrow a phrase from John Marin. I was dealing directly with the canvas, adding and subtracting shapes and patterns more or less at will, paying little attention to my sketches. As a painter, I find this stage of the painting one of the most enjoyable because I feel so incredibly involved in the act of painting—reverberating and responding to the echoes of the painting. That's what Richard Diebenkorn means when he says there are moments when the painting talks back to him. You add this or take out that because it feels right. Needless to say, I make a lot of mistakes and errors in judgment while I'm sloshing around, but, in the final analysis, I find this kind of risk-taking the most satisfying.

Later, after the general pattern and composition began to take shape, I used my full palette to refine the subtle, warm white and off-white shapes of the village in contrast to the dark

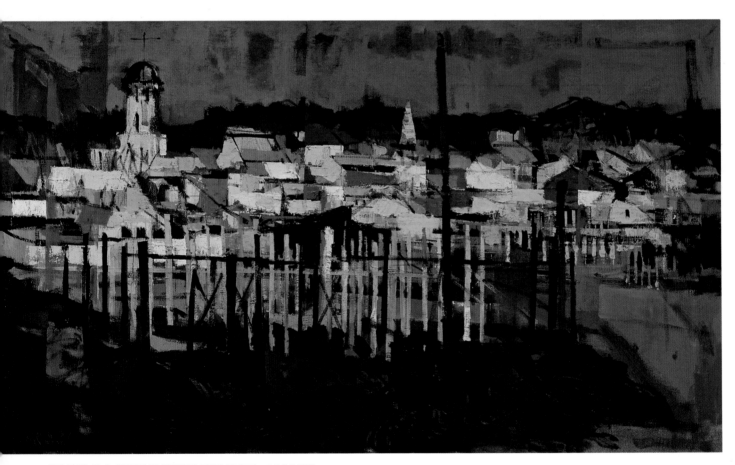

VIEW OF KENNEBUNKPORT, MAINE
30″ × 60″ (76 × 152 cm)
collection of Mr. William Ballard

trees and blue-gray tones of the sky and water. In some areas I left the actual construction lines of the initial drawing, as I felt they belonged to the overall character of the painting. In a sense, by permitting some of the framework of the picture to show through in the final painting, the viewer is invited to share in the struggle.

A DIFFERENT VERSION

A few years ago I painted another version of Kennebunkport, which differs considerably from the dark painting done twenty years earlier. I don't think my painting style has changed much over the years, but in this case my thinking changed, calling for a whole new set of precepts to guide me. For the past few years I have been deeply involved in trying to paint light, and, as a result, my pictures tend to be much brighter and higher in key. Thus, using the same basic subject matter, I tried to bring a completely different feeling to the scene, primarily through the use of higher-key colors.

When you compare the different versions, this scene is probably the closest in composition to my original pencil sketch—in part because that was my sole point of reference (I had sold both the watercolor sketch and the large oil painting many years ago). The high-key blue sky, with its white clouds. and the simple light tones in the foreground are also similar to the vignetted shapes of the original drawing.

Once I had established the dark, earthy greens of the trees, it became easier to concentrate on the strong, semi-abstract patterns of light and dark in the buildings. Moving the pilings further back into the picture space allowed the entire pattern to be centralized within the middle distance.

I'm not sure that this painting is any better than the earlier, more somber version; my purpose, however, is to show how you can arrive at a completely different mood by changing gears in your thinking. That's why I urge you to hang onto those old sketches—there may be another picture idea at work in those pages if you're willing to do a little experimenting. If you have any doubts about reworking old themes, it's worth remembering the hundreds of views of Mont Sainte-Victoire that Cézanne painted in his later years, each with its own set of dynamic principles. Or, in a more contemporary vein, we can look at the endless series of Ocean Park paintings by Richard Diebenkorn, all painted as if seen for the first time. It's worth repeating Braque: "Progress in art does not consist of extending one's limitations, but in knowing them better."

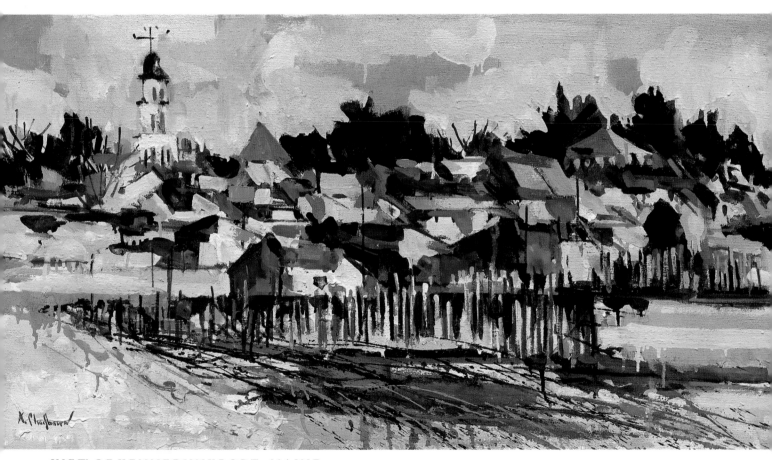

VIEW OF KENNEBUNKPORT, MAINE
30" × 50" (76 × 127 cm)
collection of Mr. and Mrs. John Watson

FLATTENING THE PICTURE PLANE

*F*lattening the picture plane is something that has concerned artists for centuries, and it's difficult to discuss without getting into a prolonged, historical essay. Essentially, it's a proposition about how to reconcile the idea of three-dimensional space on a two-dimensional surface without adhering to the Renaissance concept of pictorial space.

The classical Renaissance painter saw the world more or less as an organized theatrical set, with the horizon generally placed in the center of the canvas, imposing a unitary space in which every pictorial element obeyed the laws of perspective. The Impressionists, however, blew this whole concept right out of the water. They questioned our visual habits, redefined our point of view, and shook us out of the comfort of known and accepted conventions. Around 1860, with the opening of a shop in Paris called La Porte Chinoise, the Oriental, particularly the Japanese, print began to invade artists' studios. At one point Pissarro exclaimed, "The Japanese artists convince me of our attitude toward the visual"—referring to their use of asymmetry and manipulation of two-dimensional space. All of a sudden the axis of Renaissance perspective had been dislocated. Van Gogh's shoes arrayed on the floor from several vanishing points, Degas's sweeping floorboards of the ballet theater, Toulouse-Lautrec's figures cut at the edge of the canvas, Monet's violently plunging street scenes—these were but a few of the ways the Impressionists rearranged the visual world.

A few years later, Cézanne, properly called "the father of us all" by Matisse, opened up the whole idea of expressive perspective by manipulating spatial structures within the painting—an idea that eventually led to Cubism. Whatever one's reactions to the various schools of painting that followed, leading up to the contemporary scene, it's important to understand what these shakers and movers contributed.

In my classes I constantly refer to reproductions to explain the idea of flattening the picture plane. It encourages students to take chances and paint with a fresh eye if they can see how others have accomplished this feat. If I set a still life up on the floor, for instance, it helps them to see how Bonnard or Matisse might have handled a similar problem. The very act of placing objects on the floor gives you a freer choice of viewpoint than a still life arranged on a table, which tends to be static and uncompromising. The absence of a horizon makes the space more compressed, so you can place objects at the borders, as Bonnard and Vuillard did in their still lifes. Under the "normal" conditions of perspective, placing objects at the borders was always considered a no-no.

Flattening the picture plane can also liberate your sense of color because you're not tied to any rigid doctrine of atmospheric perspective. In my own case, I wage a constant battle to capture light in the pure sense of the word but keep the painting reasonably flat.

Flattening the picture plane may or may not appeal to your way of working, or seeing, but I think it's worth exploring so long as you feel comfortable with it. I wouldn't force it, however, if it feels unnatural to you, as these uncertainties will only show up in the final work.

STRIPERS ON THE GRILL
30" × 30" (76 × 76 cm)
courtesy of Barridoff Gallery,
Portland, Maine

In Domenico Veneziano's fifteenth-century Annunciation (sketched above), the two figures are placed in the architecture almost as if it were a stage set. The convergence of perspective lines toward the center door seen through the arch, leads the eye back into the picture space. This is typical of Renaissance use of perspective to deepen the picture space.

Although Sassetta has been labeled a fifteenth-century Italian "primitive," his ability to organize the picture plane is superbly evident in the view of the magi (below). The inaccuracies of perspective only accentuate the dramatic qualities of the story as the procession marches diagonally across our field of vision in a beautifully orchestrated design.

Learning from the Masters

Before World War II, Los Angeles was considered something of a backwater as far as art was concerned, and there wasn't much talk about flattening the picture plane when I started art school there. It was much later, during my Paris days, that I became aware of the principles governing the two-dimensional surface of the picture. I learned through my own stumbling investigations and also through the enlightened guidance of some older French artists I used to pal around with. Using the Louvre as a campus, I discovered a whole new set of revelations by viewing such early Italian masters as Giotto, Uccello, and Fra Angelico in a completely different light. By forcing myself to disregard the subject matter and story-telling content, it became abundantly clear how these artists were supreme manipulators of space; they used the same principles of two-dimensional design that I was discovering in Braque and Matisse.

The sketches shown here, drawn from fifteenth-century Italian and modern paintings, should help to clarify my discussion of flattening the picture plane in contrast to the use of perspective. What the sketches don't reveal, however, is the use of color, which often contributes to a painting's flatness, particularly with Matisse.

This sketch shows an early Matisse still life that belonged to Picasso and now hangs in the Louvre. Note how the tablecloth with the floral design has been tilted up and flattened into a two-dimensional plane. In viewing the original painting, it's interesting to see that, although the folds of the cloth follow the contour of the box-shaped table, the color and value of the cloth are painted flatly, in one plane.

In Braque's simple kitchen still life, the table seems to rest in a logical manner within the picture plane. The large, black shape of the stove, however, is tipped up onto a frontal plane so that we look down into the pitcher, frying pan with fish, leek, and spatula. This simple device, which is used over and over in Braque's paintings, is a result of his discoveries while experimenting with Cubism.

91

Flattening a Landscape

One of the reasons I'm so fond of Stonington is that it's built on a hill, with a lot of inviting, uncluttered roads to explore. On a ten-minute walk you can find hundreds of different viewpoints that could be evocative pictures.

For this painting, I chose an aerial perspective, looking down on the scene. This viewpoint has always fascinated me because it immediately tends to flatten the picture plane, adding a completely different dimension to the scene. Here I accentuated the flatness by making the curving street much steeper than it actually was.

In developing this painting, I reduced the buildings to a sweep of geometric shapes against the empty, sun-splashed street and tied the pale, high-key area of water down with a simple band of deep purple on top, obtaining a somewhat eccentric composition. Because I wanted to keep the painting simple and free of unnecessary details, I limited myself to three flat bristle brushes for the entire painting.

AN EXERCISE IN PERCEPTION

Most of my students find that it is easier to emphasize the two-dimensional quality of the picture plane when painting landscapes. This, I think, is due to the spatial ambiguities of landscapes in general. In a still life you're dealing with four or five feet of space in front of you, whereas in landscape painting the space is almost infinite. It's easier to rearrange, or move, something that's some distance, perhaps a hundred yards, away from you.

As an exercise, put away your viewer and draw the immediate foreground about ten feet away. Then let your eye move upward and draw the distant landscape at the very top of the page. Don't include the sky. Now readjust all of the areas in between, using flat shapes wherever possible. By experimenting with space in this manner, you help to destroy the horizontal stability of the landscape. In a sense, you have flattened the picture plane.

Admittedly, this exercise, while important in developing a broader sense of observation, doesn't always prove fruitful—nor would I want to impose it on every situation. Certain landscapes lend themselves more easily to this treatment than others. If you're sitting on a hill or have an aerial overview of the landscape, it obviously makes the job easier.

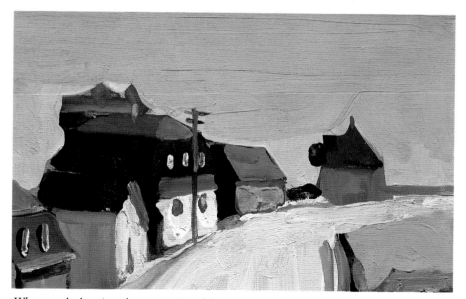

When you look at just the top portion of the painting, you can see how much the steep perspective adds to its impact.

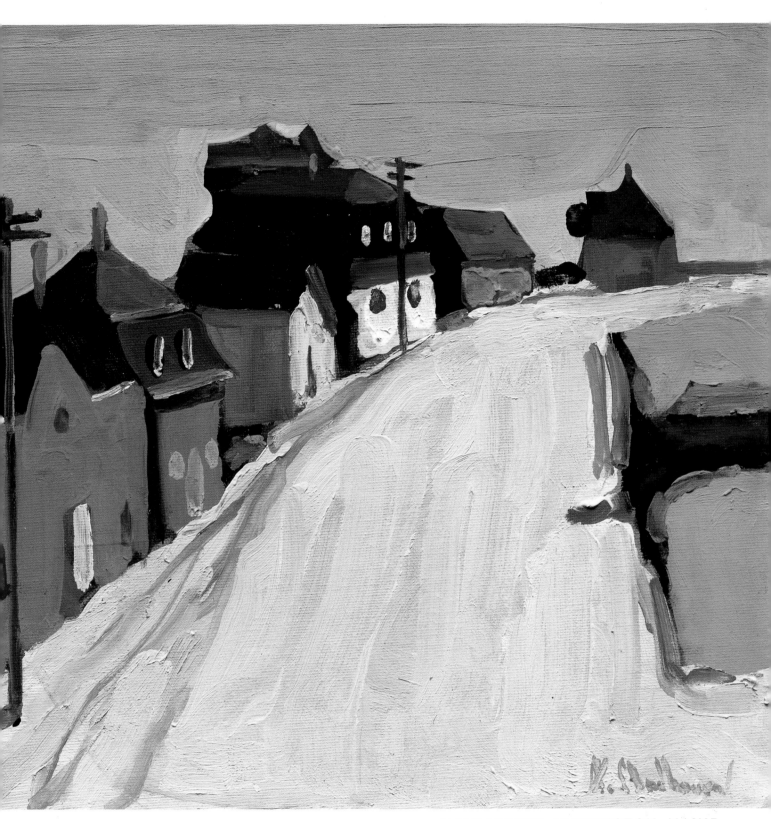

MAIN STREET, STONINGTON, MAINE
10" × 14" (25 × 36 cm)
collection of Marilyn and Gilbert Prawer

Choosing an Aerial Perspective

I have a friend who takes aerial photographs of places in Maine. Since I've traveled so many times up and down this peninsula, it was an unusual revelation to see the familiar ground from a bird's-eye view. I thought it was worth a gamble to see if I could transform one of his black-and-white photos into an effective and provocative composition.

It was summertime and, as Picasso would have said, "I felt green." So I decided to see what I could do with a large, flat painting of green fields and blue water, both of which have given me a lot of trouble in the past. Because it was a large painting, I used several two-inch housepainter's brushes to lay in the large, flat areas with thin washes of turpentine.

The first thing I did was to establish a relationship among the irregular shapes of the coastline, the flat planes of the fields, the vertical thrust of the road, and the angular directions of the piers. Notice, for example, how the vertical lines of the green fields in the foreground emphasize the strong upward movement of the pink road. I used the long pier on the right to create tension against all this vertical movement, preventing the verticals from falling off the bottom of the picture.

In developing the painting, I worked in several stages, so I could go over dry areas with other layers of paint while letting some of the original color show through. Technically, it's always a good idea to use thicker pigment as you cover one layer of paint with the next. This technique can be seen in the detail of the road.

The thickest pigment was used on the whites and off-whites of the scattered buildings, which I kept scraping out and moving around until I arrived at the pattern I wanted. Here and there I used fairly strong shadows on the road to break up and slow down its strong vertical pull. The water kept changing with the rest of the painting, until finally I added some black to the ultramarine blue in the darks to keep this area from jumping out of the picture.

It's always a bit difficult for me to analyze a large, expressive painting like this, as so many decisions are made on the spur of the moment. Even if there are pitfalls, it's sometimes a good idea to let intuition be your guide. Also, for those of you who haven't tried it, painting a large, 40-inch (102-centimeter) canvas like this one can be an exciting new experience, not just in terms of execution, but also in expanding your thinking about painting.

This detail shows a variety of greens. I did this painting shortly after a visit to Ireland, where I had been engulfed by all the shades of green. The vista gave me a chance to work with familiar subject matter while taking on the challenge of a "green" painting. For my green mixtures, I used lemon yellow, cadmium yellow, yellow ochre, permanent green light, Thalo green, and ultramarine blue.

Note the thin red showing through underneath the thicker pinks.

ALONG THE DAMARISCOTTA RIVER
40" × 40" (102 × 102 cm)
courtesy of Barridoff Gallery,
Portland, Maine

Backlighting for Flatness

Often I arrange still lifes for my classes against this window in my studio. When the class is over and most of the students have gone, my cat, Jefferson, emerges and plunks himself down among the objects to take a snooze in the sun. In this case, because his shape seemed to fit so comfortably with the other objects, I decided to paint him in the still life. Knowing that Jefferson wasn't going to stay put very long, I took advantage of his nap and made a couple of quick drawings, which I used as the basis of my composition.

One thing I like about painting against the light is that it tends to flatten the objects, so I can concentrate more on their design and shape than on their three-dimensional form. If you look at the dark shapes of the vase, bottles, brushes, jars, and cat, you will find that relatively little information is given about their volume. To be sure, there are a few light accents on the brown bottle, back of the cat, and top of the pencil sharpener, but basically these objects are seen as dark, flat shapes overlapping one another in a two-dimensional design. This flat design is enhanced by the fairly flat tone of the warm light in the window.

In developing this painting, the predominant element that attracted my eye was the bouquet of yellow daisies in the dark pitcher and how it related to the play of complementary colors in the bright orange tabletop and the strip of blue table on the right. Squinting at the jars of brushes surrounding the cat, I kept all of the values fairly dark, massed against the strong backlight coming through the window. As the composition began to develop, I pulled most of the weight of these dark objects to the right side, counterbalanced by the circular shape of the pewter plate on the left. Because I wanted to force the brilliance of the orange table, I took liberties with the color, making it much more intense than it actually appeared. In this way the violent contrast of the orange and blue tabletops would draw some of the attention away from the yellow flowers. Note that I repeated some of the bright blue in the pens and pencils in the foreground and in the thistles among the yellow daisies.

Most of the darks on the vase, cat, and jar of brushes were kept within the violet range, using alizarin crimson, ultramarine blue, and some yellow ochre. White was added to this basic mixture for the lighter violet tones on the pewter plate, the back of the cat, and a few additional lights. In general, however, I purposely avoided distracting highlights in these areas to keep things tied together in a large mass.

> **O**ne thing I like about painting against the light is that it tends to flatten the objects, so I can concentrate more on their design and shape.

CAT AND FLOWERS
ON STUDIO TABLE
30″ × 30″ (76 × 76 cm)
collection of Mr. William Ballard

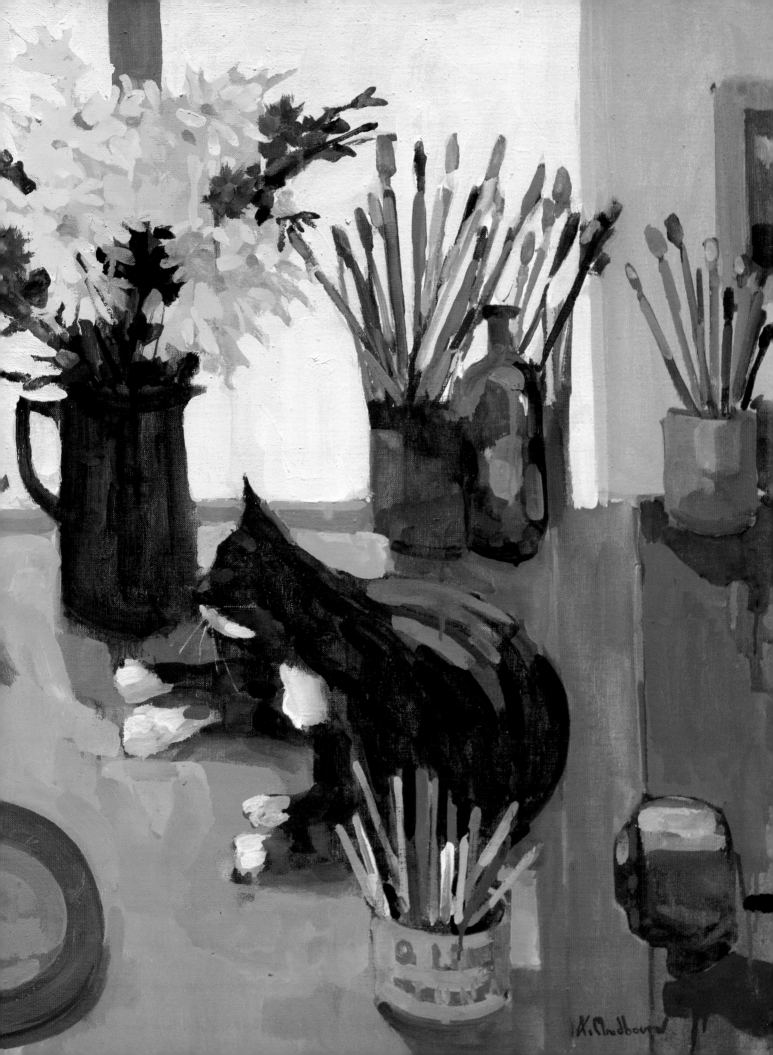

Looking Down on a Still Life

Over the past few years, I have taken several painting trips with my friend the painter Charles Reid, to his place in Nova Scotia. I always prepare myself enthusiastically for these trips, with lots of freshly stretched canvases and loads of paint, under the delusion that I'll come back with tons of new material to work from. Unfortunately, it doesn't always work out that way. First of all, it's usually drizzling or "soft," as the Irish say—a condition that seems peculiarly permanent in Nova Scotia. Second, I never seem to find anything that is really more paintable than my own surroundings in Maine.

It was on a typical gray day that I made the small pencil sketch shown here and started painting a small canvas of Charlie's kitchen table (not shown). We had come back from marketing and dumped the provisions on the table very much in the skeltered manner shown in the sketch. While Charlie was out braving the elements, whipping out his masterpieces, I struggled with the painting for three days. It seems insane to come back from an extended painting trip with only a still life to show for one's endeavors, but I suppose it has something to do with what appeals to our sensibilities. While I found the landscape a bit grim and barren, Charlie saw a certain quality of light that he transformed into beautiful paintings. On the other hand, perhaps due to my fondness for cooking, I found the cluttered table irresistible.

When I got home and started the large painting, I replaced some of the objects with pots and pans from my own kitchen and rearranged some of the elements into what I hoped would be a more cohesive and colorful composition. I already had established a steep perspective in the drawing, tilting the tabletop so it ran vertically up the paper. Now, however, I went further and placed all of the items on an old door on the floor of my studio, so I was actually looking down on the still life. This viewpoint helped me flatten the objects on the picture plane.

As in most of my paintings, I worked directly on the canvas, moving around from one object to the next, trying to keep the color as fresh and spontaneous as possible. The red pot, yellow-green lettuce, and wine bottles were added for their color and pattern, as a contrast to the light table. As the light from my studio window kept shifting, I made some adjustments to the background, adding a strong diagonal shadow, which lends emphasis to the table. Also notice how I used the blue handle of the spoon and dark handle of the kitchen knife to break up the strong vertical pull of the tabletop.

One of the nice things about painting a mass of cluttered objects like this is that you don't have to get bogged down in too many details or worry too much about the accuracy of your drawing. You can feel much freer as you paint than with a more formal arrangement, such as a Chardin still life, where the slightest movement of an object may affect the entire balance or serenity of the picture.

In this regard, I should mention that I have always been attracted to Bonnard's casual, almost accidental arrangements, in which the objects seem just left on their own, placed on the table without any preordained order. A similar unorganized clutter can be found in the early still lifes of Matisse, the later paintings of Vuillard, or, more recently, the works of Fairfield Porter. It's marvelous how objects left casually on a table after a meal can have an immediacy and psychological attraction that lures us into a painting. Seen by Bonnard, these everyday remnants take on a certain monumentality. Or, as Fairfield Porter said of Vuillard, "What he's doing seems ordinary, but the extraordinary is everywhere." It's a point worth remembering the next time you're searching for a still life subject—give that breakfast or kitchen table a second glance.

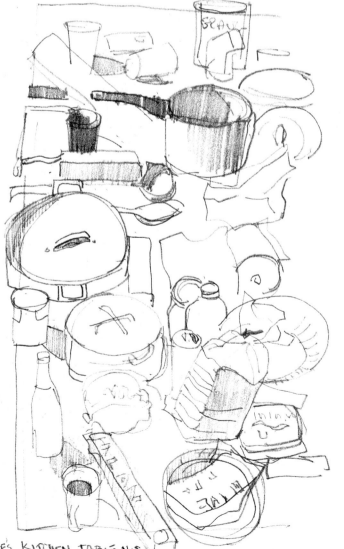

CHARLIE'S KITCHEN TABLE N.S. 27MAY76

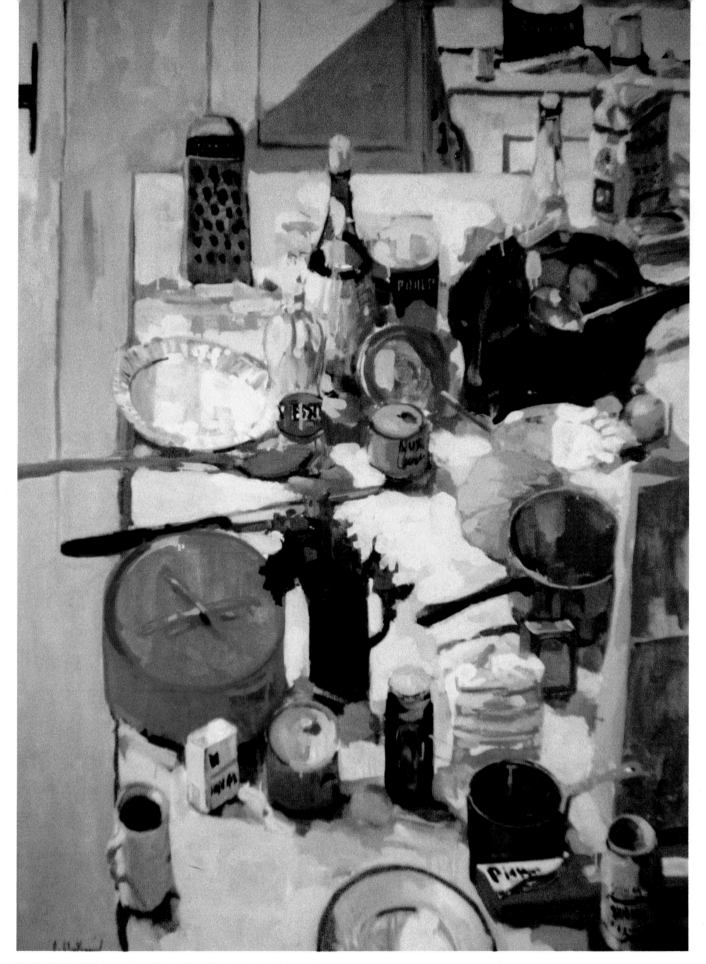

KITCHEN TABLE *50″ × 30″ (127 × 76cm), collection of Mrs. Nancy L. Payson*

PAINTING
BEACH SCENES

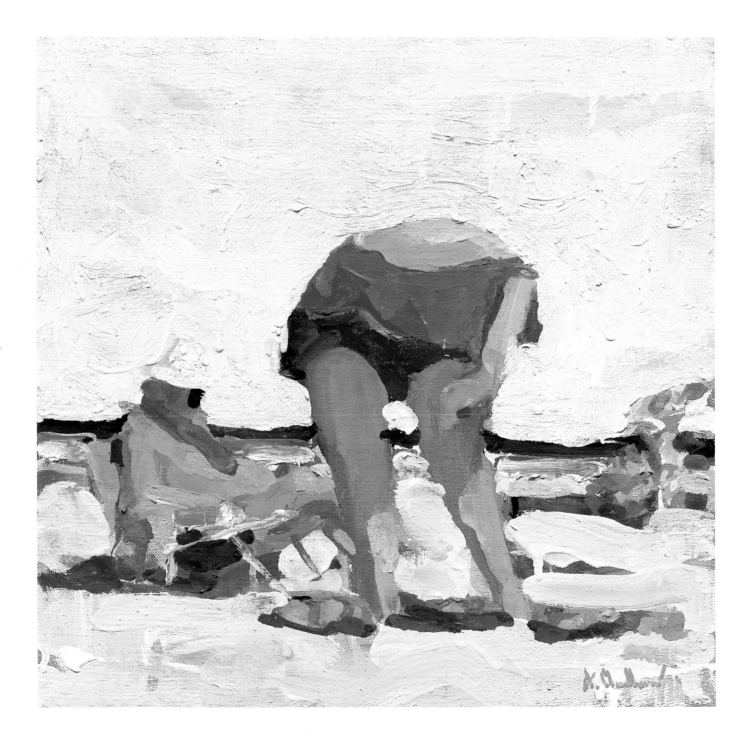

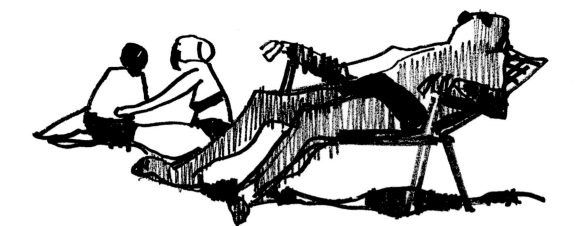

I am what my friend Edgar Beem, a Maine writer, calls a "thalassopsammophile," from the Greek *thalassa* (sea) and *psammos* (sand). A sea and sand worshiper. My fetish for hot, sandy beaches by the sea probably comes from having spent a good part of my youth on the Riviera and those great surfing waters of southern California. Living in Maine, I find this craving increases during our only two months of summer. Unless there are other pressing problems in the studio, it's a safe bet you'll find me at the beach when the sun is up in July and August.

Because beaches offer such an incredible variety of human shapes and forms, I find it handy to carry a small sketchpad or sometimes a small watercolor box. Another reason for drawing figures at the beach is that there is some reason for their "nudity." That's why I've found the nudes so compelling in the works of Bonnard, Vuillard, Toulouse-Lautrec, and Degas—because the figures are in the act of doing something: putting on stockings, carelessly lounging or washing in the studio, or endlessly climbing in and out of bathtubs. This doesn't in any way negate the rewards of painting posed nudes, but if you don't have access to a life class and you want to experiment with color and pattern, there is no better way than to try a few beach scenes of your own.

If you're not blessed with a beach nearby, you could substitute lake or swimming pool scenes, or maybe cut out beach scenes from travel magazines. I keep a large folder in my files crammed with a hodgepodge of beach-related material, just in case my own store of sketches runs dry and I want to experiment with something new and different.

In terms of color, I can think of no other subject that suggests so many ways to push one's color as far as it will go. All the crazy patterns of bronzed bodies, bright swimsuits, towels, and beach umbrellas, combined with sea, sand, and sky, offer the painter a spectacular range of color.

You don't, by the way, have to be a master draftsman to create a beach scene. Not long ago several of my faithful students and I had lunch together while pouring over half a dozen art instruction books. One salient, overriding issue that emerged was that my students felt that most of the drawings and sketches were far too sophisticated for the average amateur painter. While they admired the artist's facility, they felt inhibited from competing on this highly professional level. It's with this feeling in mind that I've included my simple sketches with my beach scene paintings—to show you that a sketch doesn't have to be "perfect" or even "good" to be useful as a preliminary study for a painting.

All the sketches shown in this section were done with a drawing pen, such as a Pentel or Penstix. I generally use a worn-down Pentel for grays or put less weight on the paper while adding a tone. If making value scales with a pen seems too difficult, I would suggest using a soft 4B pencil or a carbon pencil, which both give you an unlimited range of values.

LADY AT THE BEACH
18″ × 18″ (46 × 46 cm)
courtesy of Barridoff Gallery,
Portland, Maine

Since I was composing in a rectangle, I started by drawing in the lifeguard stand; then I divided the picture plane by establishing the diagonal of the water. I added the figures in no particular order, just dropping them in as quickly as I could to set up a pattern of busy shapes against the sky and sand. When you work quickly like this, it doesn't give you any time to pause and carefully model the figures—which is just as well, since the whole idea is to create an overall impression of the scene.

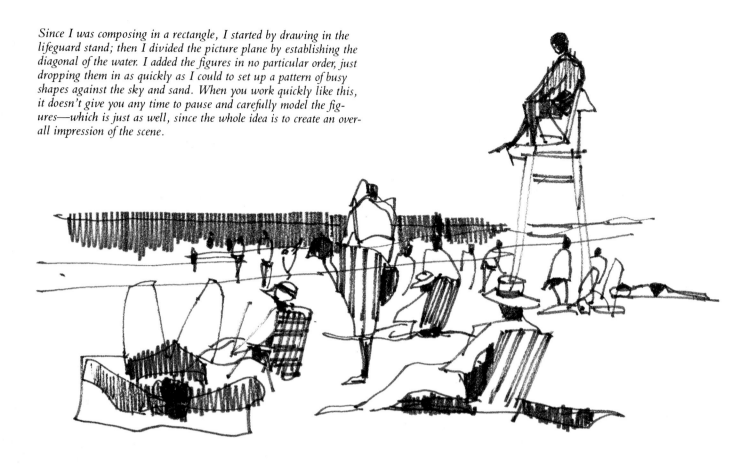

Translating Sketches into Paint

Scarborough Beach is a lovely three-mile stretch of sand about thirty minutes from my house in Yarmouth. It's basically a family beach, with a full gamut of age groups offering a wide variety of body sizes and shapes for sketching.

My painting is composed from several five- to ten-minute sketches, scribbled on a small sketchpad (6 x 9 inches, 15 x 25 cm) as I sat in a beach chair watching the colorful array of human activity pass in front of me. Later, in the solitude of my studio, I was able to pick and choose at will, readjusting certain figures, until I felt I had orchestrated a mass of color and shapes that resembled the scene jotted down in my brief sketches.

I enjoy painting sketchy figures like these as it allows me to mess around with rich pigment, using just a few brushstrokes to describe legs, arms, and torsos while pushing for a strong color pattern as I move around the canvas. That doesn't mean that everything falls into place the first time around. On the contrary, there was a lot of scraping out and repainting until I felt comfortable with the entire structure of the picture.

If you look at the two central figures—the lady in the beach chair with the yellow hat and the male figure with the white hat—you can see that only two basic values were used to describe them. If you compare these figures to my original sketches, you can see that I used the same simple shapes, only now they have been translated into pigment.

The mixture I used for these figures—the same one used throughout the painting—is Thalo red rose, cadmium orange, and white in the light-struck areas, with a little ultramarine blue added to darken the figures. By varying the amount of white, you can get lighter and darker tones, as you see fit. I like this particular mixture be-cause it has such a hot, vibrant tone and can be easily diversified with different amounts of white. Other mixtures you might experiment with for flesh tones include: (1) cobalt blue, alizarin crimson, cadmium yellow, and white; (2) Thalo green, alizarin crimson, cadmium orange, and white; or (3) cadmium red light, yellow ochre, cobalt blue, and white. As a general rule, I avoid mixing more than two or three colors (and white). Also, I avoid earth colors such as burnt sienna, raw umber, and raw sienna for flesh tones, as they tend to become muddy and opaque.

The overall pattern should be obvious: a group of dark figures against a light, sandy beach. The dark sky and water then help to force this pattern further, particularly when seen against the almost pure white shapes of the surf and lifeguard stand. I doubt that anyone has ever seen a sky quite this intense in Maine; it's probably closer to a Mediterranean blue. But this is the kind of liberty I believe in taking for the sake of the painting. It's what works in the painting that counts.

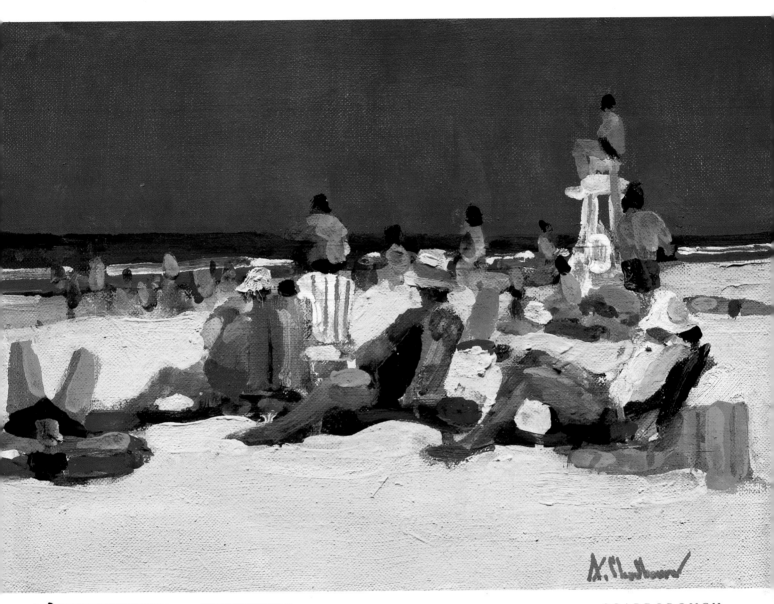

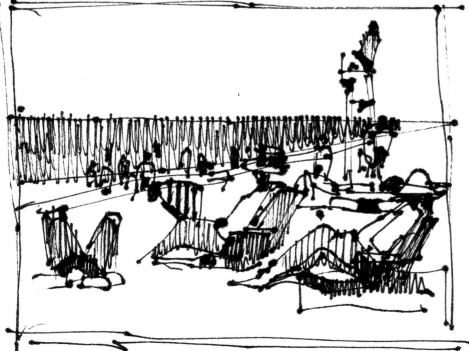

SCARBOROUGH
BEACH, MAINE
12" × 18" (30 × 46 cm)
collection of Mr. and Mrs.
David Swardlick

Giving Color Energy

This painting was done from a couple of photographs I took during a visit to Cape Cod several summers ago. The photos weren't very good, but there was enough information to get me started on a small canvas, trying to incorporate what I remembered about this quiet, uncluttered beach. There is something very relaxing about sitting on a beach on a Sunday morning before the crowds arrive and watching the early birds settle into choice spots.

To create a feeling of light within this picture, I purposely avoided a conventional light source. Instead, the shadows are primarily arbitrary shapes of color seen against the warm yellow sand. Notice the effect of halation—the vibration at the edges of brightly illuminated objects. You may have observed that the longer you stare at an object, the more it seems to pulsate. Matisse and the Fauves were aware of this phenomenon, which led them to a new, purified form of color painting, in which light and shadow were rendered by contrast of hue, not tone. Incorporating these principles, I saturated the shadows in this painting with ultramarine blue and violet, with some pure cadmium red light on the edges of the shadows underneath the seated man. This is what Wayne Thiebaud has described as "energizing the color." It's another way of intensifying the colors of nature in accordance with the painter's perception, so the artist is not imitating nature, but making the painting alive with color and energy.

There were other changes I made in what I saw. The man sitting on the right, for example, was sitting under the shade of an umbrella, but when I put in the strong shape of the umbrella, it dominated the sky—so I took it out. It probably seems incongruous to leave him sitting in the shade with no explanation of what's causing the shadows, but I rather liked the shapes on the dark robe. I left it that way as it helped the overall pattern of dark, colorful shapes against the warm, sunlit beach. There was also a gray stone retaining wall in the background, which I changed to a pink strip—again taking liberties with my material. I think it's important for you as a painter to take similar liberties with your subjects if this enhances a pictorial idea or advances a more abstract configuration.

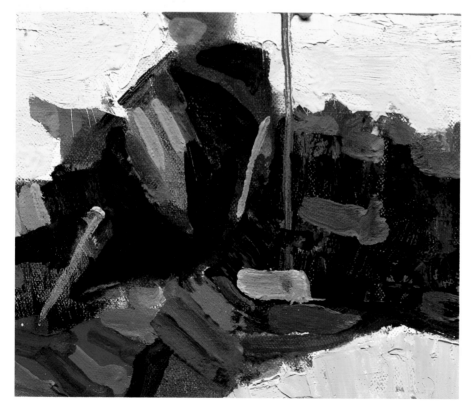

Notice how the shadows are not just dark—they are alive with color.

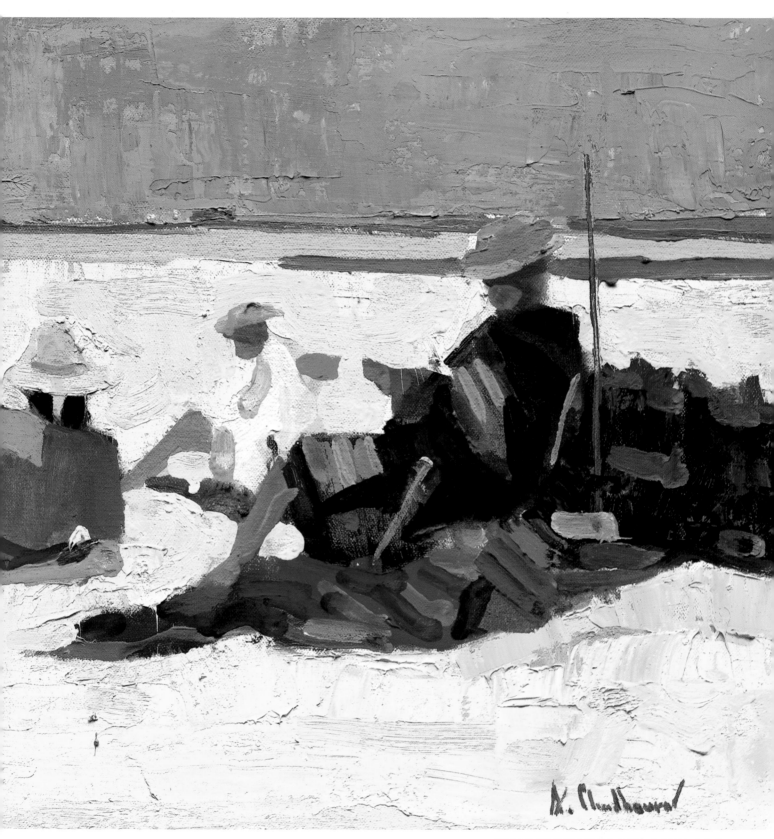

WELLFLEET BEACH, CAPE COD
10" × 14" (25 × 36 cm)
collection of Dr. and Mrs. Daniel Miller

Selecting Simple Poses

The first thing that attracted me to this scene was the girl's long horizontal shape, lying motionless on the stretched-out beach chair. While I was sketching her, there was a lot of activity behind her, with figures moving in various directions—all of which made a good foil for her prostrate position. I finally chose the large shape of the lady bending in front of the umbrella, as this offered a good, simple design element. Then I added the three small figures in the distance to introduce more scale to the painting.

The lights and darks in this painting went through many trials and adjustments before I settled on the solution you see. To obtain a high-key, sunlit effect on the prone figure, I had to darken the blue of the sky considerably, making for a better value contrast. I also forced some of the cast shadows underneath the chair and suggested halation by placing some cadmium red light along the edge of the dark blue. Then, for the sand, I added the thick, pink pigment.

If you're apprehensive about doing beach scenes, take another look at the simple poses suggested in this painting. I'm sure there are many inaccuracies in these figures, but somehow it doesn't bother me too much if the total impact works. Pick out two or three simple figures from your sketches or photographs and reduce the entire design into large, massive shapes. You'll soon discover there are endless possibilities within these limitations.

Accuracy is not essential to good painting. I remember a French painter I admired pointing out that one of Bonnard's elongated women in a bathtub would be eight feet tall if she ever stood up. But it didn't seem to matter, as the whole illusion of a nude floating in sensuous color was so incredibly evocative. Obviously we can't all paint like Bonnard, but perhaps we can simulate his thinking by standing back from the easel and asking ourselves: What's the big, overriding consideration of the painting? As one of my former teachers used to put it, "Look for the big picture."

These rough compositional sketches are more or less typical of the type of sketching I do during odd moments at the beach. I probably should have spent more time developing the girl's body, but I was fairly close and was terrified that she would suddenly wake up and accuse me of voyeurism. As you can see, sometimes I jot down color notes as a reminder, even though they may change during the development of the painting.

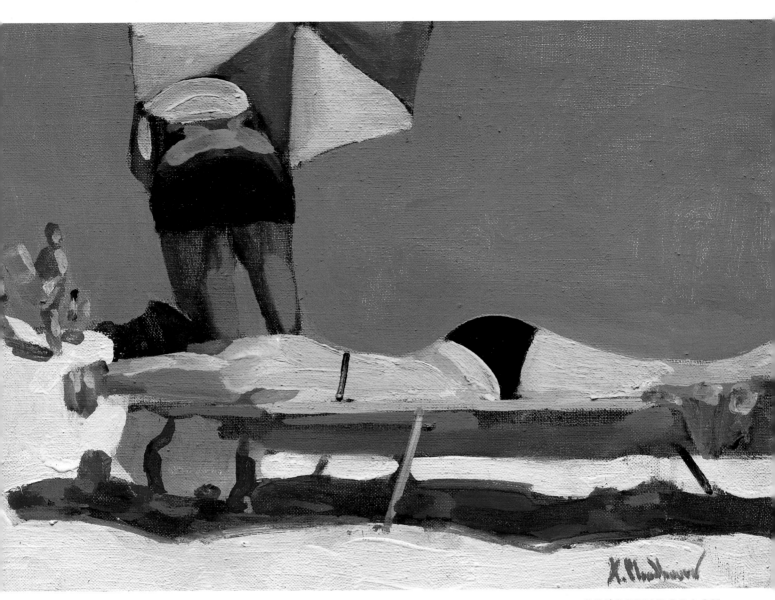

CRESCENT BEACH
12" × 18" (30 × 46 cm)
private collection

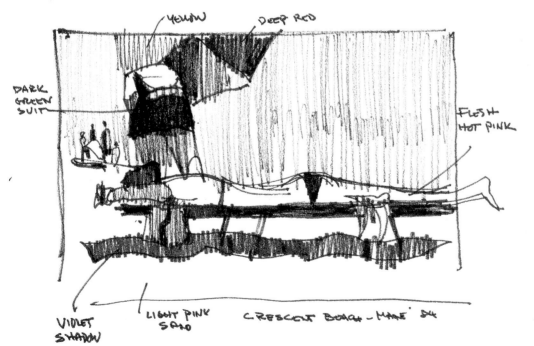

YELLOW

DEEP RED

DARK
GREEN
SUIT

FLESH
HOT PINK

VIOLET
SHADOW

LIGHT PINK
SAND

CRESCENT BEACH - MARE' '84

Conveying Strong Sunlight

Sometimes it's hard to explain why the eye, roving over the scene, suddenly stops and commands the hand to the sketchpad. In this case maybe it was the color of the orange towel that attracted my attention, or perhaps the relaxed position of the two figures surrounded by the shimmering sand.

In any case, as I worked on the painting in my studio, I decided to rivet attention on the two figures and the small blobs of bathers by the shore by raising the horizon and eliminating the sky. This helped to flatten the picture plane; it also simplified the design, making the dark band of water a foil for the large area of hot pink sand. I have always been fascinated at how the picture plane can be completely transformed by lowering or raising the horizon. You might try painting a landscape without a sky to see how it flattens the picture plane.

In terms of the light, you may notice some inconsistencies in this painting, but I felt these were justified in my quest to convey the heat of a sunny day at the beach. I was more concerned with creating a sense of light coming from the picture than with describing any light source in the normal sense. The all-dark male figure, for instance, may seem inconsistent, given the areas of strong light on the lady. But I felt this dark shape made a better contrast if it was kept simple.

Note the use of halation in the shadow of the orange towel, where a strip of pure cadmium red light is juxtaposed against a strip of light ultramarine blue. Because of the central activity of the two figures on the towel, I kept the sand as simple as possible, using a thick mixture of white and Thalo red rose. These thickly painted horizontal strokes were dragged right over and around the figures, more or less confining them within the vibrating light.

It was tempting to use a bright color for the circular beach umbrella, but a strong color note would have taken away from the interest of the two main figures. To reinforce the contrast between the dark upper portion of the water and the warm colors of the sand, I used simple horizontal strips of dark blue and white for the surf. Single strokes of warm tones were then enough to suggest the bathers.

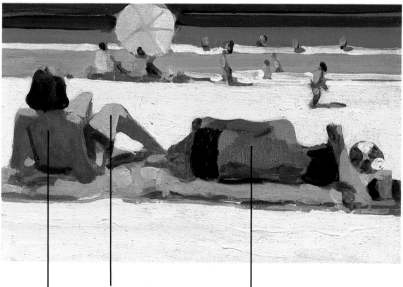

Thalo red rose + cadmium orange + white

Thalo red rose + cadmium yellow + cadmium orange

yellow ochre + ultramarine blue + alizarin crimson + (+ some white)

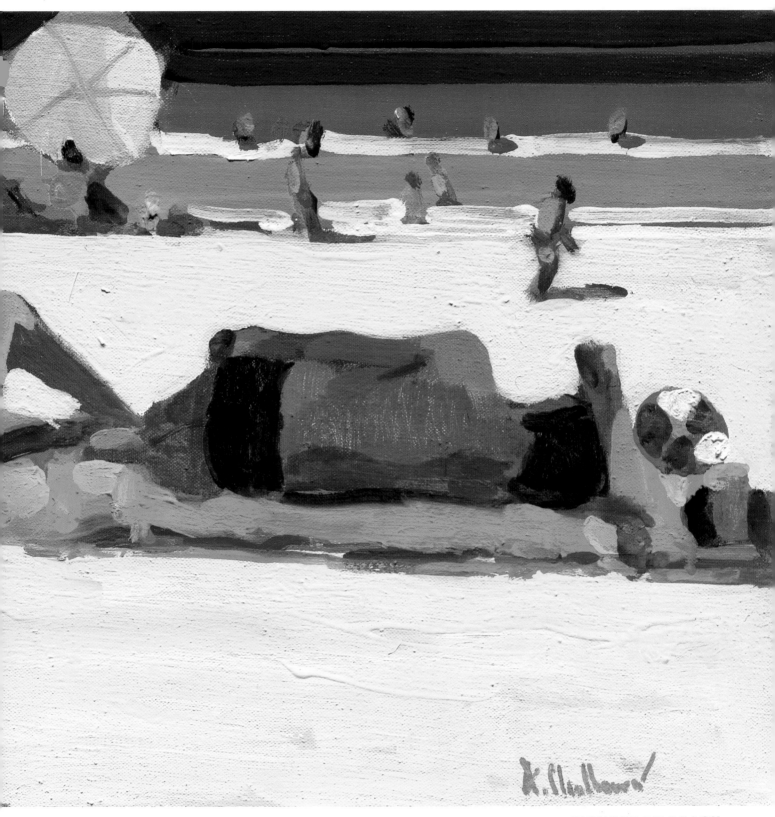

FIGURES ON BEACH
10″ × 14″ (25 × 36 cm)
private collection

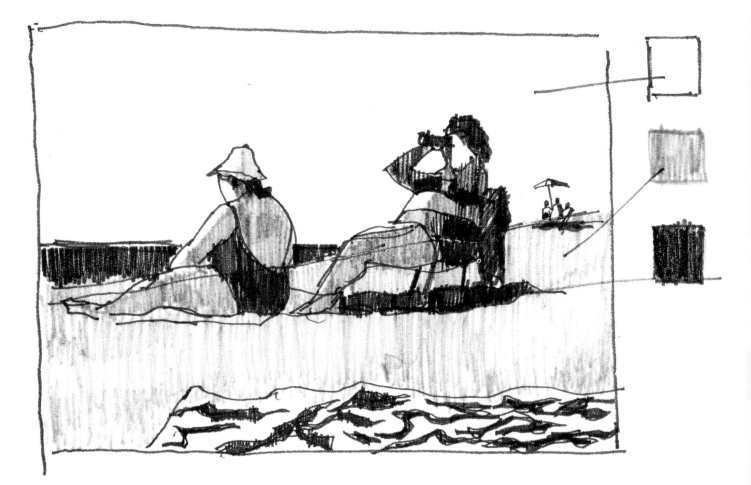

Working with Unusual Colors

This simple composition is based on some sketches I found while leafing through my sketchbook. My goal was to create a strong painting using two or three large shapes, maybe three or four values, and an untried color theme. Because I wanted to keep the painting flat, I didn't model any of the forms too much or show depth in the sand, sky, and water.

As you can see from my sketch, I used only two values to describe the figures. In the darker areas I mixed cadmium orange, Thalo red rose, and white, and then added more white for the lights. But I don't have any preconceived color formulas for painting flesh tones on the beach. As the lighting varies with each painting, I am guided more by what instinctively looks right for the painting. The one general rule I'd mention is that flesh tones at the

beach will appear darker than the sand on a bright, sunlit day.

After establishing the dark shapes of the two large ladies, I painted the entire beach with cadmium orange, straight out of the tube. At this stage the painting looked like a colored diagram, so I added a beach towel with a simple design to anchor the foreground area. Next came the small, dark wedge of pure ultramarine blue for the water, repeating the color of the swimsuit. Through these color and design choices, the painting began to take on depth, without any three-dimensional modeling.

Originally I painted the sky a light cerulean blue, but it was too bright so I repainted it a warm white, mixed with a small amount of cadmium red light. If you look closely, you can see some of the original blue showing

through this overpainting, which gives it an added dimension. Then, by introducing the small umbrella and tiny figures in the distance, I helped to give the large figures more scale and the picture an immediate sense of depth because of their diminished size.

If I had been Matisse or Milton Avery, I suppose I could have left the painting alone at this stage. But somehow the picture looked unfinished and inept, so I got out a large brush and started repainting the sand with various mixtures of white, cadmium orange, and cadmium red light until it became an offbeat color I don't usually associate with sand. Much as I admire some of Matisse's thinly painted masterpieces, I have come to the painful conclusion that his way of painting doesn't always work when I try it. What started out as a simple composition actually took a whole week of readjusting the colors and values until I felt the painting captured the effect I was after.

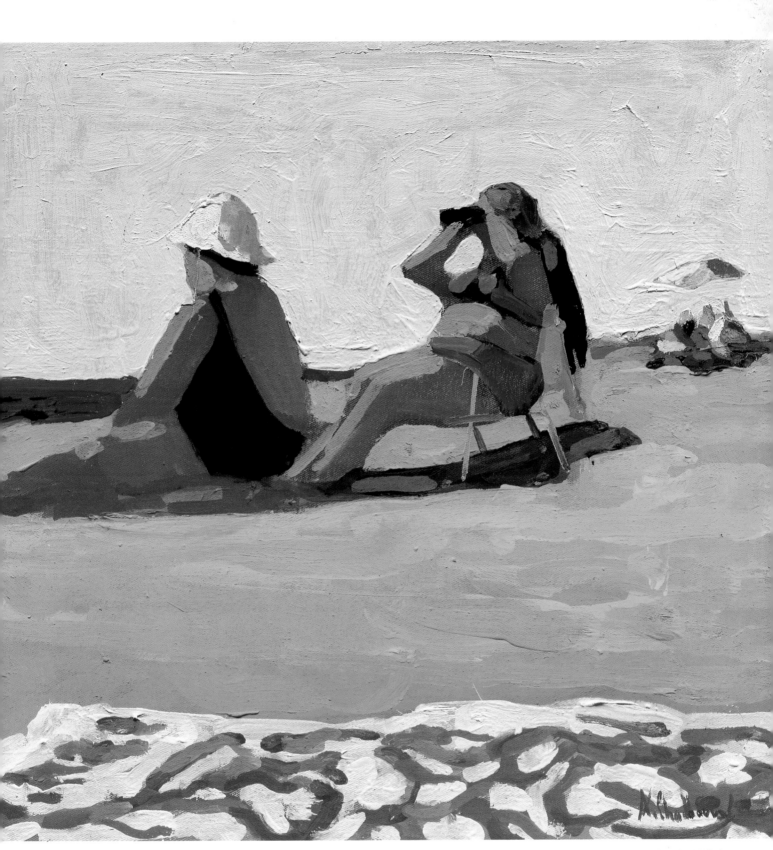

WEIGHT WATCHERS
16" × 16" (41 × 41 cm)
courtesy of Barridoff Gallery,
Portland, Maine

The sketch on top of the facing page is probably more of a diagram than a drawing, but what I want to demonstrate here is the importance of translating values into color. By comparing the drawing and the painting, you can see that the whole scene is based on three values. No matter how complicated a scene may appear, if you get into the habit of breaking it down into a basic value scale it will help to simplify the painting process.

PAINTING
A CITYSCAPE

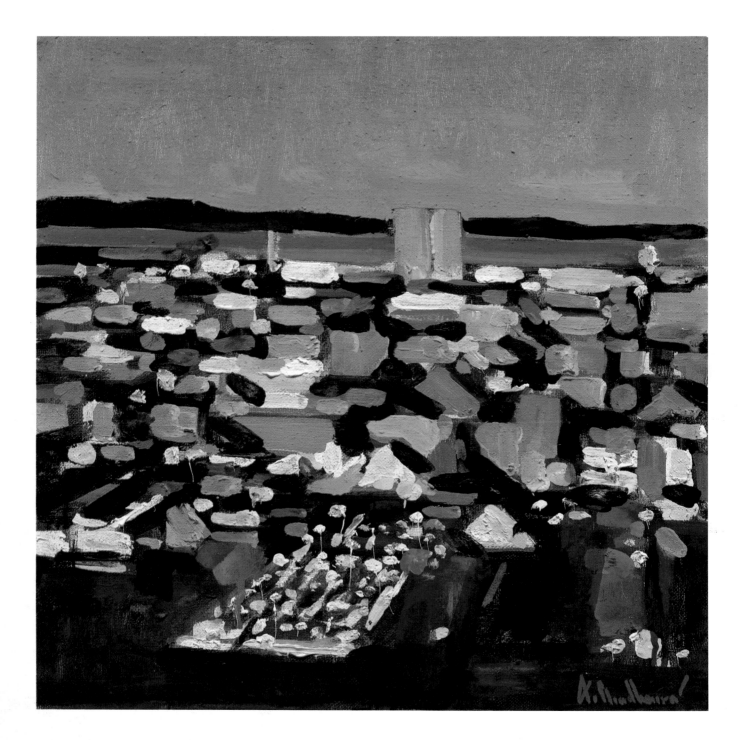

I have always been surprised that students don't paint more cityscapes. Cities tell us so much about ourselves. You can see our architectural heritage, as well as the kinds of buildings we live and work in. There is also outdoor advertising, which lends a rich variety of design elements to the ever-changing panorama. Yet when I proposed painting the city of Portland to my class, they seemed dumbfounded by the idea. Part of their apprehension lay in the preconceived notion that painting a city automatically demanded an elaborate understanding of perspective and was thus beyond their capabilities. After calming their fears, I found a vacant lot, high on a hill, with the whole city of Portland at our feet. After several false starts, the class finally warmed to the idea and produced some remarkably original paintings.

Probably one reason people shy away from painting cities is that it's not always easy to find a comfortable place to paint. Some of the best views I've encountered were when I was whizzing through a city on a crowded, elevated throughway, with no possible means of stopping. Just a brief glimpse through a car window and then it vanished. I suppose if one were courageous enough to perch oneself on a guard rail, one might do a quick sketch or take a snapshot—but I've never tried it, for fear of being blown away by a huge truck.

If you have difficulty in finding good locations to sketch from, I have a few suggestions. In almost any city you can find a parking garage with ample room on the top floor. Or, if that view doesn't work, try asking someone in a bank or tall office building to let you reconnoiter the vistas from the top floor. With a little persuasion, I have found that most people will respond sympathetically to such a request. Another source of all kinds of material is the photo file of the local newspaper, where they will make a photostat or some other kind of copy of the photograph for a minimal fee.

If aerial perspective seems too complicated or you have difficulty in translating from photographs, there is certainly nothing wrong with walking around town with a sketchpad in your quest for subject matter. Remember that a sketch, no matter how clumsy it may appear, will always give you an immediacy and a personal sense of place that no photograph can.

VIEW OF PORTLAND
14" × 14" (36 × 36 cm)
collection of Mr. Edgar Beem

Sketching in Watercolor

These watercolors are examples of the type of sketching I do primarily for my own amusement. I seldom use them for information in conjunction with my oils, as I find the transparent quality of watercolor is almost impossible to transfer into the opacity of oil painting. Years ago, when I was working with Dong Kingman at the Famous Artists School in Connecticut I used the medium much more frequently than I do now. And, much as I admire the works of Homer, Bonington, Wyeth, and Reid, to name a few, I have never felt completely comfortable or confident with using watercolor as my medium.

Both these sketches were done on Fabriano 140 lb. watercolor paper, using a small Winsor & Newton watercolor box with block colors and just one brush—a no. 12 sable. With this kind of sketch, I usually start with a light pencil or pen drawing and work more or less directly, just putting down the colors as I see them. Since it's basically a sketch, I vignette the image rather than trying to fill in all the borders of the picture. Notice that I try to use the transparency of the white paper as an integral part of the overall design.

BLUE BOY BOOK, PORTLAND, MAINE
watercolor, 16″ × 20″ (41 × 51 cm)
collection of Miss Jessica P. Chadbourn

"Blue Boy Book" was Portland's only gay pornographic bookstore, until the authorities closed it down last year with a lot of hubbub in the local press. It stood forlornly empty in a beautiful old building, surrounded by vast excavation sites and parking garages. The brilliant blue door reminded me of the shopfronts one sees all over Ireland.

HARBOR LUNCH *watercolor, 24" × 24" (61 × 61 cm), collection of Dr. and Mrs. Daniel Miller*

The "Harbor Lunch" is a type of place that is becoming harder and harder to find in Portland, due to the grinding forces of urban renewal. It used to be a favorite haunt of fisherman on the nearby wharf and served one of the best clam chowders in town. It disappeared in the masticating teeth of bulldozers last year. While I was sitting on the curb working on the sketch, an old-timer, noticing the rumble of advancing bulldozers four blocks away, said, "Once they clean up Portland, there ain't going to be much left for you fellers to paint." Sad but true.

Transforming a Mundane Scene

This is a familiar scene I pass every time I go to the fish market in Portland's harbor. One day, while my class was painting a section of the old wharfs in Portland, I did a small sketch of this scene. What caught my eye was the light-struck yellow building amid a variety of luminous darks—that was enough of an impetus for a painting.

Back in my studio, I fooled around with some compositional sketches to make the subject gel as a pictorial idea. Except for the black-green building next to the yellow, which made a sharp color contrast, the rest of the buildings in the actual scene seemed undistinguished, so I made some changes. I couldn't see the church from where I made my original sketches, but I added it to the upper right because of its unique shape and complementary color contrast of red and green. I also changed the red-brick buildings behind the yellow building, exaggerating their color into a more intense red.

I kept the foreground fairly simple, only suggesting a few lights on the pilings and the workboat, as I didn't want to draw too much attention away from the buildings. Painting this area with various deep, cool violets and blues helped to anchor the base of the composition and made a dramatic color contrast to the yellow building.

Note that I added a light yellow strip on the light-struck side of the yellow building to emphasize the light source. To further express the feeling of late afternoon light, I placed deep mauve shadows against the hot, pink shafts of light on the street leading up to the church. Finally, I chose a flat, light blue sky to offset the irregular shapes of the buildings in the background and repeated this blue in the horizontal strip in the foreground water.

Every time I revisit this scene I realize that it doesn't actually look quite the way I painted it—because, I suppose, of my tendency to overdramatize my subjects. On the other hand, I find that this is part of the painter's challenge—to transform a rather banal, undistinguished scene into an evocative pictorial statement.

WHARF, PORTLAND, MAINE
18" × 12" (46 × 30cm)
collection of Dr. and
Mrs. Daniel Miller

The varied colors surrounding the yellow building add to the interest of this area of the painting, without detracting from the impact of the yellow itself.

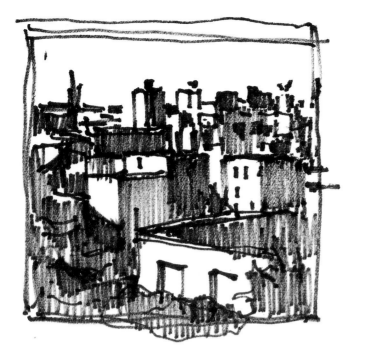

Pushing the Value Contrast

When I paint a rooftop view of a city, I'm invariably reminded of those incredibly beautiful watercolors Edward Hopper did from his roof on Washington Square in the twenties and thirties. Hopper said that it took him ten years to get over Europe, and I felt much the same when I arrived in New York in 1952. I kept comparing the sun-dappled countryside of Provence to the sad desolation of our urban landscape and felt completely at odds with my environment—until I discovered what Hopper had created with such honesty. I don't think I could have painted a picture like this thirty years ago due to my blind indifference to this type of subject matter.

This picture was painted from a very poor photograph I took of Portland several years ago. The undistinguished forms in the black shadows made it impossible to see what was going on in the foreground. There was, however, a certain late afternoon light that I found captivating. What I tried to do was to give the mundane buildings a jewel-like quality by pushing the warm color of the light-struck areas against some rich, luminous darks. Although I got a little carried away with some of the thick paint in the sky, this does relate to other thick textures in the buildings.

As I worked, the overwhelming consideration of the composition became the pattern of lights and darks on the buildings. In the painting the strong, late afternoon light is coming from the left, casting shadows to the right. Some shadows, however, are more prominent than others. The light, square building on the right, for instance, is fairly realistically painted, with a warm, yellowish white side in sunlight and a cool, bluish tone on the dark side. The light yellow building in the foreground, on the other hand, has a much darker, almost deep violet, shadow side. The impulse to create this deep shadow probably came from wanting a rich, juicy dark against the red brick building in the foreground.

Conflicts with reality often occur when I decide to take a few liberties with nature, but here—in my pursuit of a strong pattern—the inaccuracies seemed justified. If we closely scrutinized many of Van Gogh's paintings, I'm sure we could find discrepanices, but that doesn't lessen our enjoyment or emotion in viewing them. Very often a shape will be added to a painting because it feels right in developing the composition, whether or not it has anything to do with the reality of the scene. The more you paint, the more you become aware that a painting has certain dictates of its own.

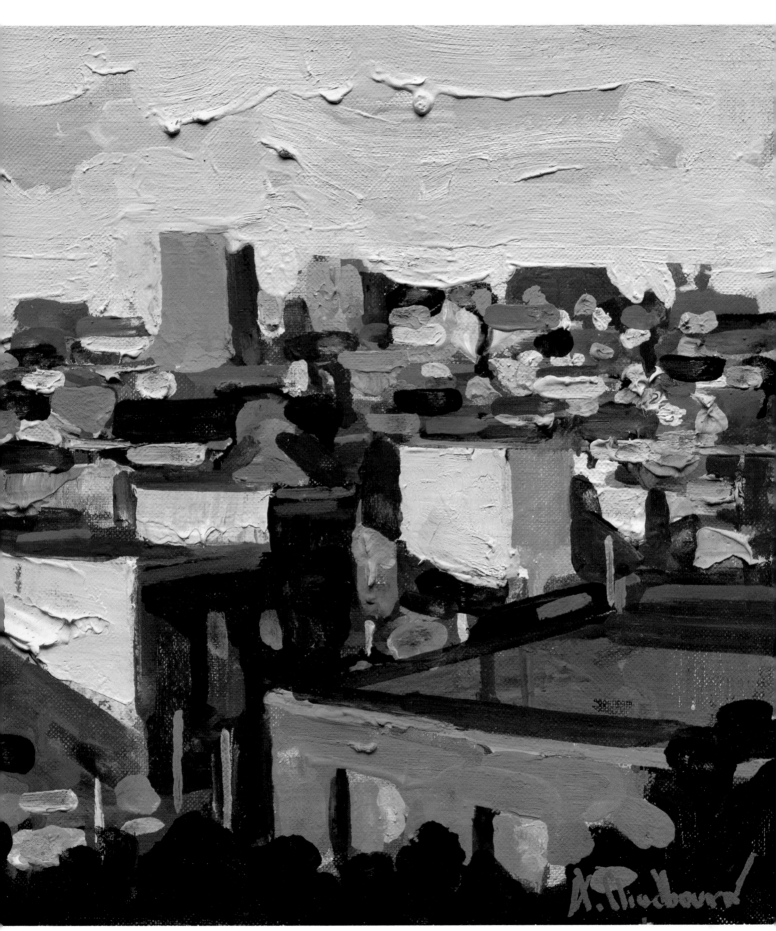

ROOFTOPS, PORTLAND, MAINE *18" × 18" (46 × 46 cm), courtesy of Barridoff Gallery, Portland, Maine*

Painting without Perspective

Robert Frost once said that "writing free verse is like playing tennis without a net." And, in a very real sense, that's the way I feel about painting a picture without perspective. In this view of Munjoy Hill in Portland, you can see that little, if any, attention was given to perspective.

Munjoy Hill has always been a closely knit ethnic neighborhood. With its landmark observatory and cluster of brightly painted working-class homes, it is one of my favorite scenes in Portland. For this painting, I was looking down at some railroad tracks, so the freight cars form a colorful horizontal bar beneath the pattern of geometric houses on the hill, with the observatory dominating the horizon. In terms of perspective, note that the two parallel streets seem to expand as they go back, rather than converging toward a vanishing point. Liberties like this were taken to flatten the picture plane and to capture the essence of the scene, rather than simply making a

factual statement of what I saw in front of me.

Although there is a strong suggestion of the light coming from the left, casting deep shadows on the streets, I used these shadows primarily as shapes to fit in with the overall pattern and design of the painting. When I painted the sky, I wanted a flat, luminous light blue to strengthen the feeling of light behind all the dark buildings. Since a brush didn't give me the effect I was after, I piled on the paint with a painting knife, using large flat strokes, as though I were painting a wall of light. Then I added other painting-knife textures in the light-struck areas of the streets and sides of the buildings, which enhanced the effect of sunlight. The final adjustments were made on the brilliant colors in the halftones of the buildings, forming a series of rectangular shapes piled on top of one another. I also left out all the windows, as they only detracted from the semi-abstract quality of the cubistic houses.

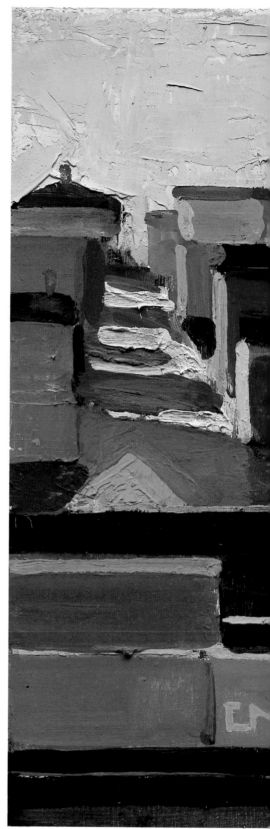

Focusing on a detail like this reveals the abstract geometry of the houses.

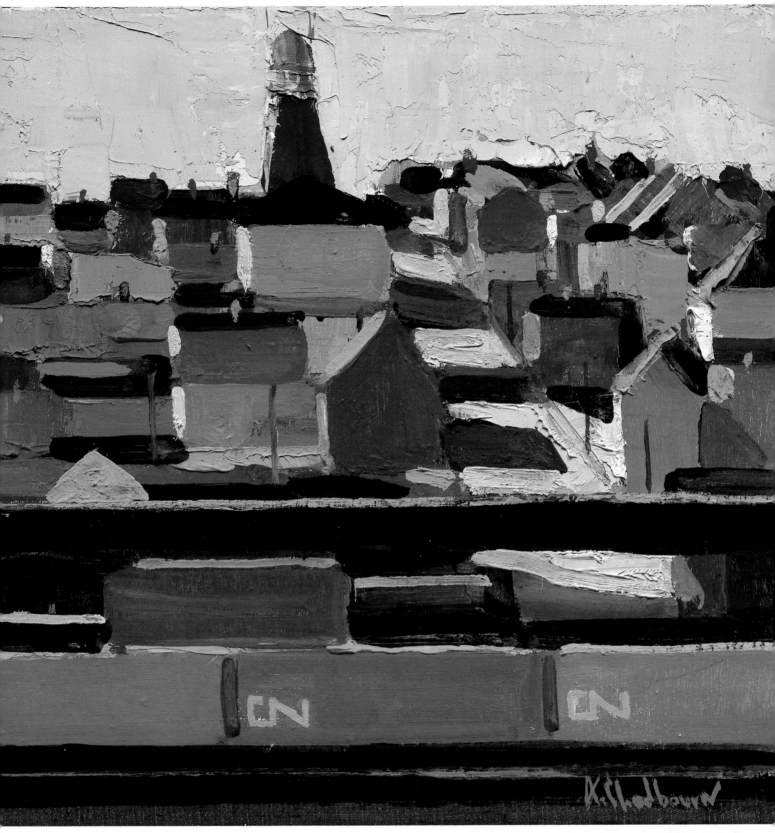

VIEW OF MUNJOY HILL,
PORTLAND, MAINE
14" × 20' (36 × 51 cm)
collection of Mr. Richard Wright

Using Halation

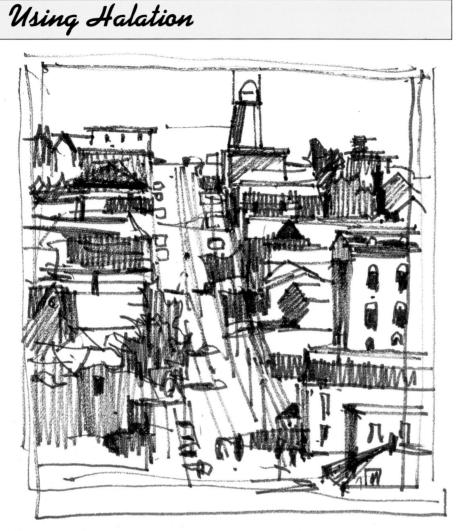

About five years ago I became interested in the works of Wayne Thiebaud, a so-called Pop artist who came to national attention with his paintings of gumball machines, lollipops, restaurant counters, pies, and ice cream cones. Since I've always been fond of food paintings, I was immediately drawn to these images, as I mentioned on page 44. More recently, I have been captivated by his snazzy cityscapes of San Francisco, with their roller-coaster perspective and brilliant color.

With a small stretch of the imagination, Munjoy Hill, with its odd-shaped, turn-of-the-century buildings, resembles San Francisco. Although it doesn't have those plunging hills, I took some liberties with the perspective to give a "sense of verticality" to the painting, as Thiebaud phrases it.

Another aspect of Thiebaud's work that particularly interests me is his creation of light through what he calls "halation." As he puts it, "If you stare at an object under a strong light, really sit there until your eyes become tired, which is what you do when you paint, you're seeing two views that are never quite merged. The halation is the disparity between the two, on the edges of things. It's also an attempt to make the object merge softly with the ground, to give a little bit of vibration, so the eye will accept the form as not being so pasted on. It's a way of energizing; the halation gives a strength that wouldn't be there without it. Actually, it's an attempt to have the picture create its own light, rather than imitating light."

This theory might be compared to what Monet discovered by painting the same haystacks at different hours of the day. Monet used more broken color in the Impressionist manner, but he, too, produced luminous shadows by juxtaposing opposite colors.

I sometimes use the effect of halation to energize or jazz up any area with strong light and dark contrasts in a high-key painting that describes sunlight. Like beach scenes (see pages 100–111) or bright street scenes. I wouldn't attempt it in a dark painting like *Cheese and Grand Marnier* (page 33), as it would completely destroy the somber mood.

Note where I have used bright blue and violet shadows with small strips of red on the rim. This use of violent contrasts is one way to "energize" a shadow in a high-key painting. Again, I wouldn't think of using this method in a low-key, somber painting, just as I wouldn't wish to superimpose a Monet color scheme on one of Rembrandt's self-portraits.

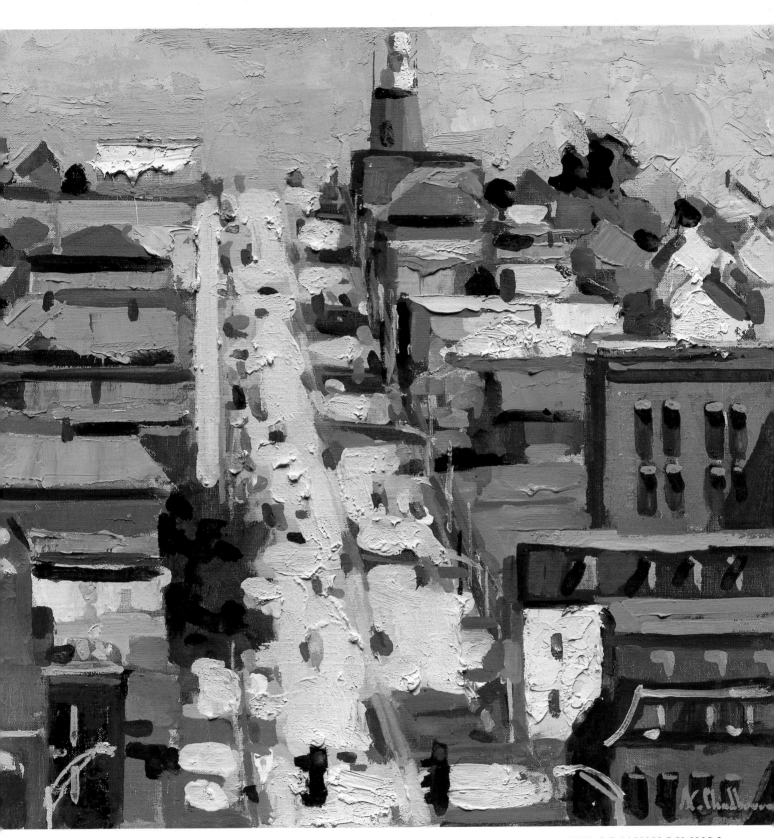

VIEW OF MUNJOY HILL,
PORTLAND, MAINE
18″ × 18″ (46 × 46 cm)
private collection

*The detail (left) provides a good example
of halation, with the red strip vibrating
against the cool blue-violet of the shadows.*

Choosing an Unusual Perspective

This painting was done from a sketch on a pedestrian overpass, viewing Portland from a divided highway called Marginal Way. It was a late summer afternoon with a warm persimmon sky, and the sun cast long, deep shadows over the green grass, leading to the violet-browns of the distant city. I've never considered paved highways as particularly painterly subjects, but here they were transformed into bands of color, which opened up all sorts of expressive possibilities.

The whole concept of this painting was to create an unusual composition by forcing the perspective of the highway on the left as a foil for the sweeping curve of the highway to the right. In contrast to the roadway on the right, which is more or less in natural perspective, the road on the left is almost perpendicular to the picture plane. Under normal conditions, this road would have a much gentler slope, leading out to the left. By playing on the expressive properties of perspective, I created spatial ambiguities and tensions that add vitality to the scene.

To paint the road on the left, I chose a high-key pink instead of a nondescript gray, while on the right I used violet shadows. To capture the effect of late afternoon light, I used bright lemon-greens in the grass with deep, cool greens in the shadows. With all these strong color contrasts in the foreground, I selected warm browns and violets for the distant city, which I then simplified into a geometric configuration.

The sky is probably as close as I come to painting what might be considered an atmospheric sky. The persimmon color was determined largely by the feeling of late afternoon light I wanted to create, although it also made a good complement to the deep violets in the foreground. As so often happens, I didn't get the colors right at first and ended up repainting several times. Sometimes overpainting in this way is an advantage, as by letting the undercoat show through, you obtain certain qualities that wouldn't be possible by painting the whole sky in one session. I kept the brushwork fairly smooth and simple in the sky, with only a slight value change, since I didn't want to interfere with the drama of the rest of the painting.

Taking liberties with color or perspective is not an easy lesson to learn, unless you're willing to take chances with your painting. Many times it means going beyond known and accepted conventions. In designing the composition, I altered the perspective to gain expressive impact. Then, in painting the late afternoon light, I was guided more by an instinct to push the color potentials a little further than by color theories. Playing the lemon and deep green areas against the pinkish browns and violets was primarily an extension of the warm and cool colors suggested by nature.

Taking liberties with color or perspective is not an easy lesson to learn, unless you're willing to take chances with your painting.

124

MARGINAL WAY,
PORTLAND, MAINE
12″ × 18″ (30 × 46 cm)
collection of Mr. Paul A. Plante

EXPLORING A FISHING VILLAGE

*W*hen I moved to Maine twelve years ago, I spent the first two years driving endlessly up and down the coast, covering every inch of each peninsula, in search of new material. Then I discovered Stonington, a small fishing village on the tip of Deer Isle, just off Penobscot Bay and the Bay of Fundy. It's been a favorite spot for painters ever since John Marin immortalized it in the twenties and thirties, and I don't think the town has changed much since then. There is an inherent simplicity to the place with its gleaming white clapboard houses, mansard roofs, tall red chimneys, and weatherbeaten wood piers.

Much as I admire Marin's explosive watercolors with their push-pull effects, I always feel that with his splintered compositions of this small fishing village, it is as though someone had thrown a hand grenade into a chicken coop. I see the town quite differently. It all seems very peaceful with the strong horizontal feeling of the water, the gentle nesting of workboats in the harbor, and the almost Japanese-print quality of the receding gray tones of the distant, overlapping islands.

The paintings and sketches of Stonington on the following pages, as well as elsewhere in this book, are the result of many, many trips to the same location. It was an important lesson for me, teaching me the value of going back and rediscovering many things I had overlooked on my first furtive visits. Once again, I am reminded of Cézanne's late work. I remember being completely bowled over by a wall of fifteen paintings of Mont Sainte-Victoire in a spectacular show at the Museum of Modern Art in New York in 1977. What impressed me, as I passed from one painting to the next, was that each picture varied in mood, color, and composition, even though they were all painted from the same location.

STREET SCENE,
STONINGTON, MAINE
16" × 16" (41 × 41 cm)
courtesy of Barridoff Gallery,
Portland, Maine

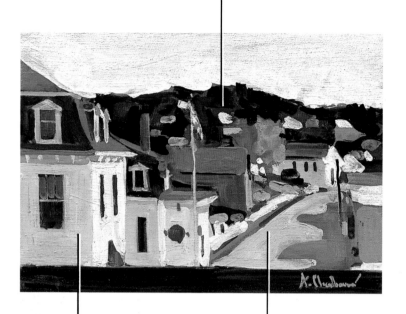

Thalo green +
burnt sienna +
yellow ochre

white +
ultramarine blue +
yellow ochre

alizarin crimson +
ultramarine blue +
white

Distilling the Color Pattern

One of the appealing aspects of Stonington—beyond its own simple beauty—is the scarcity of automobiles. Also—and perhaps more important—it's situated on a series of hills, providing a diversity of viewpoints. The view shown here is from a rocky ledge overlooking the main street on an early Sunday in September, with little or no traffic to hinder the view.

Basically I saw a pattern of violet rooftops and white buildings, offset by the lavender tones on the road and the hint of autumn in the foliage. To mix the violet tones, I used primarily alizarin crimson, ultramarine blue, and white, as noted in the callouts. For the darkest tone on the roof on the left, I used very little white, while I added

more white and a little more warmth to the roofs in sunlight. I kept the lavender tones on the street warmer than the rooftops but somewhat subdued, since I didn't want to disturb the tranquility of the scene. The red chimney, the flag, and the orange trees became the only accents of warm color in the painting's predominantly violet color scheme.

As I was close to the buildings in the foreground, there was a constant temptation to dig into the architectural details and show each and every clapboard. But I was primarily concerned with the simple pattern of the buildings, so I resisted these inclinations and tried to simplify the overall pattern of the picture.

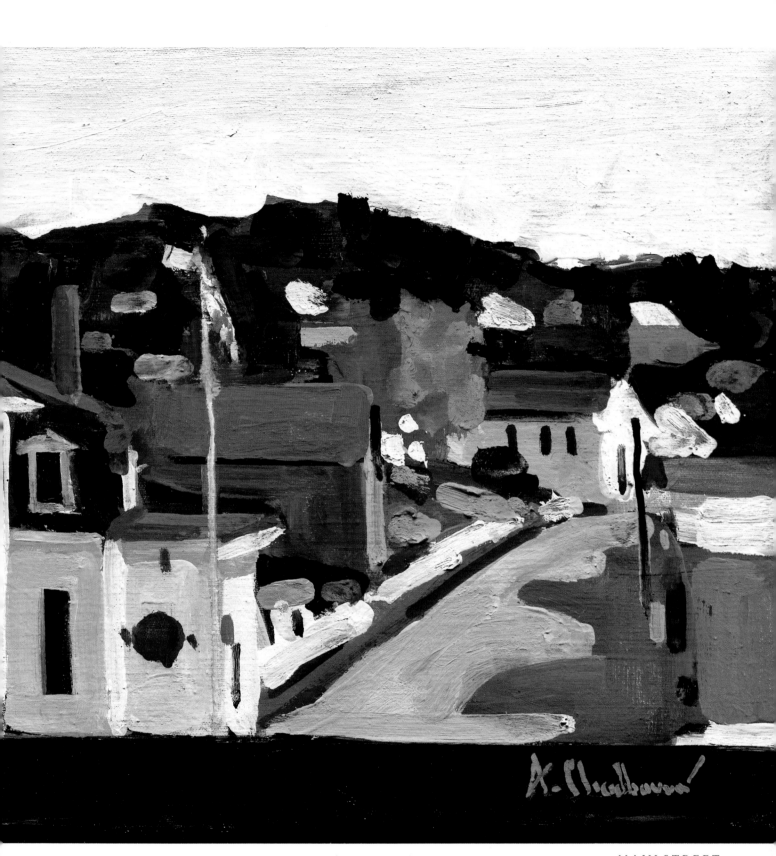

MAIN STREET,
STONINGTON, MAINE
10″ × 14″ (25 × 36 cm)
collection of Dr. John T. Libby

Finding the Color of Light

The American painter Charles Hawthorne used to tell his students, "Paint a subject that paints itself." I sometimes question the oversimplification of that statement, but in this case that's more or less what happened. Everything was in front of me; all I had to do was put it down.

My first impression of this scene was of the play of late sunlight on the simple white building in the foreground, accentuated by the strong cast shadows in the grass. In my initial sketches (not shown here), I suggested a building on the right, which cast the shadow, but in the end I left it out, as I thought it would be more interesting to make an L-shaped composition, using the vertical shape of the white building against the horizontal of the cast shadow. The other buildings then fell into place, forming a jumble of geometric shapes against the calm water.

Having decided on the general composition, I faced the problem of transforming light into color. First, I pushed the dark greens and exaggerated the cool shadows on the buildings. This gave me the chance to build up some rich, thick pigment in the lights, which helped to establish a strong feeling of late afternoon light.

As with most of my paintings, I had to paint the grass several times until I caught the effect I was after. I can't emphasize this enough: Don't settle for the first colors you put down. Keep experimenting, trying to push the color to its fullest possibilities.

COLOR MIXTURES

1. The dark greens are burnt sienna, yellow ochre, and Thalo green. As you can see in the color swatches, when burnt sienna and Thalo green are mixed together, the result is a dense, almost black color. Adding some yellow ochre to this mixture gives a little more luminosity, so you can see into the shadow.

2. The shadows of the buildings are done with a simple mixture of yellow ochre, ultramarine blue, and white. The amount of blue added to this mixture determines how cool the shadow appears.

3. Then, on the light side of the building, a small amount of yellow ochre is added, along with white, to make the lights more luminous.

4. The light-struck part of the grass is a thick mixture of cadmium yellow, white, and Thalo green. Sometimes, if too much white is used, this mixture looks vile, so I would be judicious.

5. The small green house and the green roofs are painted with Thalo green, yellow ochre, and white—a mixture that is just a bit cooler than the light grass.

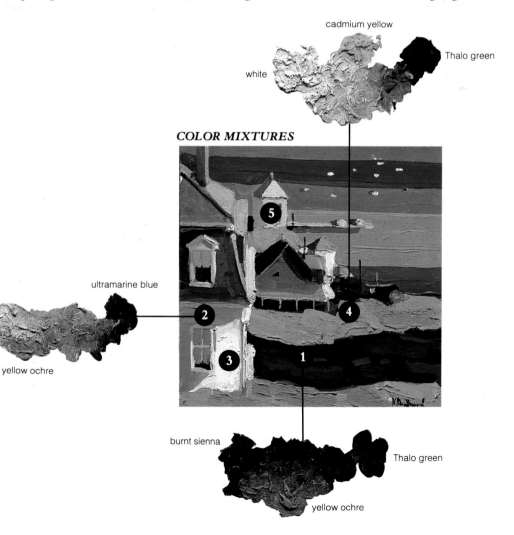

cadmium yellow

Thalo green

white

COLOR MIXTURES

white

ultramarine blue

yellow ochre

burnt sienna

Thalo green

yellow ochre

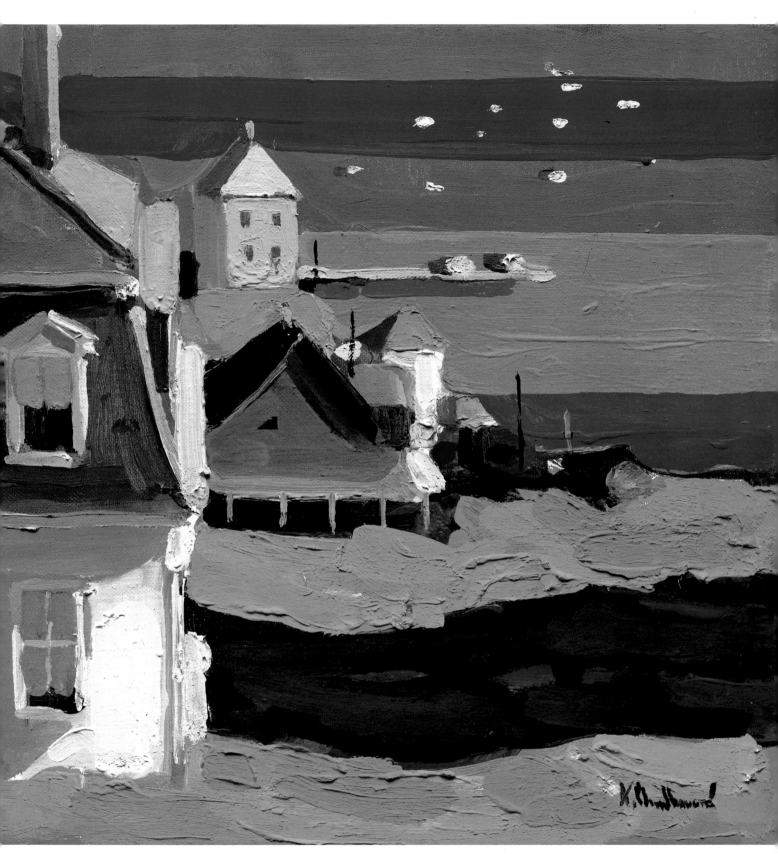

VIEW OF STONINGTON, MAINE
14" × 14" (36 × 36 cm)
collection of Dr. and Mrs. Daniel Miller

Working with Cool Blues

This painting of Stonington, which was done several years ago, is generally darker than the paintings I do now. It was prompted by a series of sketches done on the spot and later transformed into a semi-abstract design of simple, white geometric shapes of buildings surrounded by dark evergreens and frigid blue-black waters. Essentially, the painting is about pattern, with the scene broken up into abstract shapes that I felt would convey the starkness of the isolated white village.

At the time I did this picture I used a painting knife more frequently than I do now; I also used Thalo blue instead of ultramarine blue. Although this painting is not as blue as the Provincetown scene (see page 133, bottom), it demonstrates yet another range of blues—those made with Thalo blue. Note that most of these blues have a cooler, greenish tint, particularly in the gray areas. Here this was desirable, since I wanted to convey a somewhat somber mood.

alizarin crimson +
white

Thalo blue +
yellow ochre +
white

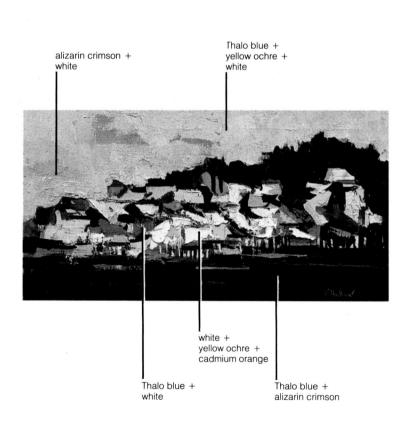

white +
yellow ochre +
cadmium orange

Thalo blue +
white

Thalo blue +
alizarin crimson

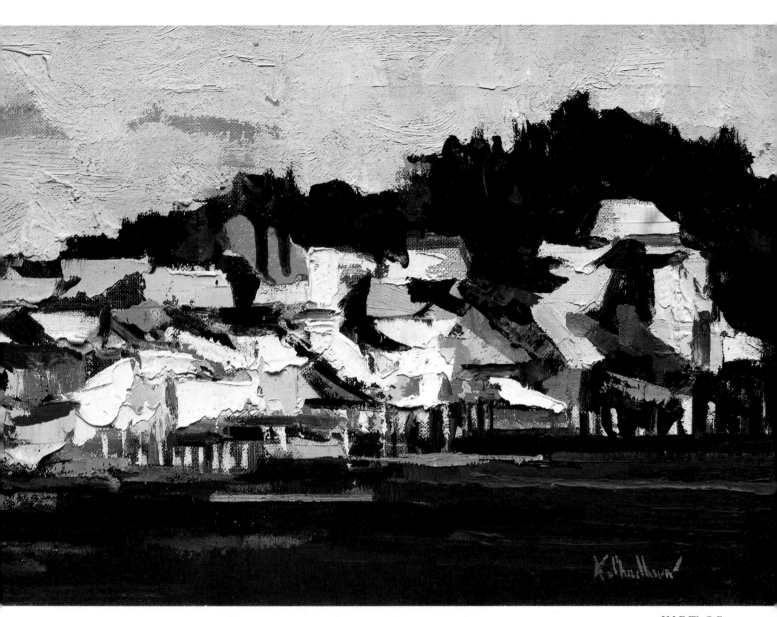

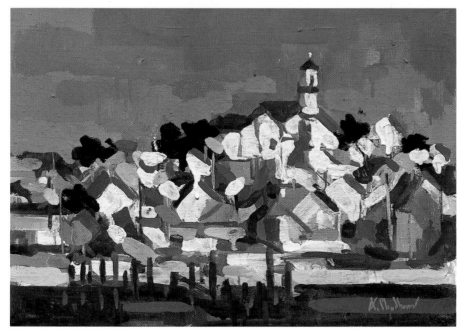

*Compare the blues in this painting of Prov-
incetown, which were made with ultramar-
ine blue, with the blues in the view of
Stonington above, made with Thalo blue.*

Strengthening the Pattern

This view of Stonington was glimpsed from a hillside overlooking the harbor during a brisk morning walk in springtime. Even though it was early morning, I exaggerated the cast shadows to add more pattern to the rich green fields in the foreground. Another painter, of a different persuasion, might have captured the quality of early morning light by using a more subtle range of values, but, to me, the overall pattern was most important.

In keeping with the tranquil mood, I darkened the water with strong horizontal strokes of deep ultramarine blue. When I first laid in the overall blue tone, however, it looked too flat for the strong light-dark contrast in the rest of the painting. That's why I added the lighter strips of ultramarine blue and white, which give a feeling of light on the water. Actually, in many of my paintings of Stonington, I use horizontal strips of blue because they express an integral part of the way I feel about this peaceful harbor

The slightly milky green house in the center is a green one sees painted on houses all over New England—what I call "bathroom green." Generally I use a mixture of lemon yellow, Thalo green, and lots of white for the light-struck areas. For the shadow side, I mix Thalo green, yellow ochre, and some cerulean blue with small amounts of white. Naturally, these colors change a bit depending on what color is next to the green and just how strong the light source is.

For the other buildings, I used a thin mixture of ultramarine blue, yellow ochre, and white on the shadow side. When it came to painting the light side, I loaded my brush with plenty of white to build up the textures and create an almost sculptural effect. In some cases I added a bit of yellow ochre to the white mixture to give it more luminosity. The question of how thick or thin one paints is a matter of personal choice, but here I wanted the gleaming whites to stand out, so I kept piling on the paint and complemented some of the textures in other areas.

As a foil for the cool colors of the water, I chose a warm pink sky, mixed with white and Thalo red rose (which is a bit warmer than alizarin crimson). I also included small bits of warm, peach-like colors—mixed with yellow ochre, cadmium orange, and white—around the piers and docks to keep the whole painting from appearing too cold. Then, near the end, I added the boats and poles by dragging light pigment over the dark.

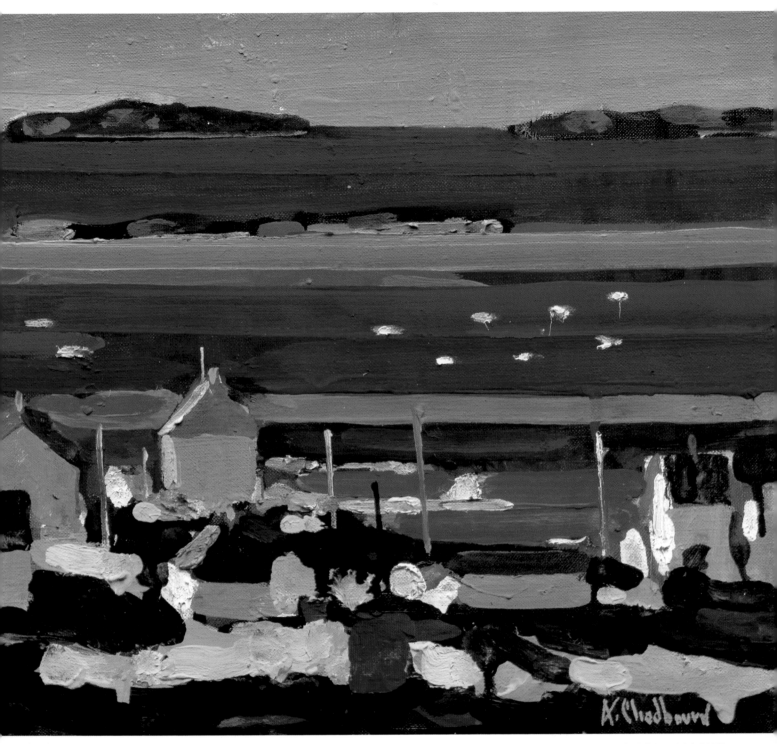

VIEW OF STONINGTON, MAINE
12″ × 18″ (30 × 46 cm)
collection of G. and P. Kendrick

Seeing Color against Light

I decided on this closeup view of Main Street in Stonington after prowling around behind the buildings on one of my early morning sojourns. It's worth reemphasizing the importance of walking around your subject, seeing it from different angles, until you feel you have exhausted all the pictorial possibilities. Even though I've been coming to Stonington for years, I feel there is still plenty of material left to uncover. It all depends on taking a fresh look at the village.

What attracted me most in this scene were the color relationships—the way the dark yellow storefront was juxtaposed against the light and dark patterns of the buildings in front and how all these buildings framed the cluster of bright colors on the pick-up trucks. As in my painting of Five Islands (shown below), the challenge was to portray a street scene against the light.

To capture the backlit effect, I started out by establishing the relationship of the dark yellow building to the warm, clear tones of the water. For the water, I used a simple mixture of Thalo red rose and white. I kept this whole area very flat, even painting the small boats and islands in flat gray tones, since I wanted to concentrate on the busy color contrasts of the street.

The hardest part was getting the right tonality for the yellow building, so that it held its place in the shadow, yet didn't become too green. In this case I probably used a lot of pure yellow ochre, mixed with a small amount of cadmium yellow.

Once the rich darks on the store windows and shadows on the street were established, it became possible to build a vibrant patchwork of lights against the surrounding halftones. Finding the right mixtures, however, wasn't easy. I know that the amount of time spent on a painting is no real indication of the merit of a work, but sometimes a small, simple painting like this one can consume more of my time than a larger, more ambitious painting.

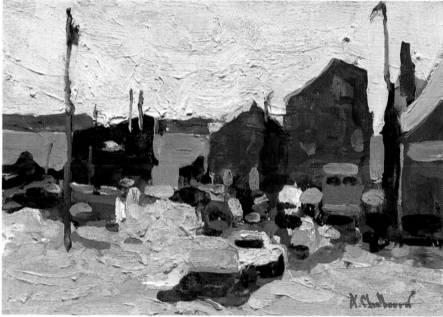

With my painting of Vic's Store, I was again painting a street scene against the light, although the value contrasts were not as pronounced as in my painting of Five Islands (shown above). Because I was standing much closer to the buildings in the Stonington scene, I was able to see more color in the halftones, making the value separations much subtler.

VIC'S STORE, STONINGTON, MAINE
14" × 14" (36 × 36 cm), collection of Mr. and Mrs. Turner Porter

136

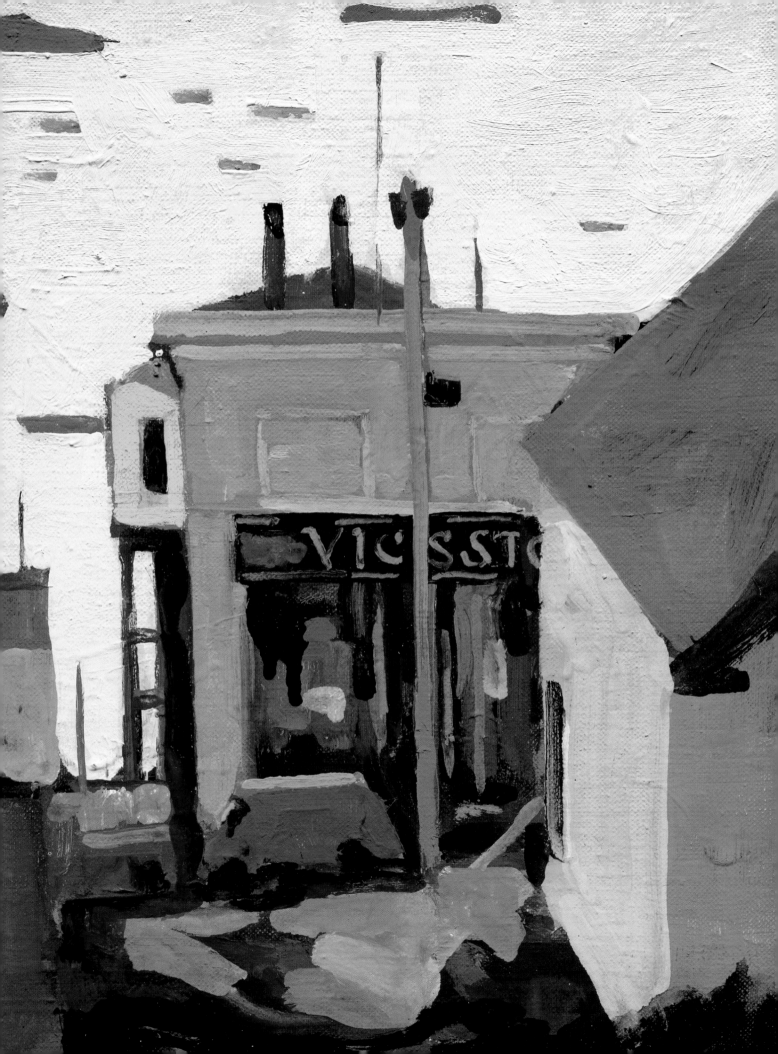

Depicting an Autumn Evening

In painting this scene I purposely set out to capture a slightly somber, quiet mood through the use of subdued values and a violet color scheme. After I had established the values and composition in a rough black-and-white sketch, the problem was to determine which violet mixtures would best describe the late-autumn evening light. First I worked on the deep purples of the tall building on the right and the halftones of the small buildings on the street. Then the challenge was to get the right relationship between the light pink water and the warm violet tone of the street. It is this relationship between the darker road and the lighter water that sets the mood and conveys the atmosphere of evening. It took a lot of adjusting and repainting until I felt I had achieved the proper relationship.

When the painting was almost finished and I had more or less resolved its mood, I felt it still looked a bit empty and lacked a certain sparkle. So I introduced the pure cerulean blue truck against the dark red building and the yellow stripes on the street. Adding these arbitrary color notes near the end of the painting was a purely personal choice—it had nothing to do with what I saw in front of me. But I think these instinctive gut feelings are often reliable and should be pursued.

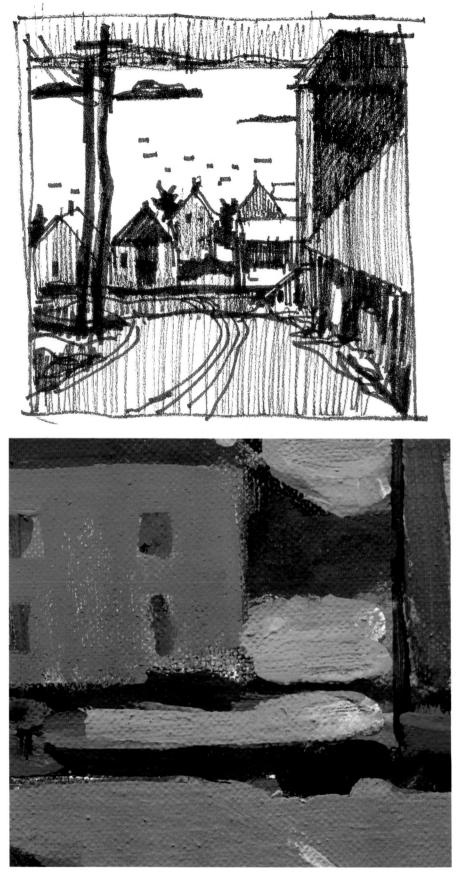

Almost all the violet tones, including the road and the small grayish houses by the water were done with a mixture of Thalo red rose, ultramarine blue, and white. This mixture can be varied, depending on how much blue or red you add to the white. To offset some of these violets, I used small amounts of hot pink on the ground, mixing Thalo red rose and yellow ochre with white. These touches helped to emphasize the feeling of an autumn evening.

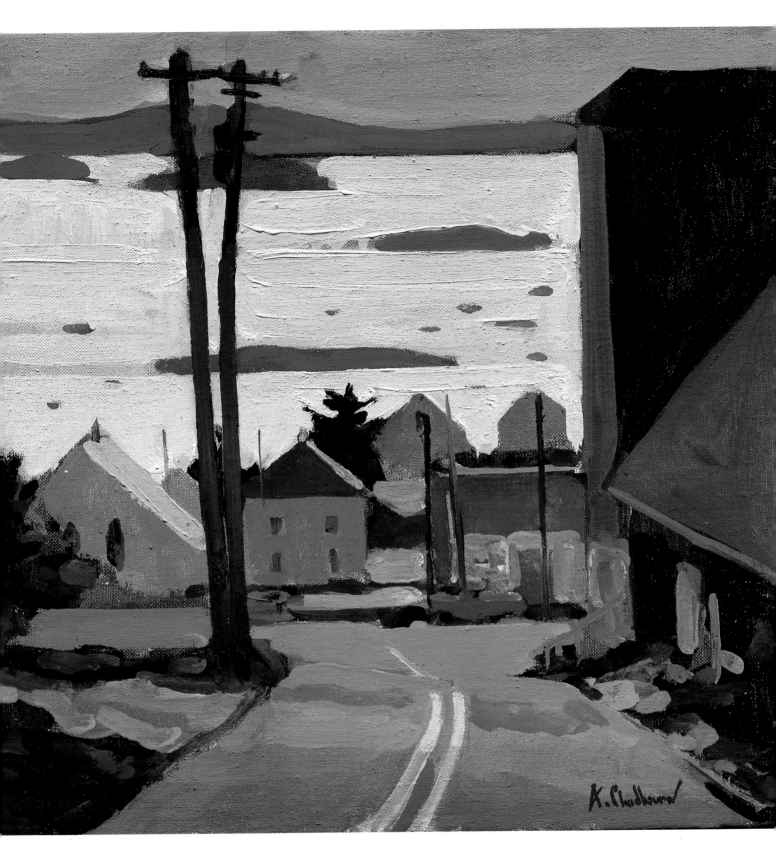

STREET SCENE,
STONINGTON, MAINE
14" × 14" (36 × 36 cm)
collection of Mr. and
Mrs. David Swardlick

CONCLUSION

*A*t the end of my classes, after all the students have gone I sit in my rocker surveying the vacant studio with all the forlorn, empty easels. There is always a slight feeling of melancholia that overtakes me. I feel somewhat the same about finishing this book.

At the beginning, I stated that the purpose of this book was to open your eyes to a more provocative and, I hope, more meaningful approach to painting. In reviewing the many problems we all share in painting, there is one point I don't think I've stressed enough—and that's the ability to criticize your own work. Just like learning how to paint, this takes time.

Most of the good artists I know review their work in their studios at least once a year, to assess the direction of their work and, more important, to find out something about themselves. In my own case, because I tend to be a bit hard on myself, I call this "reviewing the failures." It's at this time that I decide which paintings will go to the dump, which will stay with me for further work, and which will go to the gallery.

With the work strung out along the walls of my studio, I ask myself some tough questions: Is there a thread running through the work that suggests a new or different direction? What seem to be my strengths and weaknesses? Am I relying too much on one set of color possibilities? How could I stretch the color further? Have I just about run out of steam on one particular subject? Or could I find something new and challenging by approaching it from another point of view? Are there any really blatant influences that have crept into the work without my acknowledging it? These are some of the questions you, too, should start asking yourself to develop your own critical eye.

MAIN STREET,
YARMOUTH, MAINE
14" × 14" (36 × 36 cm)
courtesy of Barridoff Gallery, Portland, Maine

BIBLIOGRAPHY

It doesn't take a lot of money to start collecting your own art library. During my penny-pinching days in Paris, I began buying cheap postcard reproductions of paintings from second-hand book stores on the Left Bank, as well as museums and galleries. I have shoeboxes full of these reproductions, which are a permanent part of my luggage. I use them not just as a teaching aid, but also as a frequent source of inspiration. Even when you're not searching for something specific, it's wonderful to familiarize yourself with your favorite artists by browsing through the cards in a reflective mood. Most museums offer a vast array of good reproductions at minimum cost, and they're often a good substitute for more expensive catalogs.

For those of you who would like to learn more about some of the artists I mention in the text, I've included this bibliography, which includes some of the books I frequently use in my teaching. When it comes to taking chances and experimenting, we can do no better than to study some of the great examples of the past and keep a sharp, critical eye on the present.

Ashberry, John, and Moffett, Kenworth. *Fairfield Porter*. Boston: Boston Museum of Fine Arts, 1982.

Betts, Edward. *Master Class in Watercolor*. New York: Watson-Guptill Publications, 1975.

Buck, Robert T. *Richard Diebenkorn, Paintings 1943–1976*. Buffalo, N.Y.: Albright Knox Gallery.

Cogniat, Raymond. *Bonnard*. New York: Crown Publishers, 1980.

———. *Braque*. New York: Crown Publishers, 1980.

———. *Soutine*. New York: Crown Publishers, 1973.

Diehl, Gaston. *Pascin*. New York: Crown Publishers, 1980.

Dumur, Guy. *Nicolas De Stael*. New York: Crown Publishers, 1975.

Gordon, Robert, and Forge, Andrew. *The Last Flowers of Manet*. New York: Harry N. Abrams, 1983.

Gowing, Lawrence. *Matisse*. New York: Oxford University Press, 1979.

Hawthorne, Charles W. *Charles W. Hawthorne on Painting*. Introduction by Edwin Dickson. New York: Dover.

Hess, Thomas B. *Willian De Kooning*. New York: Museum of Modern Art, 1968.

Hogarth, Paul. *Creative Ink Drawing*. New York: Watson-Guptill Publications, 1968.

Hope, Henry R. *Georges Braque*. New York: Museum of Modern Art.

Hunter, Sam. *Larry Rivers*. New York: Harry N. Abrams, 1979.

Julien, Edouard. *Lautrec*. New York: Crown Publishers, 1980.

Kozloff, Max. *Jasper Johns*. New York: Harry N. Abrams.

———. *Robert Rauschenberg*. New York: Harry N. Abrams.

Levin, Gail. *Edward Hopper: The Art and the Artist*. New York: W. W. Norton, 1980.

Pickvance, Ronald. *Van Gogh in Arles*. New York: Metropolitan Museum of Art, 1984.

———. *Van Gogh in Sant-Rémy and Auvers*. New York: Metropolitan Museum of Art, 1986.

Read, Herbert. *The Meaning of Art*. New York: Penguin Books, 1931.

Réalités Magazine, Editors. *Impressionism*. Secaucus, N.J.: Chartwell Books, 1980.

Reid, Charles. *Painting What You Want to See*. New York: Watson-Guptill Publications, 1983.

Rey, Robert. *Manet*. New York: Crown Publishers, 1975.

Rosenberg, Pierre. *Chardin*. Cleveland: Cleveland Museum of Art, 1979.

Rubin, William, Editor. *Cézanne: The Late Work*. New York: Museum of Modern Art, 1977.

Russell, John. *The Meanings of Modern Art*. New York: Museum of Modern Art, 1974.

———. *Vuillard*. Greenwich, Conn.: New York Graphic Society, 1971.

Sawin, Martica. *Wolf Kahn*. New York: Taplinger Publishing, 1981.

Schwarz, Hans. *Painting in Towns and Cities*. New York: Watson-Guptill Publications, 1969.

Selz, Jean. *Eugene Boudin*. New York: Crown Publishers, 1980.

———. *Turner*. New York: Crown Publishers, 1980.

Shapiro, Meyer. *Modern Art*. New York: George Braziller.

Soby, James Thrall, et al. *Bonnard and His Environment*. New York: Museum of Modern Art, 1964.

Taillandier, Yvon. *Corot*. New York: Crown Publishers, 1980.

Tsujimoto, Karen. *Wayne Thiebaud*. San Francisco: San Francisco Museum of Modern Art, 1985.

INDEX